The Duke of
WELLINGTON

*and his political career after Waterloo
– the caricaturists' view*

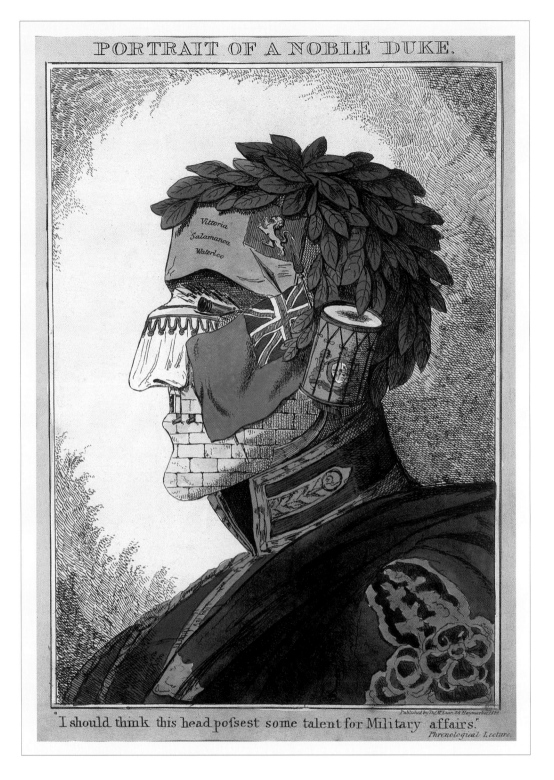

PORTRAIT OF A NOBLE DUKE.

"I should think this head possest some talent for Military affairs."
Phrenological Lecture.

PORTRAIT OF A NOBLE DUKE
Artist unknown. Published Thos. McLean 1829. BM 15691.

This fantastic portrait of Wellington contains the legend, 'I should think this head possest (sic) some talent for Military affairs. Phrenological Lecture'. It is composed almost entirely of military things: a flag adorns his cheek and another with the words Waterloo, Salamanca and Vittoria forms his forehead. Laurel leaves are his hair. A sentry box, a tent, a cannon, a drum, bayonets and masonry make up his features.

The caricature implies that the Duke was essentially a military man, perhaps unsuited to civilian ways. The implication is unpleasant: Wellington's detractors and critics often accused him of an ambition either to wear the royal crown or to become England's dictator.

THE DUKE OF
WELLINGTON

*and his political career after Waterloo
– the caricaturists' view*

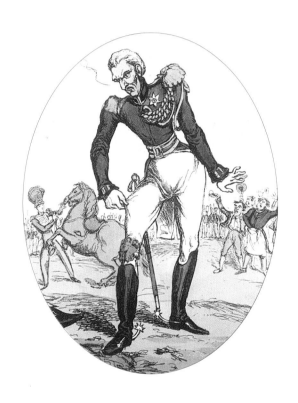

EDWARD DU CANN

ANTIQUE COLLECTORS' CLUB

— DEDICATION —

To my children – who suffered their father's passion for the subject with
an amused tolerance; who cheerfully helped to display the caricatures
and, equally cheerfully, to take them down again when he moved house.

British Library Cataloguing-in-Publication Data
A catalogue record for this book is available from the British Library

Printed in England by the Antique Collectors' Club Ltd., Woodbridge, Suffolk
on Consort Royal Satin paper supplied by the Donside Paper Company,
Aberdeen Scotland

— CONTENTS —

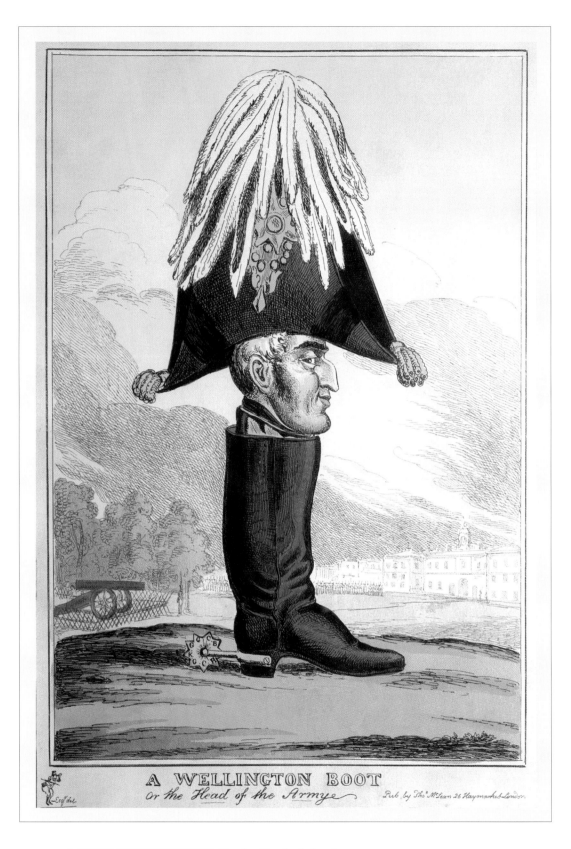

A WELLINGTON BOOT Or the <u>Head</u> of the <u>Army</u>

Paul Pry (William Heath). Published by Thos. McLean, London 1827. BM 15430.
(Reproduced by kind permission of the Trustees of the Victoria and Albert Museum, London.)

— AUTHOR'S PREFACE —

My personal interest in the 'Iron Duke' developed when, as MP for Taunton, I lived for more than thirty-five years near Wellington – the small Somerset town from which Arthur Wellesley took his title, once a separate Parliamentary division but for many years now a part of the Taunton constituency. Over a period of years I have collected a number of caricatures of him mainly through the helpfulness of a lady well known to Parliamentary collectors, Mrs Antoinette Tomsett of John Bull Prints, who has helped me make this selection, has kindly checked this text for historical accuracy and made numerous helpful suggestions. I had the caricatures photographed and the photographs are the basis of this book. (The BM numbers in the captions are references to the British Museum's invaluable catalogue.)

One of the best known (and least respectful) is the caricature opposite by William Heath (under the pseudonym of Paul Pry with an accompanying thumbnail sketch of the figure).

Wellington's public life coincided with the period in which caricature was a popular art form – which can be said to have begun in the 1790s. He had returned to England in 1818 after the constructive part he played in the peace settlement which followed the Battle of Waterloo. From that date and until his death in Walmer Castle in 1852, he appeared – by a substantial margin – in more caricatures than any of his political contemporaries. Together, they give a unique insight into the popular issues, interests and anxieties of the day. They are a window on history.

Sadly, there is not room for them all in this book. I have, therefore, made a selection based on two criteria: first, that they illustrate a key subject with which today's reader can readily empathise; and, second, that they represent quality examples of caricature. I have included mainly those which feature Wellington as a prominent, not peripheral, character. Though presented in a broadly chronological sequence, the caricatures are not necessarily chronological. Wellington's life was too full, and the caricatures about him too numerous, for such an approach to be taken without extensive and complicated cross-referencing. The result is a brief – but I hope entertaining – 'caricatour' through Wellington's political life and a spotlight on the domestic political issues which were of the greatest popular concern in his day.

There are remarkable parallels with today's political happenings – problems in a royal marriage, constitutional changes (and controversies), civil unrest in Ireland and the continuous difficulty for a Prime Minister of forming and managing a Cabinet of Parliamentary colleagues – even of remaining in office. *Plus ça change…*

Our leading contemporary politicians have (to my mind) an obsessive and unhealthy desire to obtain flattering media exposure on an almost daily basis. The Duke was above such populist considerations. His patriotism and his sense of duty led him to serve our state and to act always to the best of his ability and, as he believed, to do what was right regardless of popular opinion and, on occasion,

regardless also of the prejudices of his Tory supporters. With the perspective of time we may judge that in some matters he was correct – in others, perhaps, mistaken. He was strong in his opinions and determined to uphold them. However, if there was no alternative or when his own arguments did not prevail, he was ready to accept another view. During his time at the centre of political affairs at Westminster and when circumstances required him to do so, he changed his stance (if not his opinions) over three hugely important issues – the Corn Laws, Catholic emancipation and electoral reform. In the end, his acceptance of the inevitable and his determination to support the King's Ministry did him credit.

It is a matter of doubt whether his military experience fitted him well for political life. The fierce disciplines to which he was accustomed and the immediate obedience of firm orders by subordinates were by no means the ordinary characteristics of politics. Even his best judgements were invariably criticised, and loyalties were often uncertain among his natural allies and supposed supporters in Parliament. Members of the public, though very largely disenfranchised, were nonetheless vociferous. They might not have the vote, but they could demonstrate to make their opinions plain and throw stones if they felt like it, and they often did. Yet the Iron Duke never seemed anything but unruffled, whatever his inner feelings may have been. His was always a calm example in the streets and in Parliament, as it had been in uniform in the field.

In every circumstance it is right to honour the man. His unselfish patriotism, his integrity and his paramount sense of duty are examples for today's politicians to emulate, if they can.

Edward du Cann
Lemona, 2000

Opposite: **THE MAN WOT CAN'T KEEP HIS SEAT – A <u>GENERAL</u> REVIEW**
Sharpshooter (?J.Phillips). Published King 1829. BM 15784.

On 27 May,1829, now sixty years old and Prime Minister, the Duke fell from his horse during the review of the Tenth (Royal) Hussars in Hyde Park, apparently landing in something distasteful. This caricature is an allusion to rumours that Wellington was about to be dismissed as Premier, a double-edged pun on the difficulties of holding on to power.

A GENERAL REVIEW.

THE MAN WOT CAN'T KEEP HIS SEAT.

— Introduction —

A Short Account of Wellington's Times

Arthur Wellesley, Duke of Wellington, the Iron Duke, led an extraordinary life. As a soldier, the victor over the tyrant Napoleon, he was honoured everywhere as a hero. As an administrator of the peace which followed the Napoleonic war he was universally respected. Then he entered domestic politics. This involved him in public opprobrium, epitomised in the contemporary caricatures of him. He died as revered in popular opinion as he had ever been at the height of his fame and success.

He was born plain Arthur Wesley in Dublin on or about 1 May, 1769 (the same year as Napoleon Bonaparte) the third surviving son of the first Earl of Mornington. Educated at Eton – where he was an under-achiever – he was packed off to a military academy in France. Aged nineteen he returned to Ireland as aide-de-camp to the Irish Lord-Lieutenant. Thus began one of the most remarkable military careers in British history.

Between 1794-5 Wesley (or Wellesley as he came to write his name) first saw active service in Flanders. He was posted to India in 1796, where he worked closely with the Governor-General – his brother Richard. Under Richard's aegis, he developed into a first-class administrator and played an influential role in the rise of Britain's Indian Empire. Those experiences in India, military and civil, were the apprenticeship for his subsequent successes in both fields in Europe. His services there were rewarded with the Order of the Bath. In 1805, the year of Nelson's victory at the Battle of Trafalgar, Sir Arthur Wellesley returned home. In 1806 he married Catherine (Kitty) Pakenham – a childhood sweetheart. (He had proposed to her previously and been rejected.) His perseverance was finally rewarded but it was a sadly unsatisfactory marriage in which they spent more time apart than together. She was generous but frivolous and a poor financial manager.

For some years following his marriage, the pace of his life slowed considerably. The battles he fought were with Kitty, in Parliament at Westminster – which he had entered to defend attacks on his brother's Indian reputation – and on a brief military skirmish in Denmark. He also joined the Tory Ministry (the Government in today's language) as Chief Secretary for Ireland. This relative calm was shattered in July 1808, when he was despatched overseas in temporary command of the British forces to support the Portuguese and some Spanish opposition to Napoleon. There was pessimism in London. Wellington lacked experience of significant military campaigns in Europe and was disparagingly referred to as the 'Sepoy General'.

Within one month of arriving he had fought – and won – a major battle over the French at Vimeiro, near Lisbon. Then came an armistice. Under the generous terms of the Cintra Convention ordered by his superior officers, Wellesley's victory was not exploited. The beaten French were allowed to withdraw from Portugal intact, almost at their leisure and in British transports. Public opinion at home was outraged.

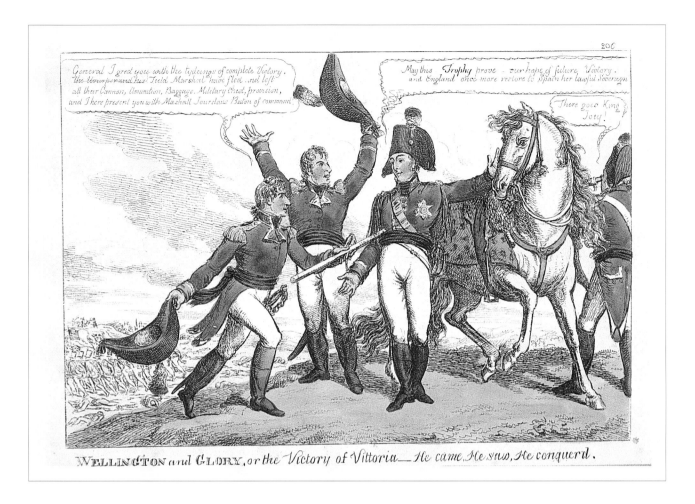

WELLINGTON and GLORY, or the Victory of Vittoria — He came, He saw, He conquer'd.

WELLINGTON and GLORY, or the Victory of Vittoria
(Williams). Published Tegg 1813. BM 12072.

Following the equivalent of a 'yomp' across Portugal and Spain in early 1813, Wellington routed the French army at Vittoria on 21 June. Such was the decisive speed of the battle that the French abandoned all their supplies (including alcohol). The opportunity to celebrate was too good for the victors to miss. This gave the French their chance to escape over the Pyrenees. Wellington was widely fêted. Joseph Bonaparte, Napoleon's brother, narrowly escaped capture. Among the captured spoils was Marshal Jourdan's baton which Wellington presented to the Prince Regent.

Although Wellington's features were distinctive, the caricature is a poor likeness. After his return to England, later examples were to be vastly better. The painting of Wellington by the celebrated Spanish painter Goya is an equally poor likeness in which he had overpainted a previous representation of a member of Napoleon's family. Discretion apparently overruled his original choice of subject.

'Britannia sickens, Cintra, at thy name,' wrote the poet Wordsworth. Not only did he write a critical pamphlet, he also addressed a public meeting of protest. The caricaturists stimulated the public's concern. Gilray and George Cruikshank published sardonic caricatures, the first showing British officers kissing the *derrière* of the French Commander. Wellesley was criticised in effect for not having seen the job through and was subjected to a humiliating court of enquiry, held in the Great Hall of the present Chelsea Hospital. His was not the responsibility; it was that of his superiors, and he was rightly cleared of blame.

Peace was not to last and Sir Arthur Wellesley was to have another chance to exploit his genius and to justify his conviction that Portugal could be held against

the French. In 1809 he resigned his seat in Parliament on being appointed Commander-in-Chief of the British and allied forces in Portugal with the instruction that its defence was his principal object. The odds against him were heavy. He commanded 26,000 British and Hanoverian soldiers. He was immediately faced by over 50,000 French veterans with perhaps another 200,000 in the Iberian peninsular.

The British army was an incomparable fighting force, with an effective order of battle. The Royal Navy, at the peak of its strength and efficiency, assured its supply. The indefatigable Wellesley, diligent always in his preparations for battle, a strategical and tactical genius, achieved a remarkable series of victories over the next five years, first in Portugal and subsequently in Spain: Oporto, Talavera, Salamanca, Vittoria.

A successful soldier hardly excited the caricaturists, always more eager to damn than to praise. Nonetheless a few examples of their comments survive, of which the caricature on the previous page is one.

Wellington took Toulouse on 10 April, 1814, defeating the French on their own soil, effectively ending the Peninsular War and Napoleon's attempt to conquer the Iberian peninsular. In that year he was created Duke of Wellington.

The subsequent victory of the allies over Napoleon at Leipzig owed much to Wellington's successes in the Iberian peninsular. Napoleon's mistake was to weaken his effort by fighting on more than one front, a mistake copied by Hitler. In 1814 Napoleon was forced to abdicate and he was exiled to Elba.

For his successes in the field Wellesley was handsomely rewarded by his sovereign and by Parliament. In 1809, after Talavera, he was made a Viscount. His brother chose the name of Wellington for him – deriving from the small country town of that name in Somerset where it was said his family had once held land, and he would again.

In August 1812 he was created Marquis of Wellington and given £100,000 – a figure which paled in comparison with the £500,000 which awaited his return from the Peninsular Wars. He received many other British honours, being made a Knight of the Garter and a Field Marshal in 1813. In total, five separate Acts of Parliament (some 25,000 words) were passed in his honour – a true indication of the extent and gratitude of public feeling towards British military leaders (Nelson was similarly fêted). The esteem in which he was popularly held in England may be gauged by the fact that the inhabitants of Wellington were so affected by their unexpected connection with him that they raised the money to erect a monument in appreciation, a spire 170 feet high, which stands today on the most elevated point of the Blackdown Hills, bordering Somerset and Devon. It is visible for miles around, in particular from the M5 motorway which by-passes the town. Other countries, too, were quick to confer their own distinctions on him, including thirty-five civil honours (he was even made a Knight of the Holy Ghost) and eight military ranks among others. From 1809 on, he signed his name 'Wellington'. He was neither Wesley nor Wellesley any longer.

There were political ramifications of his victories, too, in that they paved the way for the establishment of the 'Holy Alliance', a pact against Napoleon who

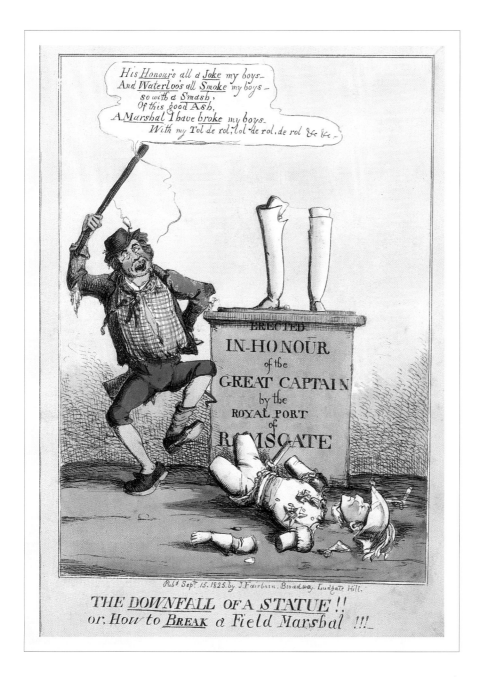

THE <u>DOWNFALL</u> OF A <u>STATUE</u>!! or How to <u>BREAK</u> a Field Marshall!!!
Unknown. Published by Fairburn 1825. BM 14795.

It was a radical thesis (and a calumny) that during Waterloo, Wellington had lingered in Brussels away from the battlefield, and that the victory over Napoleon was due solely to the Prussian Field Marshal Blücher.

So it is throughout history in England: we are ever quick to demean our heroes. How foolish is this habit.

was now safely imprisoned in Elba, or so it was thought. Napoleon escaped in 1815 during the Congress of Vienna – a meeting of the Alliance attended by Wellington in his role as British ambassador to the newly reinstated Bourbon court of Louis XVIII. Thus began Napoleon's 'Hundred Days'. Britain was prompt in declaring war and Napoleon's vain adventure ended on 18 June with his total defeat at Waterloo. Wellington became one of Europe's most enduring,

illustrious and popular military heroes. The country's military prestige had not stood higher since Marlborough's day. Even so, there were those who would carp. Denigrating our heroes is, sadly, still a popular English sport.

If Parliament's effusive reaction to Britain's military successes seems to our modern outlook to be excessive, it should be remembered that until Admiral Duncan's comprehensive defeat of the Dutch fleet at Camperdown and the defeat of the Spanish by Jervis and Nelson at Cape St Vincent at the turn of the century, Britain stood in dread of armed invasion. Napoleon's military successes renewed it. Nor was this all.

In Napoleon's time Britain was faced with a most serious economic threat. Napoleon's military domination of Europe's land mass and his 'Continental System' which followed it was designed to exclude British trade from continental Europe, with fearful potential consequences for our economy and our people. Nelson's brilliant victories at Aboukir Bay and Trafalgar and the success of British armies under Wellington relieved this threat. The relief and the gratitude of the British people were heartfelt.

After Waterloo, Wellington was appointed as Commander-in-Chief of occupied France – a role in which he displayed outstanding administrative skills and sound political judgement. With the wounds and prejudices of war to heal, he opposed moves to dismember France and organised loans to rebuild the country. His wisdom as an administrator in victory did not go unnoticed. In 1817 he was given the funds by the Government to acquire a country seat (he chose Stratfield Saye) and he bought Apsley House in London (for £42,000). The French King had so high a regard for him that he offered Wellington a French peerage, the Dukedom of Brunoy, which he accepted. He was not only an English Duke and a French Duke but he also had Dukedoms in Spain and Portugal, he was a Prince of the Netherlands and held no fewer than twenty-eight Knighthoods. The merchants and bankers of the City of London made him presentations. He became a freeman of numerous municipalities in the British Isles – Cork, Waterford and Dublin in Ireland; Doncaster, Gloucester, Plymouth, Oxford, Liverpool, among others, in England. The Merchant Venturers of Bristol also honoured him.

Following the withdrawal of the Allied army from France in 1818 he returned to England. So ended the first period of his public, as opposed to his military, life. Wellington now accepted the post of Master General of the Ordnance and a seat in Lord Liverpool's Tory Cabinet.

King George III died in 1820. He was succeeded by his son who had previously been appointed Prince Regent on the supposed mental illness of his father. One of Wellington's first tasks was to attempt on behalf of Lord Liverpool's Cabinet to negotiate a settlement between the former Prince and Princess of Wales, whose failed marriage threatened to bring the monarchy into disrepute. In this he was unsuccessful. He could only stand by and watch as the argument between the new King and his estranged Queen became public property and descended into high farce. This marked the rather inauspicious start of the second period of his public life.

Though attractive to ladies and having undoubtedly pursued the opposite sex with vigour, the private life of 'Wellington the beau' played almost no part in

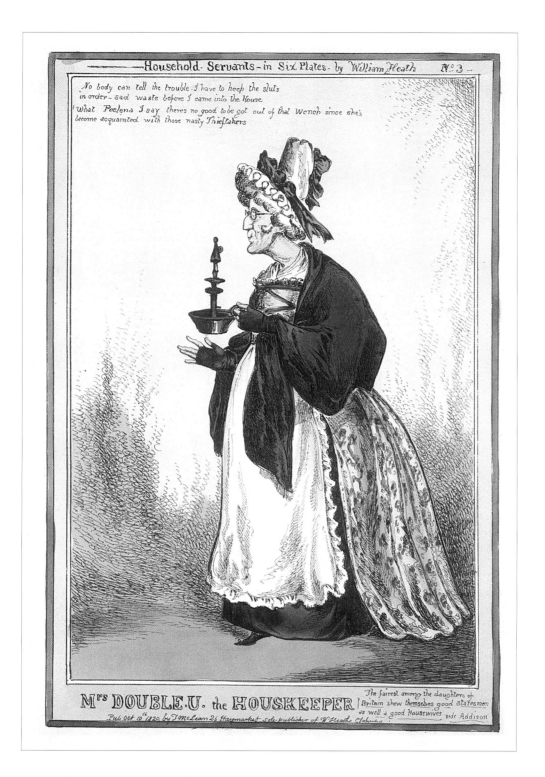

Household Servants in Six Plates by William Heath No. 3

No body can tell the trouble I have to keep the sluts in order – sad waste before I came into the House

What Peelena I say theres no good to be got out of that Wench since she's become acquainted with those nasty Thieftakers

Mrs DOUBLE·U· the HOUSEKEEPER

The fairest among the daughters of Britain shew themselves good statesmen as well a good Housewives vide Addison

Pub Oct 10th 1829 by T McLean 26 Haymarket sole publisher of W. Heaths Etchings

Mrs DOUBLE.U. the HOUSEKEEPER
William Heath. Published Thos. McLean 1829. BM 15880

The Prime Minister is portrayed as a parsimonious housekeeper endeavouring to curb King George IV's extravagances over Buckingham Palace and Windsor.

No 3 in a series of six caricatures entitled 'Household Servants' which included the Lady of the House (Lady Conyingham, the King's mistress) Georgina the Lady's Maid (the King) Roberta Peelena, the Maid of all work (Robert Peel) Old Mother Scarletta (the Attorney General, James Scarlett) and Coplinda Lindhursta, the Cook (the Lord Chancellor).

A more common theme of the caricaturists, especially at the time of the passage into law of the Catholic Emancipation Bill, was the Duke's ability to influence the Sovereign to his point of view, abetted by Lady Conyingham, the King's mistress.

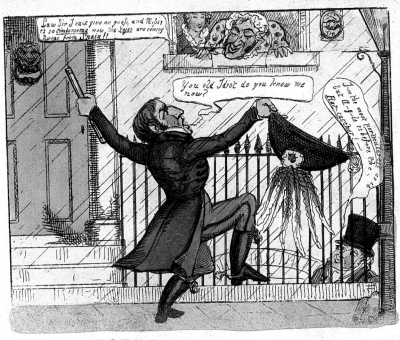

HARRIETTE WILSON
Artist unknown. Published Duncombe 1825. BM unlisted.

Harriette Wilson was a noted courtesan who was reputed to have had liaisons with numerous aristocrats including the Duke of Argyll and Wellington. Wellington at one time had the reputation of being a serious flirt, no doubt in part because his marriage was largely unsuccessful and he relished female company. Here he is shown outside Harriette's house, imploring the maid to let him in while Argyll – pretending to be an old woman – refuses him entrance. The long verse is a parody of Collins's ode – 'The Passions'.

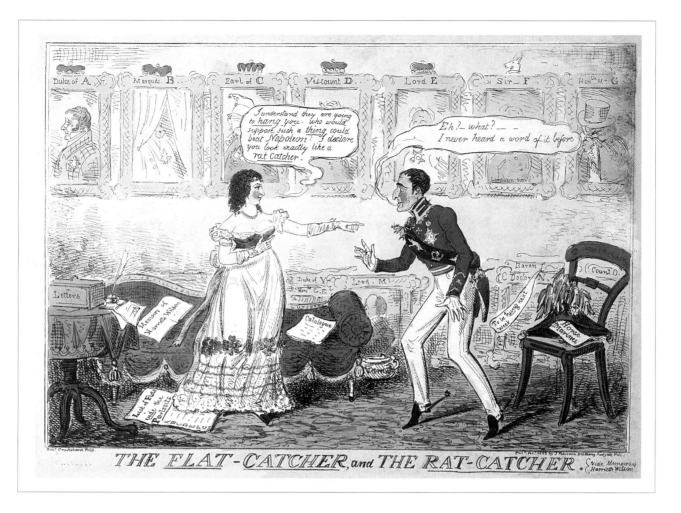

THE FLAT-CATCHER, and THE RAT-CATCHER
Robert Cruikshank. Published Fairburn 1825. BM 14830.

Here, Harriette Wilson is shown receiving Wellington in a room filled with pictures of the aristocracy. Among these are the 'Duke of A' (Argyll, who allegedly vied with Wellington for her attentions).

Many of these individuals featured in her memoirs, published by Stockdale. He wrote to all her former beaux offering them the chance to pay for their names to be omitted. There are, inevitably, stories about his exchanges with the Duke. 'There are various anecdotes of your Grace which it would be most desirable to withhold,' Stockdale said to Wellington. 'Publish and be damned,' the Duke is famously said to have replied.

Wellington was rarely linked in caricature with even a trace of personal scandal, the caricaturists concentrating their attacks on his love of power or his alleged lack of political acumen.

caricature. In contrast, the King was often depicted in caricature with one or other of his mistresses, Lady Conyngham in particular. A few caricatures about Wellington were published which were plainly slanderous.

In 1827 Wellington had resigned his command of the Army and his cabinet post when George Canning – whom he distrusted – became Prime Minister. His period of isolation was short-lived, however, for after the death of Canning and the resignation of Canning's successor Goderich in 1828, he was asked to take over the Premiership. This could hardly have happened at a more testing time.

His Premiership coincided with continuing and widespread disenchantment over the fearful economic state of the nation and increasing clamour for political

change – both of which put the public and leading figures in Parliament at almost constant loggerheads.

Though the issue of electoral reform was a constant preoccupation inside Parliament and in the country, Catholic emancipation (i.e. the removal of the disabilities which prevented Catholics from playing a full part in public life, notably their admission as Members of the Imperial Parliament at Westminster and the holding of many civil and political offices) was the first issue seriously to test his mettle as a political leader.

Though a Tory, he mistrusted the extreme faction of his party, the ultra-Tories (the predecessors, perhaps, of those Conservative MPs Prime Minister John Major in his time called the 'bastards' – those who opposed his policies in respect of the European Union.) Every British political leader in my lifetime has faced opponents within his (or her) own party. Striving for moderation, Wellington's first Cabinet was a mix of Tories and Canningites. This was at a time when party lines were far less rigorously drawn than is the situation today. Most Parliamentarians in those days gave their loyalty to a leader rather than to a party – hence the terms 'Canningites', 'Rockinghamites' and so on.

Cabinet government, the direction of the nation's affairs and the originator of national policy, was a comparatively recent development. By the end of the seventeenth century, the Privy Council had become too large to be an effective instrument of Government. Monarchs therefore relied on a small number of Ministers, a so-called 'Cabinet Council', though after 1717 the Sovereign almost never sat with them. Thereafter the Cabinet increasingly took decisions on its own and on the Prime Minister's initiative. Its membership was determined by the Prime Minister and not by the King, although in Wellington's day it was known that the King would give his opinion about Cabinet appointments. It was not until 1937 that legislation formally recognised the office of Cabinet Minister when an Act of Parliament provided a distinctive salary level for office holders. Cabinet was originally, the history books tell us, a term of abuse.

The convention of Cabinet governments is that its members are equally and collectively responsible for its decisions, although a major disagreement is occasionally demonstrated by an individual's resignation. Wellington suffered his share of resignations. He must have contrasted, both ruefully and unfavourably, the indiscipline of his political colleagues with his earlier military experience. On occasion he showed his impatience – 'In truth the republic of a Cabinet is but little suited to any man of taste or of large views'.

The Tory Party in Wellington's time, as always, was a loose association of what would now be called, misleadingly, left and right: there were Tories and ultra-Tories. The Whigs, too, in Wellington's day were far from a coherent group. Wellington incurred unpopularity among his natural supporters by omitting some ultra-Tories from membership of his first cabinet and preferring Canningites. The development of party influence in the modern sense had its roots in the broadening of the franchise when it came about in 1832. The term Conservative dates from this time. The Tories were pioneers in the business of local party

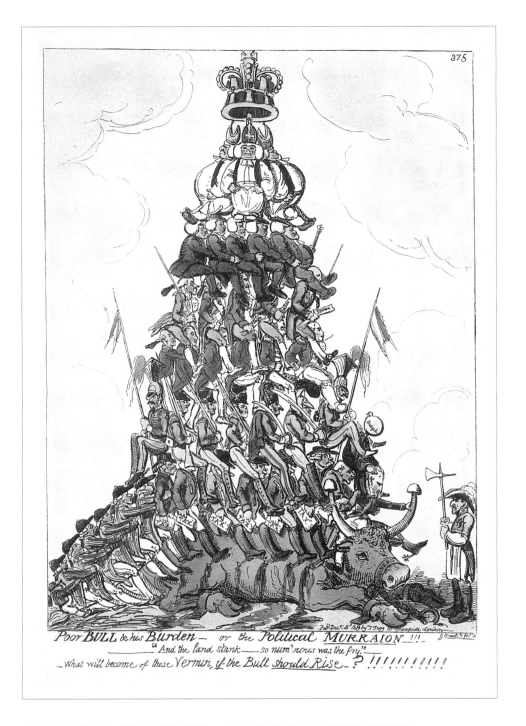

POOR BULL & HIS BURDEN or the POLITICAL <u>MURRAION</u>!!!
G. Cruikshank. Published Tegg 1819. BM 13288.

Wellington returned as a hero from the Napoleonic wars to find the UK in dire economic straits. Harvests had been a disaster and poverty was widespread. At one large public meeting at St Peter's Field in Manchester (soon to earn the nickname 'Peterloo'), eleven people were killed and over 400 wounded as a result of military intervention, ordered by frightened Magistrates.

All this comes together in this caricature in which the public – represented as John Bull – is shown being crushed by the Establishment (including tax collectors, overfed bishops and the monarchy), while the public's fear of militarism is vividly depicted by Wellington – now Master General of Ordnance – wielding his axe. His image had begun to crack.

It was widely believed that political reform i.e. a broadening of the franchise would be a panacea for economic troubles. There was fear of serious civil unrest: the fearful example of the bloody French Revolution was still fresh in English minds, as were the Gordon Riots of 1780.

Murraion [*sic*] refers to Murrain, an infectious disease of cattle caused by parasites.

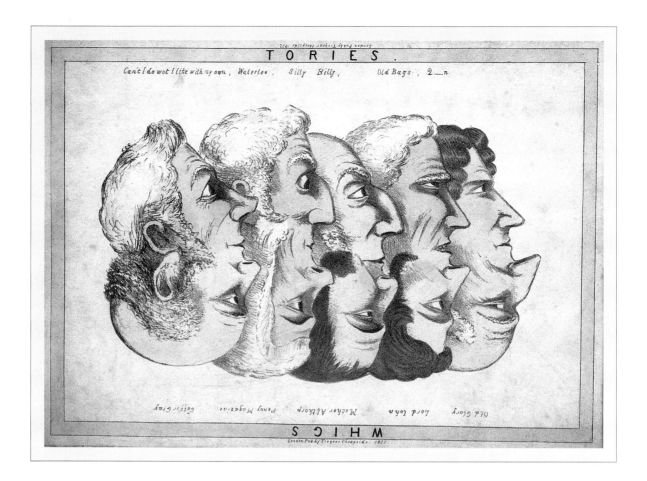

WHIGS AND TORIES
Anon. Published by Tregear 1832. BM unlisted.

Each Party is a mirror image of the other. Party disciplines in Wellington's day were vastly less severe than is the contemporary habit. Political parties as we now comprehend them simply did not exist. Canning, in his time, was known both as a Whig and a Tory. It was not unusual for Whigs to serve in Tory Cabinets and vice versa.

organisation and most successful at it. During my political lifetime, to my sorrow (and sometimes impatience) the Conservatives and their political opponents have both been more sympathetic to local politicians when they constitute the official Opposition than they ever are when in Government.

A sound idea it might have been for Wellington, a Tory Prime Minister, to bring Canningites into partnership, but it quickly backfired. Some of his Cabinet – most notably William Huskisson – were unwilling to support Wellington's anti-reform stance and resigned. Barely had he resolved this crisis than the matter of Catholic Emancipation flared up once more.

Daniel O'Connell, the Irish Catholic Leader, was elected MP for Clare in July 1828, effectively signalling that English rule in Ireland could no longer be taken for granted. At that time Catholics were not allowed to sit as MPs in the Imperial Parliament at Westminster. O'Connell's election thus raised the spectre of constitutional anarchy in Ireland (what if many other Irish electorates sent Catholics to Westminster and they could not take their seats?) – and even civil war. Alarmed by this possibility, pragmatic as ever, Wellington reluctantly accepted that Catholic emancipation was inevitable and began campaigning in its favour.

Legislation was eventually passed in 1829 – though not without difficulty. Wellington had to fight a farcical (but potentially deadly) duel with the ultra-Tory Lord Winchilsea; he also had to combat the stubborn resistance of King George IV – the head of the established Protestant church – and leading figures in the Lords and the Church of England. Other doubters among his friends in Parliament had similarly to be convinced. Public opinion too was strongly against the proposal. The odds against him were heavy.

Eventually, after a titanic struggle with the King, with Parliament and popular opinion, Wellington won this battle. Parliament voted in favour of Catholic emancipation. The Duke of Sussex (the King's brother, radical of temperament) said that this was Wellington's greatest victory, but in winning it he lost much public support.

Then came a second battle: the public pressure for electoral reform. The fight to achieve a broadening of the franchise, however, was a battle that Wellington – who opposed it – even with all his influence and determination, was certain to lose.

A poor harvest in 1829, followed by a fierce winter, meant extreme hardship in Britain. It seemed that the divide between rich and poor had never been greater. Then with the death of King George IV in 1830, King William IV came to the throne.

Monarchs at this time wielded far greater influence over political matters than today (for example, they were solely responsible for selecting the Prime Minister – unlike today's Sovereign who depends on advice), and much was expected of the sailor 'King Billy'. There was a mood of optimism in the country and the caricaturists reflected it. They had often represented George IV as being led by the nose by the Iron Duke. Now they pictured his successor as being well able to put Wellington in his place and keep him there. Nevertheless, it was neither strained relationships with his Sovereign nor growing civil unrest in the country, but a surprise defeat in the lobbies in the House of Commons over a trivial matter which defeated Wellington's Government and brought about his resignation as Prime Minister.

In early November 1830, Wellington had surprised even his friends by making a fierce speech in the House of Lords against electoral reform. That created a furore. Shortly afterwards, his Ministry was unexpectedly defeated over a relatively inconsequential issue regarding the Civil List in a Commons vote. The vote itself may have been unimportant but the pattern of voting clearly indicated that Wellington's support had been eroded. Realising that he would be defeated over the far more critical issue of electoral reform due to be debated in the Commons on the following day, he and his cabinet resigned on 16 November. So ended a turbulent period as Prime Minister, during which he had been threatened and abused – and much caricatured.

Despite this abrupt resignation, he remained politically active and, for a while at least, maintained his opposition to electoral reform. Then this turned, almost overnight, to neutrality – an about-turn prompted by the machinations of his successor, the Whig Prime Minster Grey. In 1831, and in a desperate attempt to push the Reform Bill through an antagonistic House of Lords, Grey had asked the King to increase the numbers of Peers, allowing him – in theory at least – to appoint more sympathetic figures. His request was rejected. Grey promptly resigned.

The King was ready to accept the proposals for electoral reform: he reasoned that if legislation to that end was introduced by the Tories this would avoid the necessity to create new Peers to force the measure through. He therefore invited Wellington to form a Ministry. As ever, Wellington was ready to subordinate his personal opinions to his Sovereign's wishes; but he found no supporters.

Change was inevitable. Grey again became Prime Minister and the Duke, albeit reluctantly, acquiesced to it. In 1832 the Reform Bill was passed and the foundations laid for today's electoral practice in Britain.

Wellington's formal career in politics was by no means over. He would rejoin the cabinet and he occupied a cabinet position as late as 1846, nine years after the accession of the young Queen Victoria. However, after 1832 he appeared much less often in the prints, and caricature as an art form was declining in popularity.

Caricature – or at least pictorial representation – has a long tradition. Although it was a popular medium for portraiture in Italy, it was the English who perfected the form as a political tool. From 1750 onwards interest in the caricature became something of a fashionable pastime – used to amuse, to deflate the pompous and to expose incompetence, folly and corruption. Some caricatures were mere social satires; others were vulgar; the political caricatures, if amusing or perceptive, could also have a bitter flavour. The twenty-five years or so either side of 1800 can now be seen as a golden age of English caricature.

It is hard today to appreciate the power and popularity of caricature, mainly in the metropolis, during the period that Wellington was prominent in public life. In today's newspapers and periodicals pictures and caricatures are an invaluable adjunct to news stories and current events. Caricatures can even be influential in forming opinion. The socialist Vicky created the legend of Supermac and did much to enhance Tory Prime Minister Macmillan's popularity and electoral success. The immortal David Low's representations half a century ago of the Trades Union Congress as a lumbering carthorse and of the typical ultra-Tory of his day as Colonel Blimp, still live on in the popular mind.

In the eighteenth century newspapers were dominated by written material, relieved only by an occasional woodcut. Consequently, any picture was welcome – especially if that picture was amusing – and even more so if it ridiculed some powerful figure. Prints, therefore, became the main visual form for portraying political and social propaganda from the early seventeenth century. This period saw the rise and rise of print shops, especially in London, where at one time there were scores in existence, selling caricatures either as single prints or in collected, bound editions and hiring them for an evening's home entertainment or for exhibition.

In Wellington's day these shops in central London were commonplace, each one churning out caricatures to meet a heavy demand – among them Fairburn in Ludgate Hill and Blackfriars in the City, Thomas McLean in the Haymarket, Samuel W. Fores in Piccadilly and George Humphrey in St James's Street. With displays in their windows and a steady flow of new work, each was a fashionable attraction and a focus for daily discussion. Election caricatures would be 'executed in 2 hours', advertised Thos. McLean of 26 Haymarket. The quality of caricature was high, often

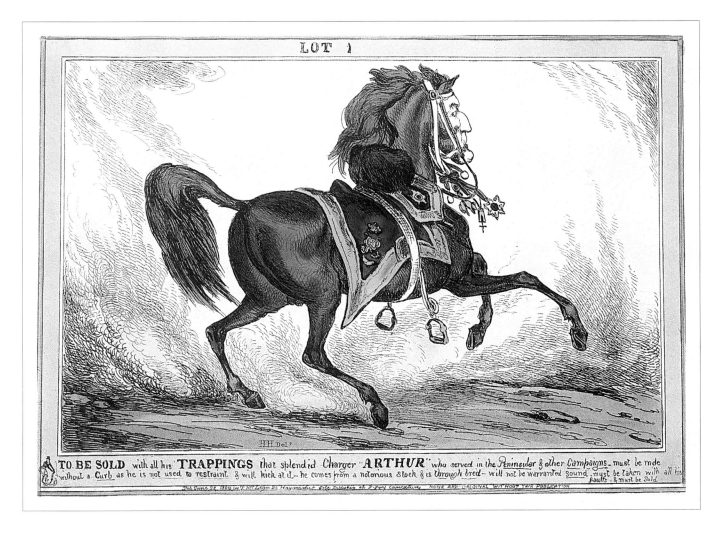

LOT 1

Paul Pry (William Heath). Published Thos. McLean 1829. BM 15814.

William Heath's caricatures of the Duke (whether published under his own name or under the pseudonym of Paul Pry) are invariably imaginatively drawn and coloured. The Duke is represented by him in many different ways, none perhaps more striking than this.

'To be sold with all his TRAPPINGS' says the legend 'that splendid charger ARTHUR who served in the Peninsular & other campaigns – must be made without a <u>Curb</u> as he is not used to <u>restraint</u> & will kick at it – he…is <u>thorough</u> <u>bred</u> – will not be warranted <u>sound</u> – must be taken with all his faults – and must be sold.' (The caricaturists had a habit of emphasising their points – particularly their puns – with capital letters and underlining.)

The message is a pointed one. A large section of the Tories felt betrayed by the Duke's about-turn over Catholic emancipation and felt he should resign.

There were other lots on offer, according to Heath's caricatures.

Lot 2 was Peel – tied to a post with a halter. Wellington and Peel were often represented by the caricaturists as inseparable. Peel was a 'ratcatcher', a tribute to his skill in mobilising Tory MPs in support of the policies of the Ministry.

Lot 3 was the Lord Chancellor, Lord Lyndhurst, 'well calculated to ride to the dogs' and 'out of NOTHING by PLACEMAN and DAM the EXPENCE'. (Prime Minister Blair's Lord Chancellor, Lord Irvine, was similarly attacked by the accountants for his profligacy in refurbishing his quarters in the House of Lords in 1998.).

Lot 4 was Lord Eldon 'the well known Old Race Horse old "John by Hesitator" out of Prejudice: Dam-Trial by Jury' the leader of the ultra-Tories, appointed by King George III to be an adviser to Princess Caroline in 1806 and a strong opponent of Catholic emancipation and Parliamentary reform.

outstanding. The most effective were usually those with fewest words, letting the pictures speak for themselves. The drawings were always topical and usually irreverent, radical, scornful at best, libellous at worst – and so it is hardly surprising that many of the people who regularly featured in caricature would attempt to suppress publication, by either direct means or bribery. Royalty were among those who attempted such ploys, with little noticeable effect – either the attempts were ignored, or another artist emerged to step into the breach. King George IV paid George Cruikshank £100 not to depict him in any immoral situation. Nonetheless he bought many political prints. Gillray was a secret Ministerial pensionary – hence his endless attacks on Fox 'to make money'. Political caricatures were in practice immune from legal process. It is the same today.

Each artist had his own style, idiosyncrasies and his particular hobby-horses – again, just as satirists do today. The 'grandfather' of them all (the description of that great modern cartoonist David Low) was perhaps William Hogarth (1697-1764) whose work was so widely plagiarised that his complaint led to the passing of the Copyright Act in 1735. With this protection, the industry was literally kick-started, and careers were made. The most famous of these included Thomas Rowlandson (1756-1827); James Gillray (1757-1815); William Heath (1795-1840) who first appeared under the pseudonym of 'Paul Pry' (a stage character in a play who was 'perpetually interfering' in other people's affairs); John Doyle (1797-1868) who worked under the initials HB; George Cruikshank (1792-1878), who also illustrated Dickens' work; his brother Robert (1789-1856) and their father Isaac (1756-1811).

Though respected, they were hardly rich men. For each etching (or, later, lithograph) they were paid little more than a pound, compared with a carpenter's wage of perhaps thirty shillings a week. Publishers had to pay teams of colourers who worked by hand, as well as bearing all production costs. On the other hand, caricatures sold in their hundreds at around a shilling (five new pence) for an uncoloured version, or one or two shillings (ten new pence) for a coloured. Such was their popularity that there were attempts to mass-market caricatures and to hold permanent exhibitions. Folios could be borrowed – at a cost. The caricaturist and his publisher prospered according to the popularity of their work. To the contemporary historian, therefore, the subjects they chose and the way they depicted their heroes are an accurate record of public interests and anxieties at the time.

It was perhaps Wellington's misfortune that he rose to power at a time when caricature was at its most potent and influential, and that his features – hooked nose and prominent chin – were such a gift. ('Proud Wellington, with eagle beak so curled, that nose, the hook where he suspends the world' wrote Byron in his *Age of Bronze*). More importantly, perhaps, he was 'pushy' and had an uncanny ability to project himself into the thick of important events, so many of which proved fertile ground for waspish political comment and complaint – the frequent changes of Government; excessive expenditure on favourite royal projects; economic and social distress; Catholic emancipation in the teeth of furious Protestant anxiety and protest; the King's marital problems – and his lady companions; the mounting pressure for broadening the franchise which led, eventually, to the Reform Act of 1832.

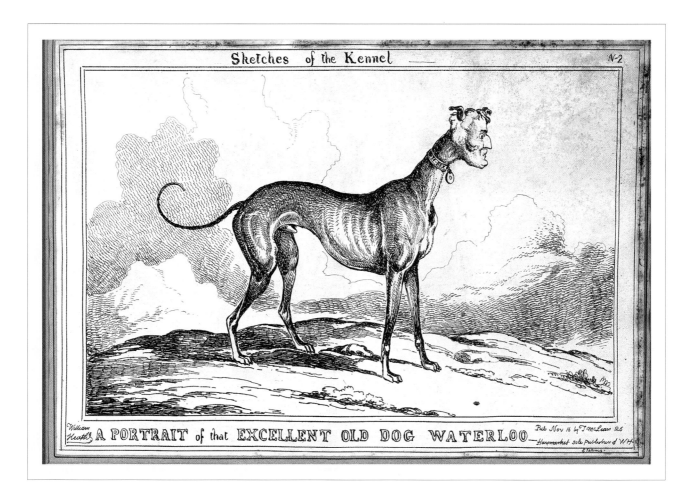

Sketches of the Kennel
William Heath. Published Thos. McLean 1829. BM 15907.

The subtitle of this caricature ('A PORTRAIT of that EXCELLENT OLD DOG WATERLOO') may sound harmless enough, but the references to Waterloo allude to a generally held belief that the Duke was firmly locked in his past. This reputation was to haunt him throughout his political life. In civilian life, as a politician, he was often portrayed by the caricaturists in military uniform.

Caricatures of Wellington clearly indicate his rise – and fall. In his military days, there were few caricatures. In political life his popularity plummeted: 'Waterloo man' became a term of opprobrium and it was generally held that a military training did not necessarily act as a satisfactory apprenticeship for a career as a statesman. This did not stop Wellington, however, and for almost two decades he was to feature in caricature – quite often in soldier's dress – more regularly than any of his contemporaries.

Once he was no longer Prime Minister and the Reform Act was passed in 1832 Wellington became less of a target. But the heyday of the print shop was already coming to an end. Illustrated newspapers and satirical magazines would take their place. Political caricatures first lost their bite with the death of King George IV in 1830 ending a period of some debauchery and profligacy. The accession of King William IV soon to be followed by Queen Victoria and a new moral code of what came to be known as Victorian values – sobriety, prudence and the like – marked their decline as a specialised art form.

But, as today's exponents of the art clearly show, they never lost their appeal.

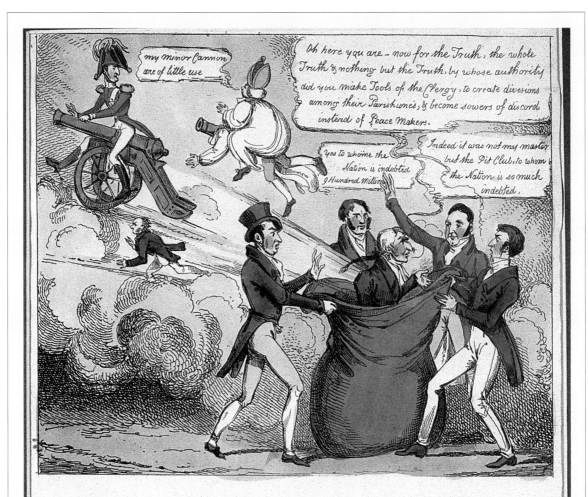

THE HAMPSHIRE GREEN BAG OPENED;

Or, The Secret Spring of Ultra-Loyal Addresses, Discovered and Exposed.

See the following witty and elucidating speech of Mr. Marsh, at the Hampshire meeting, January 12, which was attended by 6000 persons: the principal speakers were—Mr. A. Baring, M. P. Sir W. C. de Crespigay, M. P. Sir C. Mill, Lord Carnarvon, Mr. Marsh, Mr. Fleming, Mr. Jervoise, and Mr. Hinksman. Petitions to both Houses of Parliament, praying them to take measures for preventing the renewal of any proceedings against her Majesty, and to remove every obstacle to a final satisfactory arrangement, were carried unanimously.

Mr. MARSH came forward, and was received with great applause. He expressed the great pleasure he felt at seeing so numerous and respectable a meeting assembled on this occasion, under the auspices of the constitutional officer of the county. (Applause.) The presence of such a meeting gave the lie to the base and mischievous misstatements of a venal and corrupt press, which published that meetings like the present could not safely be convened, for that sedition and blasphemy were abroad, and a contempt for the laws but too prevalent. The people, however, showed that they respected both the laws and the constitutional authorities by whom they were administered. They showed it there this day in the reception they gave a constitutional Sheriff who presented a fine contrast to the Sheriff of Dublin, who dismissed his fellow subjects at the point of the bayonet, when they were assembled at a regularly convened meeting under his own auspices. (Hear, hear.) The conduct of the ultra-loyalists of Hants was very ludicrous; they proclaimed that there ought to be no county meetings, because 9 peers and 130 freeholders thought it inexpedient. He had often heard, but whether true or not he could not say, that it took 9 tailors to make a man; and it now appeared that it took 9 peers to make a county meeting. (Loud laughter.) But where were they this day. The requisition by which the present meeting was convened could only boast of the signatures of one peer and 17 freeholders. Why did not the 9 lords and the 130 freeholders come before the public and crush them with their superior weight? (A laugh.) Two to one formed great odds, but nine to one would have been tremendous. (Repeated laughter.) Besides the Ultras had a terrible weight of metal for the fight. They could muster all the great guns from Portsmouth; and if these did not do execution enough, they had at hand the little canons of Winchester. (Loud bursts of laughter.) But they had fled: their whole weight was spent after the attempt to become the great Colossus bestriding the county, and letting the poor freeholders like himself peep beneath, and find

dishonourable graves. The hon. gentleman proceeded in a strain of fine humour to ridicule the pretensions of the ultra-loyalists, and to expose the secret machinations by which they endeavoured to prop a falling ministry. It had been asserted by a leading character in the French Revolution, that courts were the workshops of crimes. Sincerely attached as he was to constitutional monarchy, he hoped and trusted the assertion was not founded in truth; but he felt assured, that the conduct pursued by those in authority, within the last few months, had done more to create and confirm such an opinion in the public mind, than all that the avowed enemies of royalty had been able to do in half a century. (Hear, hear.) Mr. M. then alluded to the treatment her Majesty had received from various political parties—said, she had been cruelly bit by the tories: and tho' he by no means wished to rip up old grievances, he was fearful upon some former occasions she had been a little mumbled by the whigs. (Much laughter.) Her Majesty had therefore, in his opinion, displayed sound judgment in committing her cause to the public—a party whose interests it was, and always must be that right should overcome might. (True, and bravo.)—Another point which he wished to impress on their minds was, the system which had long been pursued of attempting to injure persons in their trade or profession, because they had the honesty to express publicly their political opinions. Was that illiberal prejudice to be tolerated at the present day that would persecute an Englishman for coming forward to express his sentiments? (Applause.) The meeting were about to petition Parliament for the restoration of her Majesty's name to the Liturgy; and this naturally led him to inquire how the House of Commons and his Majesty's Ministers might stand affected to each other? How the conduct of the house would please the ministers he should not venture to anticipate; but, considering the treatment which that house had experienced, he should not be surprised if they were to say to ministers as a lover once said to his mistress—"Perhaps, you did right to dissemble your love, but why did you kick me down stairs?" (Laughter.) But, whether Parliament did its duty or not, he was sure that the freeholders of Hampshire would do their's. Mr. Marsh concluded a very ingenious and humourous speech, by thanking the meeting for the patience with which they had heard him, and assuring them that he gave his hearty consent to the petition which had been moved. (Great applause.)

London: Printed and Published by S. W. FORES, 41, Piccadilly. [PRICE ONE SHILLING

THE MARITAL TROUBLES OF THE PRINCE & PRINCESS OF WALES

The Prince of Wales was made Prince Regent in 1811 on the 'madness' of his father, King George III (we now know that the King's illness was less likely to have been insanity than a recurring physical condition). They called him 'Prinny' and he was King in all but name. He had a number of mistresses who appeared frequently in caricatures.

He had married Mrs Fitzherbert, at a secret ceremony in 1785. (Charles James Fox had denied in the House of Commons that the marriage had taken place, though Gillray recorded it in a celebrated caricature). Mrs Fitzherbert was a widow, a Roman Catholic and six years older than the Prince. The marriage, which undoubtedly took place, was valid under Anglican canon law and was later stated to be valid also in the eyes of Rome. However, it was illegal as it lacked the consent of the King, which the law of the land required. The law of the land also made it clear that by marrying a Catholic, the Prince forfeited his right to succeed to the throne (a subject which again is a matter of debate in our country as the Act of Parliament of 1701 remains on the statute book). Prinny was later to argue that as the marriage was invalid he remained the rightful heir to the throne.

His subsequent public marriage in 1795 to the Princess Caroline Amelia Elizabeth of Brunswick, his first cousin and a German, was to be a source of controversy and embarrassment to the royals and to Government for twenty-five years. The Prince had married Caroline (with whom he was unfamiliar) in order to induce Parliament to pay his debts of some £630,000 – an enormous sum by today's standards. It was far from a love match.

The Prince was dissolute and extravagant, yet he had style. Financially profligate he may have been, but our nation owes him Buckingham Palace,

Opposite: **THE HAMPSHIRE GREEN BAG OPENED**
William Heath. Published Fores 1821. BM 14106.

Public support for Caroline, the Princess of Wales, was by no means confined to London. Speeches and meetings in her favour were held across the country. This refers to a meeting in Hampshire on 12 January, 1821 addressed by Mr Marsh, a Berkshire Magistrate and attended by some 6,000 people, during which petitions were presented in favour of the Queen. Wellington and the Bishop of Winchester are seen being blasted away by the contents of a green bag (as was the case in all enquiries at this time, green bags were used to hold evidence relating to a case. The caricaturists came to use them to represent symbols of tainted testimony). The force of public opinion is therefore clearly expressed. The Duke was Lord Lieutenant of Hampshire.

The proceedings of the Government-sponsored enquiries into the Queen's behaviour in Italy were hastily assembled and put into two green bags for the attention of the Lords and Commons. A so-called secret committee was set up to examine this evidence. Unsurprisingly, it reported that the case against her was overwhelming.

Windsor Castle, Regent's Park and the Pavilion at Brighton, much as we know them today. The Prince was fastidious whilst Caroline, even before the marriage, had a reputation for vulgar conversation and being dirty in her person. One observer said she used 'the language of an ostler and smelt like a farmyard', an exaggeration perhaps, but truth was its basis. Horrified by her behaviour and, no doubt, by her person also, the Prince was drunk at his marriage ceremony and he became insensible on his wedding night. 'He fell in the grate where I left him', wrote the Princess. (In a contemporary jibe he was said to drink like an *ancien postillion restiré*). Nevertheless, he apparently accomplished his marital duty. The unhappy couple separated shortly after the birth of their daughter, Princess Charlotte, who was born in 1796 but sadly died in childbirth in 1817. A huge and ornate memorial was erected to her at Windsor. Obviously, in the moderate language of the day, the Prince and Princess of Wales 'were not suited to each other'. The Prince had been consistently unpleasant to her and had even appointed Lady Jersey, his new mistress, Mrs Fitzherbert's successor, as her lady-in-waiting, a bizarre arrangement. (Later, the Prince sought to establish his old, intimate relationship with Mrs Fitzherbert.)

The Princess of Wales went to live at Blackheath, her style of life attracting criticism and a formal enquiry conducted by four Commissioners, all members of the Cabinet, including the Lord Chancellor and the Lord Chief Justice. After sixteen years she went to Italy and lived at the Villa d'Este on Lake Como and elsewhere in Italy. From there, and on her 'royal' tours, rumours about her dissolute conduct were rife: her promiscuity, her reckless conversation, her extravagance and even a supposed illegitimate child by an Italian servant were gossiped about. This led to a further official enquiry.

When George III died in 1820 to be succeeded as King by the Prince Regent, it meant that Princess Caroline, who had never been divorced, was now to be Queen. Wellington's proposal to the Cabinet to send a handsome young aristocrat to Italy to warn her that if she came to England she might well kill the goose that laid her golden eggs, was not proceeded with. She was determined to take up her entitlement as Queen and returned to England forthwith to prepare for her new office. The Prince, now George IV, and his Government had other ideas and they set out to stop her. At first they tried persuasion, sweetened with a financial inducement.

Matters did not begin well for the King, or the Government. On her arrival in England the Princess of Wales attracted a huge volume of popular support. There were continuous demonstrations in her favour in the streets and at the houses where she lodged. It is said that the Duke of Wellington was accosted in the street by workmen brandishing pickaxes demanding that he declare support for the Queen. 'Well gentlemen,' he said in a double-edged reply, 'since you will have it so – God bless the Queen and may all your wives be like her.'

Some of the Whigs and the Radicals pounced on the opportunity to get their own back on the King for having preferred the Tory Lord Liverpool as Prime Minister to their own nominee – public sympathy was their platform. Meantime,

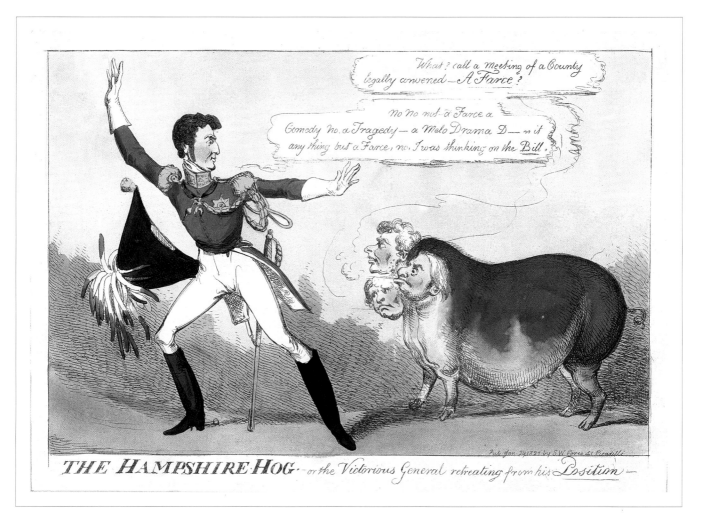

THE HAMPSHIRE HOG or the Victorious General retreating from his Position.
Artist unknown. Published Fores 1821. BM unlisted.

A petition in favour of Queen Caroline with 900 signatures had already been presented to the Duke. Then came proposals for another petition and meeting. In a speech in Parliament, Wellington said he saw no point in going through the 'farce' of another country meeting, as they seemed to be totally one-sided affairs in which the Government was pilloried. As a result, he was attacked by the Whigs for his anti-democratic sentiments. Here, suitably chastised, he is shown retracting the word 'farce'.

Wellington was charged by the Cabinet with a task of negotiating a settlement out of court. He and Castlereagh negotiated with Brougham, Caroline's lawyer and a future Lord Chancellor, but they had no chance of success. Caroline, encouraged by her warm public reception, refused to budge. She would not be fobbed off, or paid off. The basic proposal throughout was that she would be 'uncrowned and unprayed for', i.e., excluded from the liturgy but remain a member of the royal family and be pensioned. It was not a bad deal for her in the circumstances but, alas, she was poorly advised throughout, not least by Brougham.

Wellington was criticised for his failure in the negotiations – perhaps, his detractors argued, a more sophisticated man, less of a trammelled soldier, would have been a better choice for such a delicate political task.

When negotiation failed, the Government went to battle stations. Adultery was treason, they reasoned. So they determined to stop her by legal means, but here they were on difficult ground. The law, which dated from the time of King Edward III, asserted that it was treasonable for the wife of the King's eldest son to commit adultery with a subject of the King. This was a capital offence. However, as Caroline's alleged lover was Italian and not one of the King's subjects, existing law, therefore, could not be relied upon. Another route must be followed. For this there was a Parliamentary precedent.

So began a bitter, sordid and drawn out affair whereby the new King and the Government attempted to discredit the Queen through the introduction of a Bill in Parliament. The intention was to deprive her of her privileges; and witnesses, testifying to the Queen's immorality, would be heard without the risk of counter-accusations against the King.

The public remained restless. Revolution seemed to be in the air. The 'Queen's affair' (as it came to be called) began only a short time after the Cato Street conspiracy, a plot to murder the whole Cabinet at dinner. A large public meeting in favour of Parliamentary reform at Peterloo near Manchester had led to panic on the part of local magistrates who sent in the troops to break it up. The outcome, eleven deaths and 400 wounded demonstrators, became known as the Peterloo Massacre and was an event still fresh in the public memory. Elements in the army were toasting the Queen's health: could they be relied upon to keep public order? Even middle- and upper-class ladies petitioned in favour of the Queen – an early example of feminist agitation, perhaps. Her cause was well supported by such notables as George Canning (who, some said, had enjoyed a close relationship with her in the days before she left Blackheath for Lake Como), William Cobbett and Alderman Wood, a former Lord Mayor of London and one of the City's MPs. Wellington, in a rare visit to the Commons, had heard Canning describe her as 'the grace and ornament to female society'. Nonetheless, Canning decamped abroad when the proceedings started so as not to embarrass the Government.

The King remained determined on divorce. The method chosen by Government to give effect to his wishes was to use an old procedure when recourse to the courts was considered inappropriate, in effect pass legislation to deal with the particular problem:

> ' …to deprive Her Majesty, Caroline Amelia Elizabeth, of the Title, Prerogatives, Rights, Privileges and Exemptions of Queen Consort of this Realm; and to dissolve the Marriage between His Majesty and the said Caroline Amelia Elizabeth.'

A Bill of Pains and Penalties was introduced by Government in the House of Lords – the object being to take away Caroline's rights as Queen by exposing evidence of her adultery. The complaint was specific. The preamble to the Bill contained a particular description of the accusation against the Queen.

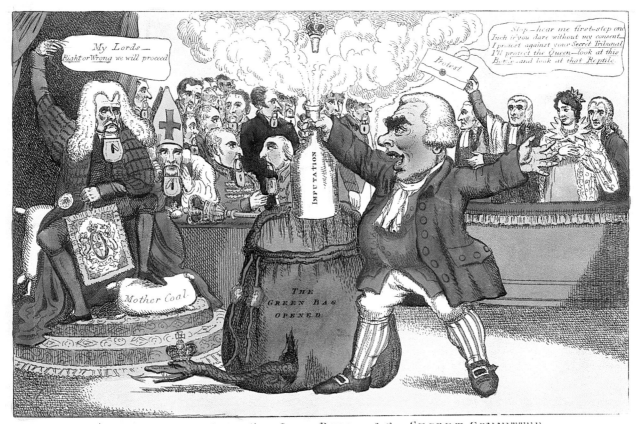

ALL A BOTTLE OF SMOKE!! or JOHN BULL and the SECRET COMMITTEE.
Published July 1820 by John Fairburn, Broadway, Ludgate Hill.

ALL A BOTTLE OF SMOKE!! or JOHN BULL and the SECRET COMMITTEE
Artist unknown. Published Fairburn, July 1820. BM 13761.

The caricature shows John Bull producing an effervescing bottle labelled IMPUTATION. Lord Eldon, the Lord Chancellor, says 'My Lords, Right or <u>Wrong</u> we will proceed'.

The Archbishop of Canterbury, Wellington, Prime Minister Liverpool and others are shown with padlocked mouths. Caroline's three counsel, Brougham, Denman and Lushington utter a protest, say they will protect the Queen and draw attention to the crowned snake (representing the King) emerging from the bag.

She had, it was alleged 'a most unbecoming and degrading intimacy' with 'one Bartolemeo Bergami, a figure of lower station'.

> 'Unmindful of her exalted rank and station' Caroline had '…conducted herself toward the said Bartolemeo Bergami, both in public and private, in various places and countries which her royal highness visited, with indecent and offensive familiarity and freedom, and carried on a licentious, disgraceful, and adulterous intercourse with the said Bartolemeo Bergami, which continued for a long period of time, during her royal highness's residence abroad; by which conduct of her said royal highness, great scandal and dishonour have been brought upon your majesty's family and this kingdom.'

Proceedings began in the House of Lords, including the testimony of some forty witnesses. They were in effect a public prosecution of the Queen for immorality.

The caricaturists launched their attacks.

Much salacious material was available to the caricaturists. A procession of witnesses described Caroline's customary sleeping arrangements on board ship and on land with this favourite male servant in proximity. One caricature showed the Queen in a tub with her nearly-naked servant in close attendance – her 'Knight of the Bath'. The witnesses included a comic foreigner who answered most questions put to him in Italian with the words '*non mi recordo*' – I don't recall – which became the comedians' catch phrase of the moment. On the whole the Crown's witnesses were not impressive, but neither did the witnesses for the Queen do much to establish her innocence. The general impression generated by these undignified proceedings was that the Queen was doubtless an immoral woman; but then the King was well known to be an immoral man.

The final speech of one of the Queen's Counsel, Denman, lasted ten hours. Its ending did more harm to the Queen's cause than it did good. First, Denman compared the King to the Roman Emperor Nero, a comparison which gave offence to all who heard it. Then he quoted some words from St John's Gospel, the story of the woman taken in adultery, 'Neither do I condemn thee: go, and sin no more', a statement hardly supportive of his case that the Queen was innocent.

An unknown poet had an appropriate comment:

'Most gracious Queen we thee implore
To go away and sin no more;
or, if that effort be too great,
To go away at any rate.

In the National Portrait Gallery in London there exists a fine and detailed painting by Sir George Hayter showing the moment on 23 August in the House of Lords when one of the witnesses was being cross-examined by Lord Grey. It is a dramatic picture, combining portraiture with theatre. There are 186 likenesses. Many faces are easily recognisable among the Peers in the crowded chamber, including the Duke of Clarence, the King's brother (afterwards King William IV) who himself questioned more than one Naval witness and the Duke of Wellington.

Remarkably, a representation of this painting was the House of Lords' official Christmas card in 1990. Many who were pleased or flattered to receive it in the post nonetheless wondered why their Lordships chose to remind us all of this little episode in our national history; did someone with a mischievous and unpleasant sense of humour see some parallel with contemporary royal events when the Prince of Wales and Princess Diana were at loggerheads, I wondered?

When these distasteful proceedings eventually terminated, their Lordships had to decide whether or not to pass the Bill of Pains and Penalties. It was not only the King's convenience they had to decide; they had also to consider the national interest. Meantime, like a roll of thunder out of doors, popular opinion continued vociferous in the Queen's favour. The Lords found it hard to be decisive.

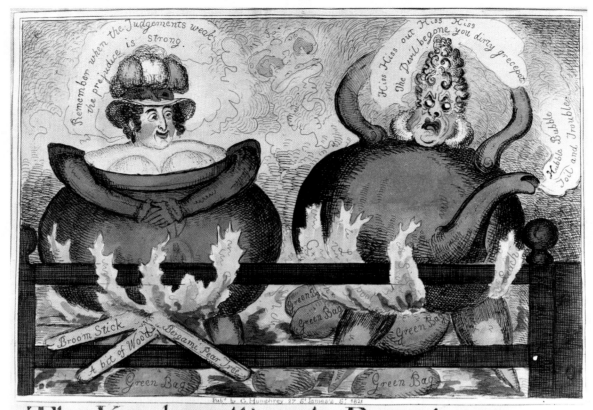

The Kettle calling the Pot ugly names
Artist unknown. Published G. Humphrey 1821. BM unlisted.

The King is in a boiling kettle fuelled by green bags (i.e. the vehicles in which evidence was carried. The term 'green bag' came to mean tainted evidence). An apparently naked Queen Caroline, adorned with usual feathered hat, sits in a snug-fitting cauldron. The crown floats between them in a vaporous atmosphere.

The pot and the kettle steamed away above the flames, as at a cannibals' tea party. The King's complaints against Caroline were everywhere seen as a case of the pot calling the kettle black.

'Which is the dirtiest!' was the title of one of William Heath's caricatures depicting King George and Queen Caroline throwing mud at one another.

The print is a copy of BM 13788 engraved and published by John Marshall, a year earlier.

The third reading of the Bill (that is to say, its final stage of debate) was eventually carried in the House of Lords, but by only nine votes. To become law the Bill then needed to be approved by the House of Commons (Royal assent could no doubt be taken for granted). It was not sent there. With so little support, a bare majority, it could not proceed. It would not pass the Commons. Prime Minister Lord Liverpool promptly proposed that the Bill pass in six months' time (Parliament-speak for shelving it). Thus it was effectively dropped.

The Lord Chancellor fulminated privately that it was an untidy end. This was perhaps the case, but the end it incontrovertibly was. For Queen Caroline the result was a triumph. She was, she boasted, 'Regina still in spite of them'. She

admitted committing adultery once – with the husband of Mrs Fitzherbert (she was not without humour). Politically, however, she was now friendless.

On 5 May, 1821 Napoleon died on the island of St Helena where he had been exiled after his defeat by Wellington at Waterloo. The news was taken to the King. 'Sir', his informant announced, 'I have, Sir, to congratulate you: Your greatest enemy is dead.' 'Is she, by God!' the King exclaimed.

The Queen appealed to the Privy Council, arguing that she was entitled to be crowned Queen as of right. The Privy Council decided in July 1821 that there was all the difference in the world between having the title of Queen and being crowned Queen, holding that the Queen's coronation lay in the gift of her husband, the King. (Here indeed was a precedent while Princess Diana lived. It was never to be tested). Lawyers are always able to split hairs and the most senior lawyers are the ablest.

Public opinion – ever fickle – was changing. On 19 July, 1821 the Queen attempted to gatecrash the Coronation ceremony in Westminster Abbey for which she had no ticket. She found every door closed to her, and the mob's cheers turned to jeers. By 7 August, only a few days later, she was dead. Inflammation of the bowel was the official cause of her death, but many said she died of a broken heart.

But the people did not altogether desert her at the end. Her body was refused passage through the City of London by the authorities. The crowds objected. Although some of them were killed by troops in the ensuing struggles, the crowd had its way. *The Times* newspaper, a consistent supporter of Caroline, wrote: '…loyal to the last, she died as she had lived, a Christian heroine and martyr', – a comment that was a bit over the top.

Caroline was an awkward, tactless, prattling, absurd figure and, it seems, smelly too. Even so, her tale is a sad one. On her tomb it states that she was the 'injured' Queen of England. Whether that is so perhaps matters not a great deal in the context of England's long and glorious history. Certainly she was right in supposing that the events in which she was involved were concerned more with politics than they ever were with her, and that was her misfortune.

Now she was no longer on centre stage occupying Parliament's attention (and how she loved popular notice and how, perhaps like others in our own time, she was misled by it) there were other pressing matters for the Government and Opposition to attend to.

The monarchy had survived a squalid farce. Affection and respect for the institution, it seems, were well rooted and strong enough to allow it to shrug off a temporary, if merited, criticism. Deep-felt anxieties on that score were expressed at the time by many responsible citizens. Happily, their fears were not realised; a precedent for our own time, let us hope.

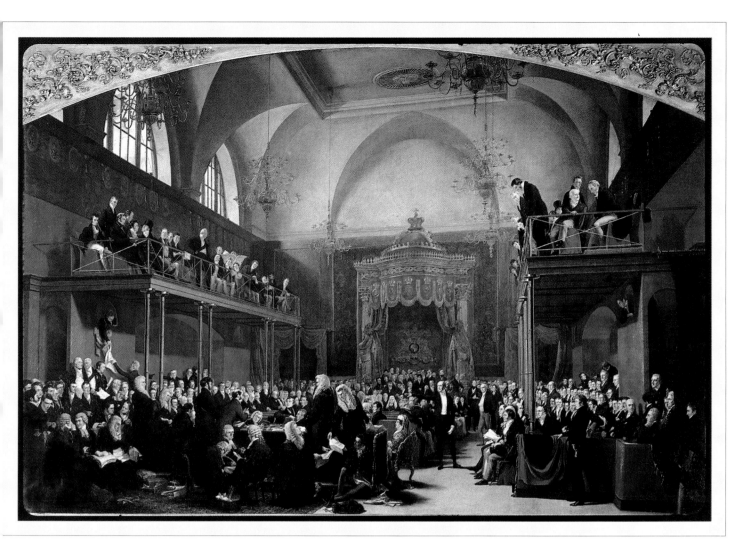

THE TRIAL OF QUEEN CAROLINE. THE HOUSE OF LORDS, 1820.
SIR GEORGE HAYTER, 1823.
(Reproduced by kind permission of the National Portrait Gallery, London.)

Theodore Majocchi, an Italian witness, is being cross-examined by the Peers led by Lord Grey. The accuracy of the individual portraits in such numbers is remarkable. The scene is the old Chamber of the House of Lords, gutted in the fire of 1834 and then used as a temporary home for the Commons before being replaced by the present Victorian Gothic building in the 1850s.

367 Peers were entitled to attend the proceedings. Their Lordships' House was vastly smaller than today's. Attendance was compulsory on pain of a fine of £100 for the first three day's absence, £50 a day thereafter. Age, illness or absence abroad on official duty excused attendance. 109 Peers qualified on these grounds.

The Queen is clearly visible in the picture. On one occasion she slept through the proceedings. This gave rise to a piece of doggerel:

> Her conduct at present no censure affords
> She sins not with courtiers but sleeps with the Lords

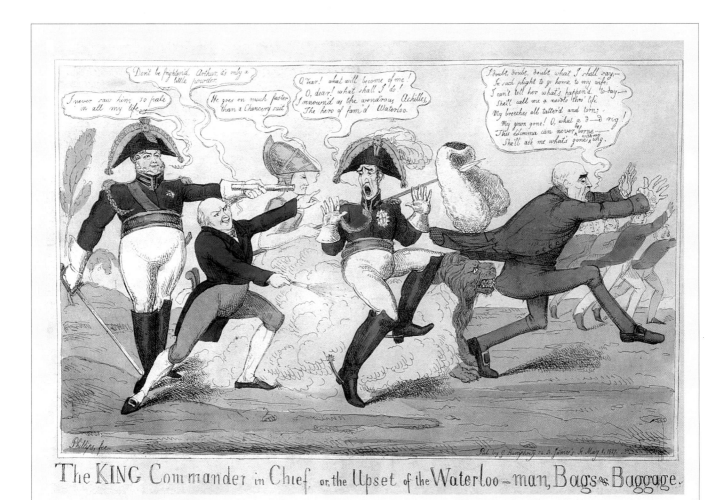

The KING Commander in Chief; or the Upset of the Waterloo-man, Bags & Baggage.
Phillips. Published G. Humphrey 1827. BM 15387.

Here Wellington and Bags (Eldon, the Lord Chancellor) are seen on the run while Canning fires a pistol. Here is a use of the word 'Waterloo-man' as a term of opprobrium, taken from a derogatory, bawdy song. The caricaturist rejoices that the King preferred Canning to Wellington as successor to Prime Minister Lord Liverpool.

Opposite: **THE TORY BAND**
HB (John Doyle). Published Thos. McLean 1827. BM 15382.

The resigning Tory Ministers are shown performing an overture together, led by Wellington's drum. Others present include Eldon, (Lord Chancellor, double bass), Melville (First Lord of the Admiralty, bagpipes) and Robert Peel (Home Secretary, the double flageolet).

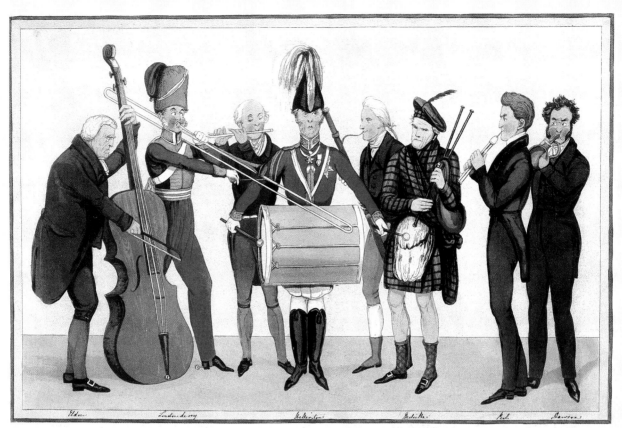

THE TORY BAND,

CONCERTING an Overture to the Serio, Ludicro, Tragico, Comico, Whimsiculo, Burletta, called the RESIGNATIONS.

— TWO —

THE TROUBLED ROAD TO BECOMING THE KING'S FIRST MINISTER

There is, inevitably, much personal disappointment in the world of politics. Wellington's path to the office of Prime Minister was anything but smooth – for all his greatness and his ability he was not an obvious choice for the office. Lord Liverpool, a Tory, had become Prime Minister when his predecessor, Spencer Perceval, was assassinated in 1812 in the House of Commons by a madman (not, I hasten to say, another Member of Parliament but a private citizen, a bankrupt, who rightly or wrongly blamed the Government for his problems).

Wellington had joined Liverpool's Cabinet in 1818 as Master General of the Ordnance. After fifteen years as Prime Minister, in February 1827, Liverpool suffered a stroke which forced his resignation. (The Whigs were discontented that he survived so long as Premier). The Tories were split on his successor. Wellington was not invited by the King to form a Ministry and Canning was appointed Prime Minister after some five weeks' hesitation on the part of the King.

The HEAD WATCHMAN of the TREASURY

The HEAD WATCHMAN of the TREASURY
Artist anon. Published Thos. McLean 1837. BM unlisted.

The resigning Tory Ministers flee from the 'enlightened policy' of night-watchman Canning. Eldon is followed by Wellington, Melville and Westmorland with Bathurst and (?) Goulburn at the back. In his pocket Canning carries a rattle labelled 'Eloquence'. As Foreign Secretary and leader of the Commons after Castlereagh's death in 1822 he deservedly acquired a reputation for it.

Canning had considerable difficulty in forming his Ministry. Wellington and six other Ministers had resigned – Robert Peel (Home Secretary), Lord Eldon (Lord Chancellor), Viscount Melville (First Lord of the Admiralty), the Earl of Westmorland (Lord Privy Seal) Earl Bathurst (Secretary of State for War and Colonies) and Goulburn (Chief Secretary for Ireland). Wellington also resigned as Commander in Chief of the Army which was thought to have been a petulant act.

On his appointment Canning combined the offices of Prime Minister and Chancellor of the Exchequer, an unthinkable present day combination.

The problems for the Tories naturally caught the caricaturists' attention. Canning was popular; Wellington and his colleagues – referred to as the seven sages – were not, as these caricatures show. The caricaturists, an almost universally radical bunch, were glad to see them go.

Within the image:

Battle of Waterloo.

His M—j—sty accepts the resignation of his Grace the Duke of W—ll—ngt—n with the same regret that it is communicated — G.R.

Achilles in the Sulks after his Retreat, or,
The Great Captain on the Stool of Repentance!!

here for brutal courage far renowned, *(others in council fam'd for nobler skill*
I live an idle burden to the ground, *More useful to preserve than I to kill;)* Vide Homer Ill8

Com: in Cheif

London Pub.d May 7 1827 by G Humphrey 27 St James St.

Achilles in the Sulks after his Retreat or
The Great Captain on the Stool of Repentance !!
(?) T. Jones. Published G. Humphrey 1827. BM 15386.

After Wellington's (unexpected) resignation as Commander in Chief of the Army, the King said, 'I shall keep the command of the Army in my own hands until my friend Arthur recovers his temper'. This episode is vividly captured in this caricature which shows Wellington 'the Great Captain' sulking on the stool of repentance. Behind the Duke is the Statue of Achilles. This was visible from his home at Apsley House and had been subscribed for by the ladies of England in the sum of £10,000. It was the first public nude statue in England, and was made from the metal of French guns. It was the subject of some contemporary ribaldry, not least because of the Duke's known preference for the society of intelligent ladies to that of his wife with whom his relations, if correct, were less than cordial.

THE GAME COCK and the DUNGHILLS
H. H(eath). Published by Fairburn 1827. BM 15374.

Canning is the game cock; King George IV is at the window. The caricature praises the King for choosing Canning to succeed Liverpool. The Dunghills are Wellington and the ultra-Tories who resigned on Canning's appointment.

 It is said that Canning had won an audience with the King when he touched the King's pride.

 Said he: 'Sir, your Father broke the domination of the Whigs. I hope your Majesty will not endure that of the Tories.' (Lord Liverpool's Ministry had lasted fifteen years.)

 'No,' said the King. 'I'll be damned if I do.'

 Wellington and co. shrink away. 'Vermin', says the notice, '…will be <u>utterly exterminated</u>.'

Opposite above: **LOAVES and FISHES**
C. W(illiams). Published Knights 1827. BM 15383.

Canning, the new Premier, distributes loaves and fishes, representing the sweets of office. Wellington and Eldon scramble under the table for the leftovers.

Opposite below: **THE THREE GEORGES – THE PATRON – THE SOVEREIGN – and the PATRIOT**
C.W(illiams). Published John Fairburn, 1827. BM 15385.

This caricature indicates clearly that the new Premier had the support of public opinion. The three Georges are St George, King George IV and George Canning. The heads of the monster of corruption include Wellington, Eldon and Peel. The populace cheers in the background.

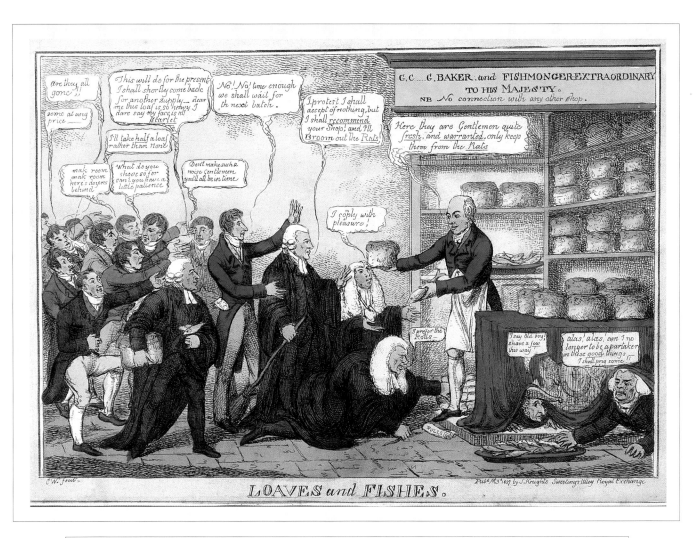

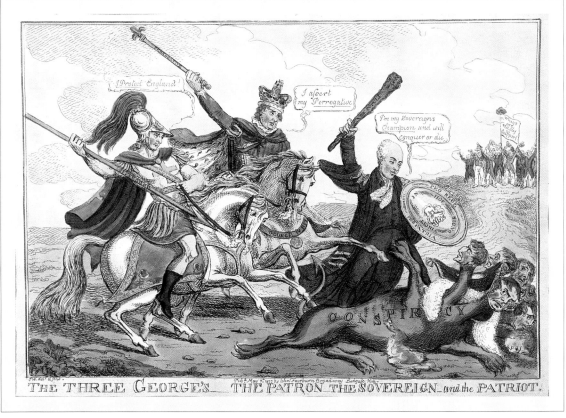

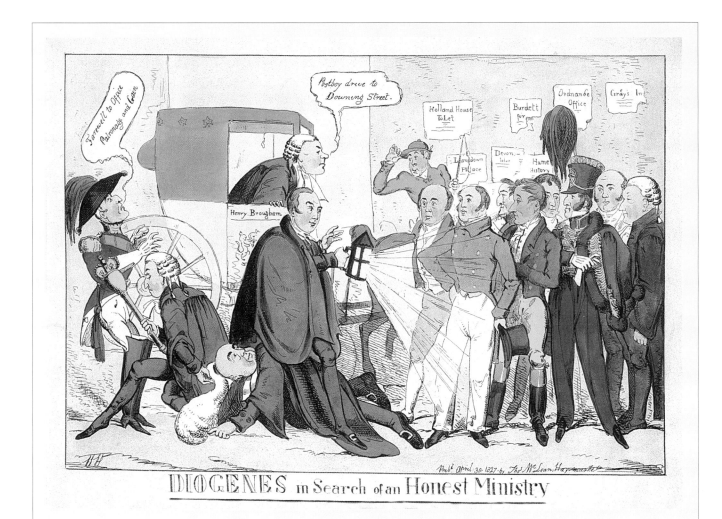

DIOGENES in Search of an Honest Ministry
W.H(eath). Published Thos. McLean, 1827. BM 15378.

Diogenes was the archetype of the sect of Cynics. Legend had it that he set out in daylight with a lantern to find an honest man.

Canning shines his lantern on some Whigs and the other 'Catholic' supporters hoping for office. Among them are Brougham (in the coach) Holland, Lansdowne, Devonshire, Burdett, Hume, Anglesey, Grey and Scarlett. (It would not only be the Tories who would be disappointed not to be included in Canning's Cabinet).

Wellington bids farewell as Master General of the Ordnance and Commander in Chief. Copley (the new Lord Chancellor, for eight years a Tory MP and one of the prosecutors of Queen Caroline) steals the wig of the ex-Lord Chancellor. Copley was the son of John Singleton Copley, the celebrated American artist, a loyalist, who fled America after the Boston Tea Party. His father was impoverished in England but his son became Lord Lyndhurst on his appointment as Lord Chancellor, a remarkable achievement.

How many of our contemporary caricaturists, one wonders, would be familiar with the career of Diogenes? More relevant, perhaps, is a second question – if they were, how many members of the public would appreciate the significance of Diogenes's inclusion in a newspaper cartoon?

Grey, who did not join Canning's Ministry, made a bitter speech in May accusing Canning of unworthy motives. Canning's wife believed that this speech shortened his life.

Canning was a paradox. Many looked on him as a champion of liberalism, yet he was an opponent of Parliamentary reform. His career ended prematurely. He died on 8 August, 1827 having caught a chill at the funeral of the Duke of York, a mere four months after he was appointed Prime Minister, with nothing significant achieved in so short a time.

The Tories now expected office under Wellington but that was not to be. The King sent for Goderich, 'Goody Goderich' as Cobbett called him. Mr Disraeli was ruder, calling him 'the transient and embarrassing phantom'. (So Goderich proved to be.) Goderich formed his Cabinet without Wellington.

The King wrote to Wellington offering him a resumption of his command of the Army, signing himself 'Always, with great truth, your sincere friend'.

The Duke accepted in a cordial letter affirming ' …the happiness I shall have in receiving you'.

Thus, whatever the Duke's private feelings of disappointment that he was not asked to form a Ministry, the courtesies were faithfully observed. As the caricaturist says, 'A Friend in need is a Friend indeed'.

His time would come, but not yet.

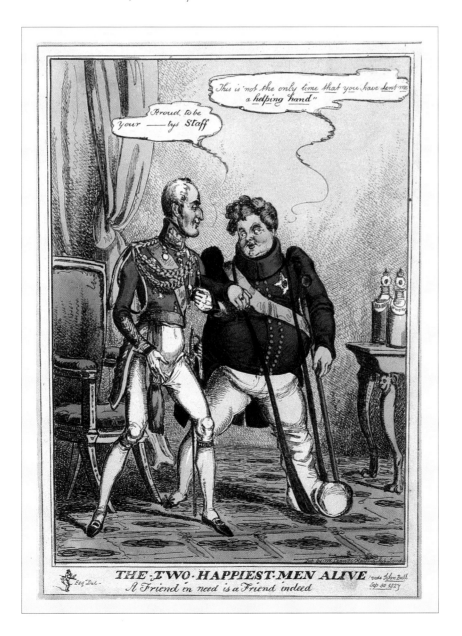

THE TWO HAPPIEST MEN ALIVE
A Friend in need is a Friend indeed
Paul Pry (William Heath). Published Thos. McLean 1827. BM 15429.

The King is on a crutch, with a gouty foot. He and the Duke both look cheerful indeed.

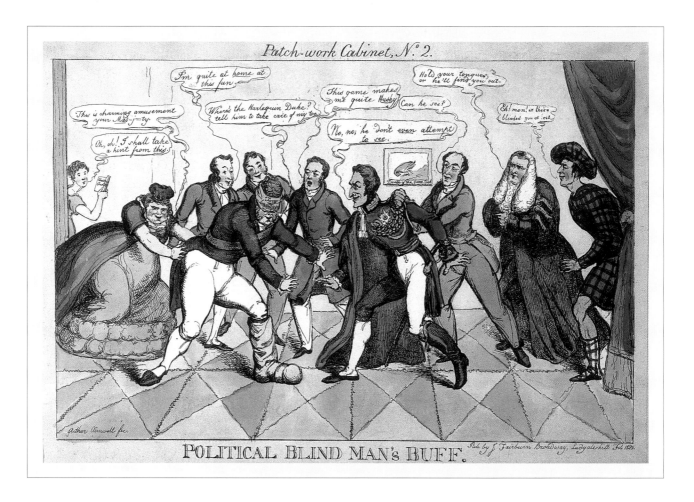

POLITICAL BLIND MAN'S BUFF – *Patch-work Cabinet Nº. 2*
Arthur Aimwell (?John Phillips). Published Fairburn 1828. BM unlisted.

It was widely felt that Wellington's time as Prime Minister was overdue, and here he is shown in Harlequin's pantaloon and cloak trying to catch the attention of the blindfolded King (selecting the PM was the Monarch's duty). Wellington took his time to form a cabinet: it was almost three weeks before he and the King were satisfied with his team. The King appears to be guided by his latest mistress, Lady Conyngham. She would appear in more caricatures than any other of the King's favourites.

Opposite: A CHANGE IN THE HEAD OF AFFAIRS
Paul Pry (William Heath). Published Thos. McLean 1828. BM 15498.

The King instructs Wellington to throw away his wig. The Duke fastidiously accepts it. Says he, 'I'll try and administer something that shall fit your Majesty better.' The King's gouty foot is prominent.

The play on the word 'Whig' is obvious. The King was known to possess a large collection of wigs. The public's assumption was that Wellington's Ministry would be dominated by the ultra-Tories but the King had instructed him to form a broad-based government, and this is what he did.

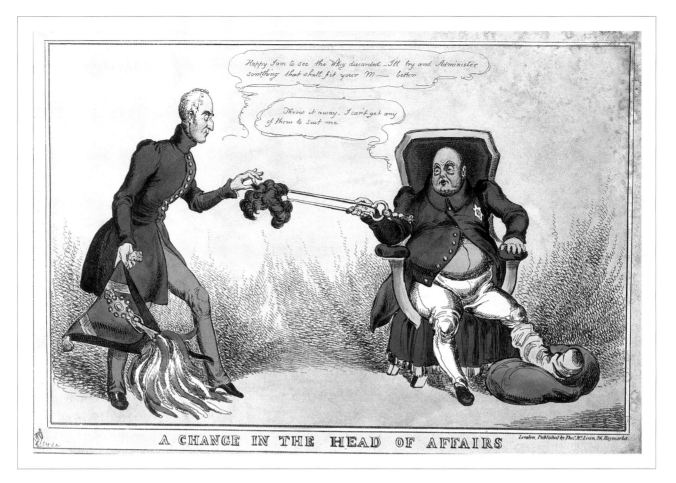

A CHANGE IN THE HEAD OF AFFAIRS

— THREE —

PRIME MINISTER WELLINGTON

Prime Minister Goderich, Canning's successor, a weak man, said to be 'as firm as a bulrush' resigned office in early January 1828. His term as Prime Minister was, like that of his predecessor, short; five months to the day. Thus he and Canning were in office for a total of only nine months. King George IV at last offered the Premiership to Wellington, the Tory.

Wellington's acceptance of the King's invitation to form a government as Prime Minister was prompted by his sense of duty and his wish to unite the Tory Party. In this respect he was to be largely disappointed. He had certainly not been ambitious for the appointment. On the contrary, he had let it be known that he did not seek the office.

The story of Wellington's premiership is an account of his relationship with Robert Peel. Peel, as the manager of the House of Commons, was indispensable to the Duke. Caricaturists often portrayed them working together – as apparently inseparable as Siamese twins. Although Peel is considered one of the greatest of Home Secretaries for his campaign of criminal reform, Wellington has never been given sufficient credit for his major role in the formation of both a military and a civil police force. In 1809 during the Peninsular Campaign, the Duke instituted a corps of military police for the first time in the history of the British army. In 1820 there were riots in England arising from King George IV's attempt to divorce

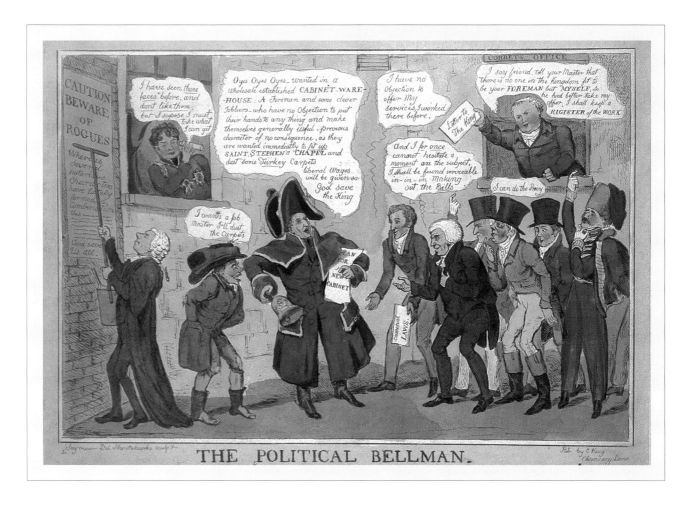

THE POLITICAL BELLMAN
Robert Seymour. Published King 1828. BM 15502.

The King had invited the Duke to form a broad-based ministry. Wellington is surrounded by aspirants for office: Brougham, Lord John Russell, Peel, Eldon, Westmorland, (?)Bathurst and Londonderry. Observers include the King himself, and William Cobbett, the radical pamphleteer – who in an open letter had claimed that he was the best person for the PM's job.

Queen Caroline via the Bill of Pains and Penalties. It was realised after the mutiny of a Guards battalion that the army could not be relied upon to control the street mobs and the Duke wrote in a memorandum to the Prime Minister in 1820:

> ' …in my opinion the Government ought, without loss of a moment's
> time, to form either a police in London or a military corps, which should
> be of a different description from the regular police force, or both.'

It is hard to imagine the widespread dislike of the new police system in 1829. In the parishes, officials of the corrupt type rightly feared that the system of graft and bribery which they had built up in co-operation with their watchmen and constables on the one hand and the purveyors of vice and the criminal classes on the other, would disappear overnight. Even honest householders disliked the scheme because it would hurt their pockets; a police rate of a maximum of 8d in the pound was to be imposed in every parish. And, of course, the immense criminal class of the metropolis, the most vociferous and dangerous of all sections of the population, naturally fermented all the trouble it could against the system.

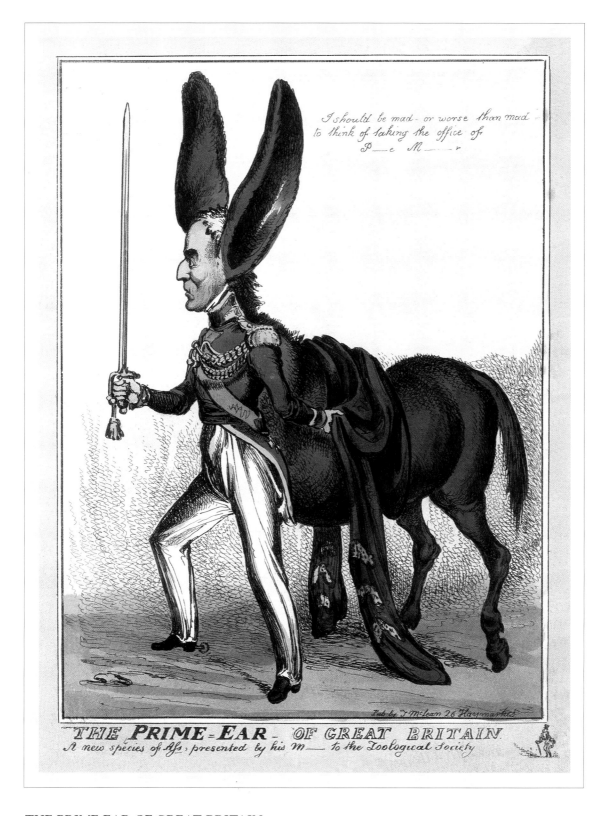

I should be mad - or worse than mad -
to think of taking the office of
P—e M——r

THE *PRIME=EAR* OF GREAT BRITAIN.
A new species of Ass, presented by his M—— to the Zoological Society

Pub by J. M°Lean 26 Haymarket

THE PRIME-EAR OF GREAT BRITAIN
A new species of Ass presented by his M— to the Zoological Society
Paul Pry (William Heath). Published Thos. McLean 1828. BM 15499.

The Duke's acceptance of the Premiership in January 1828 led to some harsh comment because only seven months earlier he had ruled out the possibility of his becoming Prime Minister. 'I am not qualified,' he said, and 'I should have been worse than mad if I had thought of such a thing.' On the ass's back is the gown of the Chancellor of the Exchequer. The print incorrectly assumes that the Duke would take this post also.

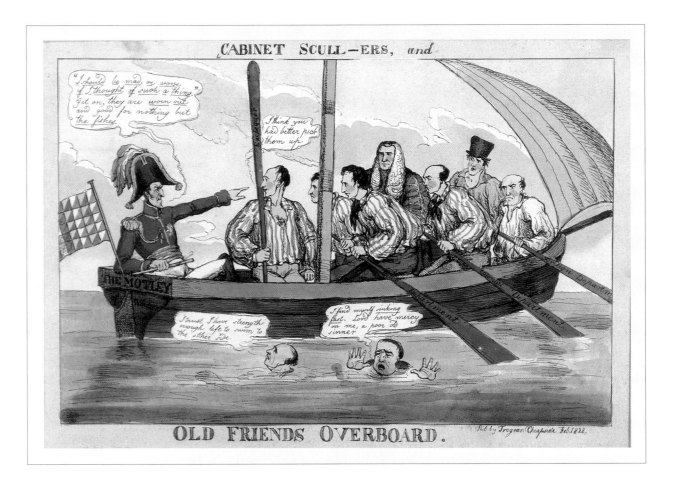

CABINET SCULL – ERS, and OLD FRIENDS OVERBOARD.
Artist unknown. Published Tregear 1828. BM unlisted.

Wellington left the ultra-Tories out of his cabinet choosing a broad-based government including some Canningites led by Huskisson whose support Peel needed in order to help him control the unruly and unsympathetic House of Commons. Thus old friends went overboard, giving caricaturists an obvious opportunity. It was ever thus. The back-benches always include some who are disappointed to be omitted from an administration, potential troublemakers all.

Opposite: **A NAUGHTY BOY TURN'D OUT OF SCHOOL**
Paul Pry (William Heath). Published Thos. McLean 1828. BM 15532.

Wellington's first cabinet – the 'strong Government' he had hoped to install – had twelve members and included both Canningites and Tories. Strong it might have been, but it was also split down the middle in terms of its support for Wellington's policies.

In May 1828, four of the cabinet – including Huskisson, the leader of the Canningites, featured here – had voted against the Ministry over the disenfranchisement of East Retford, one of the so-called Rotten Boroughs. The same evening Huskisson offered his resignation, which he subsequently attempted to withdraw (it is said that he never expected it to be accepted). The other dissenters also quit their offices, and the Duke promptly replaced them with his own supporters. All the naughty boys were thus turned out of school, and the Prime Minister acquired a reputation for ruthlessness.

The affair was to have significant consequences. In those days a newly appointed Minister was obliged to seek re-election at a by-election. Wellington appointed Vesey Fitzgerald as President of the Board of Trade in succession to Grant who had resigned with Huskisson. Fitzgerald was defeated by Daniel O'Connell, a leader of the Roman Catholics, in the by-election at Clare – suddenly the Catholic question was again at the top of the political agenda.

Huskisson's life ended in a bizarre way: he was run over by a train when, with Wellington, he attended the opening of the Liverpool–Manchester railway in 1830. He was the first railway casualty.

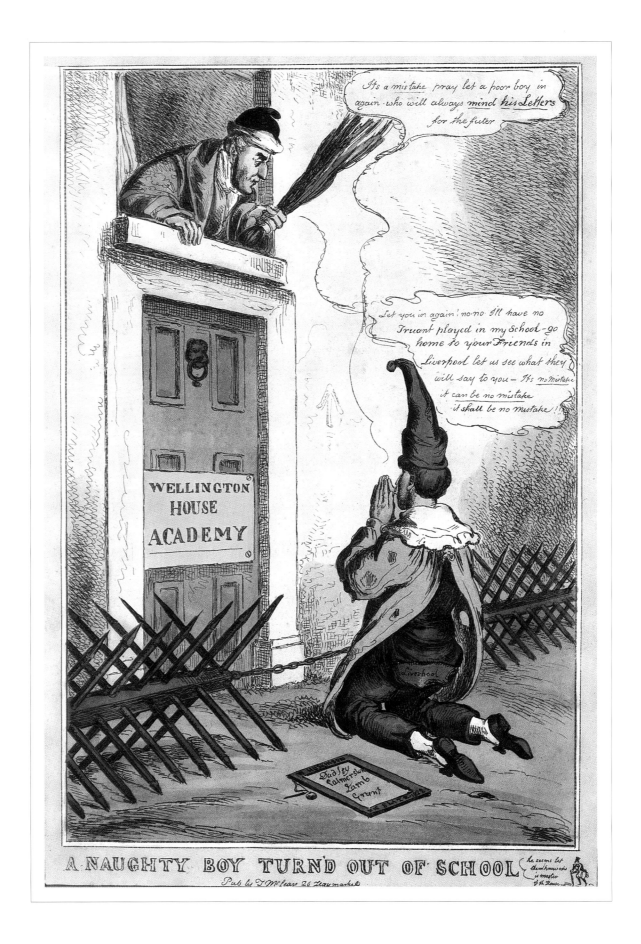

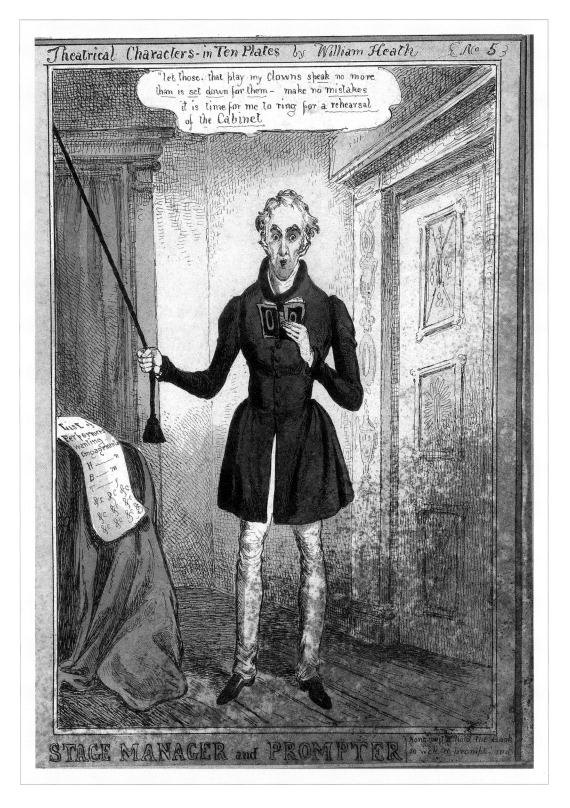

STAGE MANAGER and PROMPTER
William Heath. Published Thos. McLean 1829. BM 15899.

Theatrical allusions abound in the caricatures during Wellington's period as Prime Minister. In this example, his management style is clearly depicted. (In recent years Prime Minister Harold Macmillan was regarded as an actor-manager and often quoted as such.)

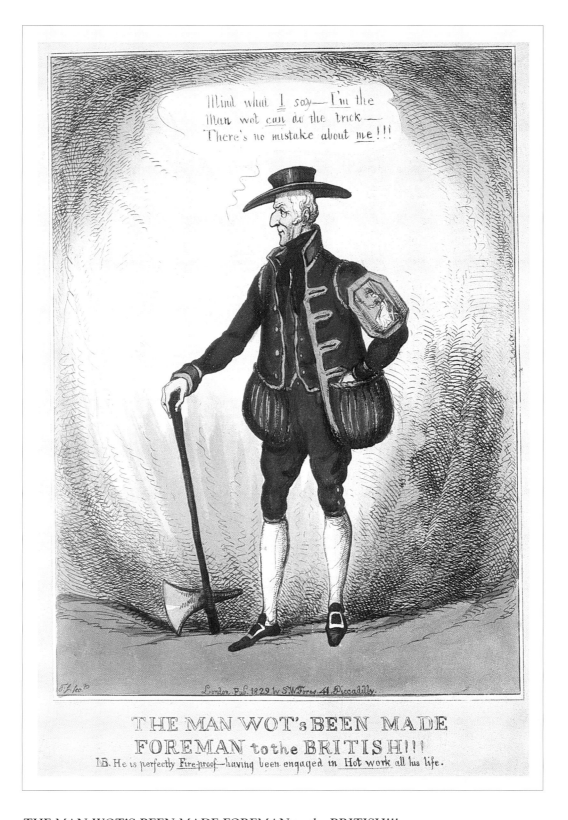

THE MAN WOT'S BEEN MADE FOREMAN to the BRITISH!!!
T.J(ones). Published S.W. Fores 1829. BM 15755.

Throughout his premiership, Wellington was depicted in various guises. Most were unflattering, but not all. Here he is depicted wearing the uniform of the London fire insurance companies. His arm-badge depicts Britannia. The suggestion is that he is 'fireproof', after having been engaged in hot work all of his life. (The term endures in naval slang – 'b****r you Jack I'm fireproof' is one I remember from my wartime days on the lower deck in the Navy). Self-confidence is always an asset – in peacetime and in war.

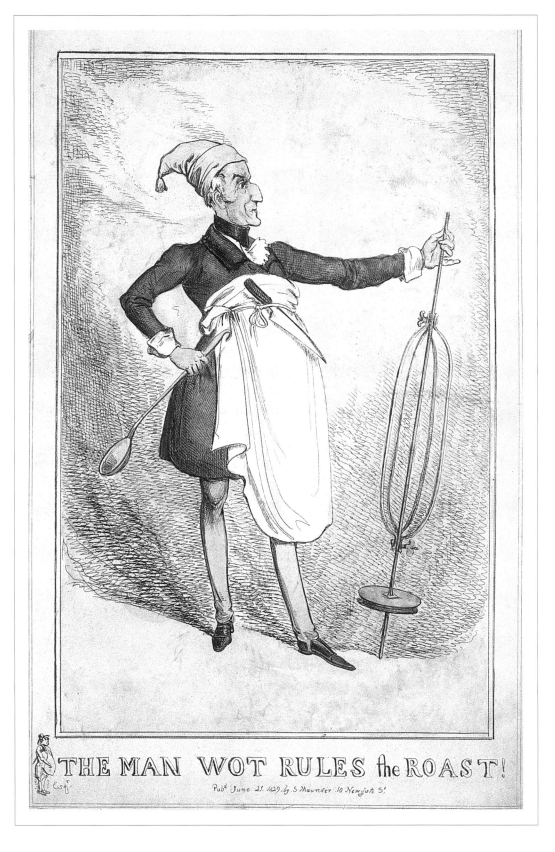

THE MAN WOT RULES the ROAST!
Paul Pry (?)T.Jones. Published Maunder 1829. BM unlisted.

By June he had changed from being a fireman to a fire-user. Here he is a cook. The implication is clear.
 The logo of Paul Pry has obviously been pirated by another engraver. Because of continued plagiarism, William Heath abandoned the pseudonym of Paul Pry later in 1829.

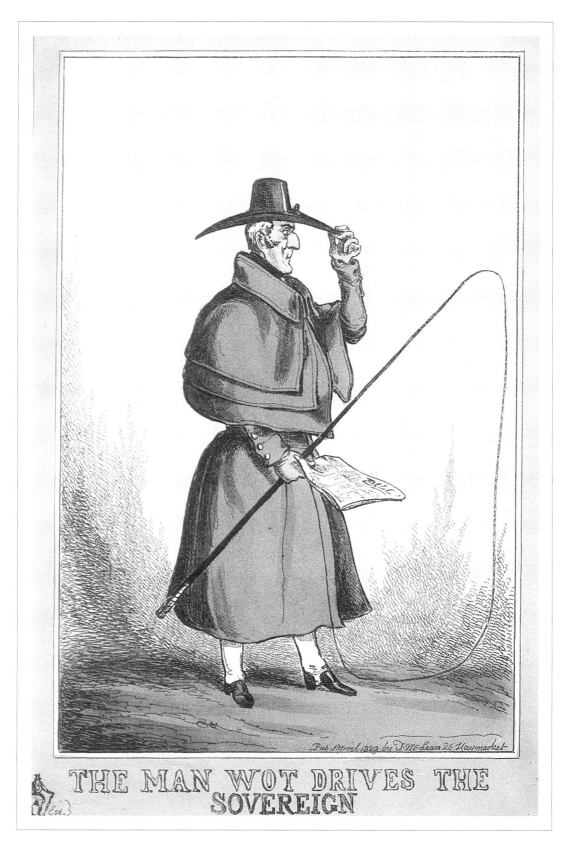

THE MAN WOT DRIVES THE SOVEREIGN
Paul Pry (William Heath). Published Thos. McLean 1829. BM 15731.

A favourite representation of the Duke, often copied. He may well tip his hat, argues the caricaturist, and thereby profess subservience, but in truth he is the director.

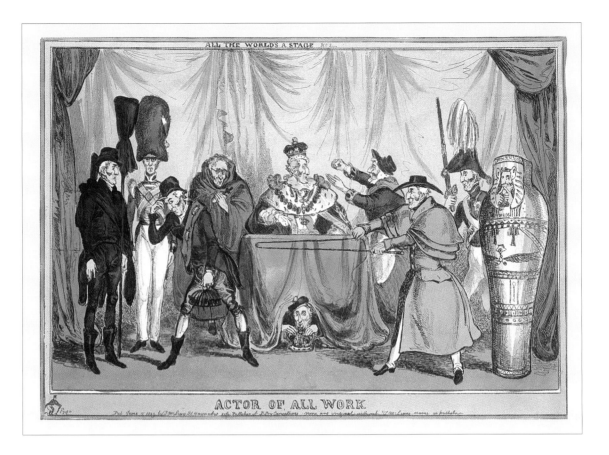

ACTOR OF ALL WORK

ACTOR OF ALL WORK
Paul Pry (William Heath). Published Thos. McLean 1829. BM 15805.

The Duke was reported as saying that he was 'obliged to think of everything'. In mid-1829, Heath portrayed Wellington in ten different poses in the manner of the contemporary impersonator Charles Matthews, whose one-man shows were a huge success both in England and America. Perhaps the most celebrated representation of the Duke is as a coachman – 'the man wot drives the Sovereign' – a guise that was copied several times by other caricaturists.

Opposite above: **NEW POLICE ACTIVITY**
H.B.(John Doyle). Published Thos. McLean 1830. BM 16029.

If managing a Cabinet is difficult, managing Parliament is certainly no easier. Wellington and Peel, uniformed as police officers, are shown complaining in early 1830 to the Magistrate, King George IV, about a truculent and noisy crowd in the dock of a police court comprising members of the opposition, including Brougham. Eldon, former Lord Chancellor, stands alone. The caricature is a comment on the attacks on the King's speech made by an unholy alliance of Canningites, Whigs and ultra-Tories.
 A crowd of witnesses (the general public) seem to have no sympathy for the process.

Opposite below: **THE CABINET-MAKER'S COMPLAINT**
Sharpshooter (?J.Phillips). Published S. Gans 1829. BM 15807.

The cabinet-maker (Wellington), saw in hand, complains to the King about two unruly members of his Cabinet, foreman Bob (Peel) and Chancery Jack (Lyndhurst). Both are depicted in a framed picture behind him in pugilistic attitudes – as Prime Minister Attlee complained to me about the Bevanites, Home (in private) about the Heathites, Thatcher about certain of her colleagues and as Major savagely did, publicly, about those who objected to his actions on the European Union.
 The King looks surprised but offers no advice.
 The caricature refers to rumour of Ministerial changes and is a tilt at the supposed ruthlessness of the Duke. 'A good Prime Minister', said that leading Conservative politician R.A. Butler, must be 'a good butcher'.

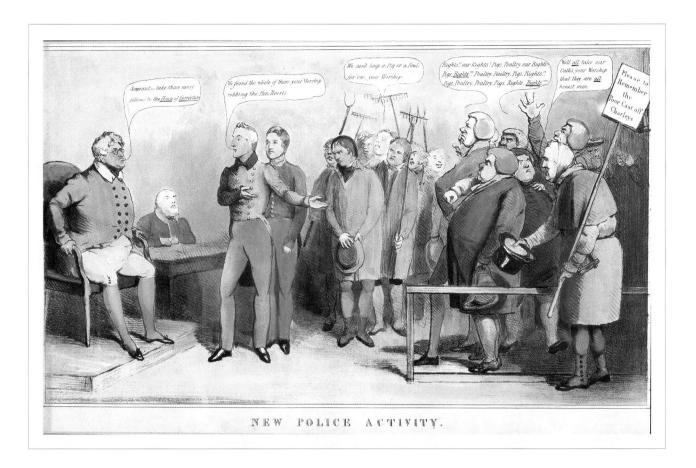

NEW POLICE ACTIVITY.

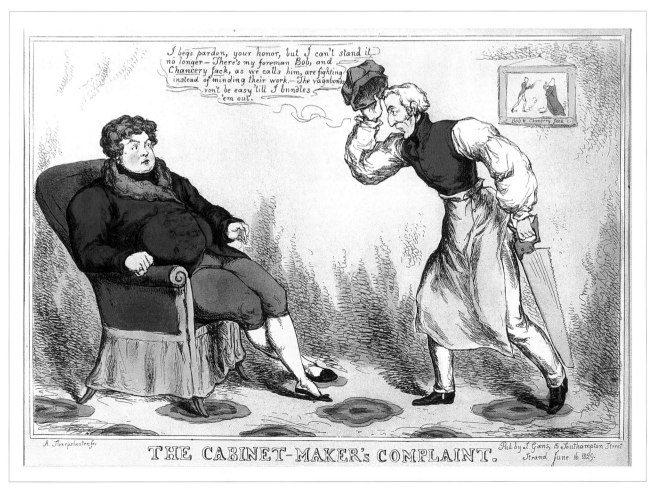

THE CABINET-MAKER's COMPLAINT.

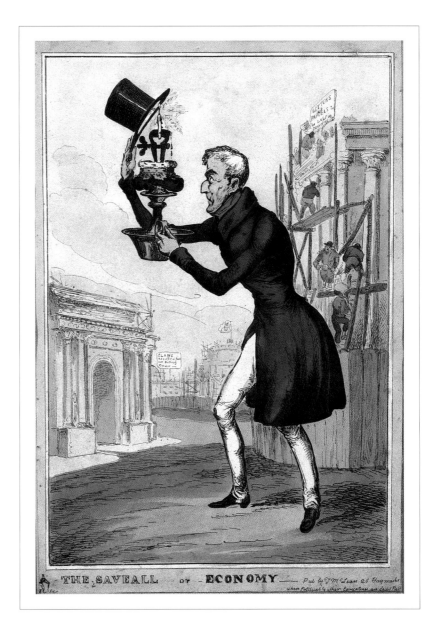

THE SAVEALL of ECONOMY

Paul Pry (William Heath). Published Thos. McLean 1828. BM 15563.

The original estimates for work on the King's homes at Buckingham Palace and Windsor Castle had been grossly exceeded, with Parliament continually being asked to approve further funds. Here the 'penny-wise' Duke is lampooned for his own 'pound foolish' works – at both Apsley House, his London residence (shown under scaffolding to the right) and the memorial Constitution Arch (on the left, originally called the Triumphal Arch, standing at the top of Constitution Hill). Buckingham Palace and Windsor Castle appear in the background. Wyatt's original estimate for Apsley House was £22,000. It rose to £66,000. It was finally agreed at £42,000. Builders' estimates then, as now, are ever elastic.

Creevey, a political commentator of the day, wrote :

'Nash, or some of his crew, waited upon Wellington the other day, stating the King's pleasure to have a part of the new palace at Pimlico [Buckingham Palace] pulled down and the plan altered; to which the Beau replied it was no business of his; they might pull down as much as they liked. But as this was not the answer that was wanted, he has at last said '…if you expect me to put my hand to any additional expense, I'll be damned if I will!! – Prinney is said to be furious about it…'

Creevey was a Whig MP. His letters, 'The Creevey Papers', are an important source of Georgian social history. London owes John Nash, the architect, the design of the Marble Arch, Carlton House Terrace, Regent Street and Regent's Park and its splendid terraces. He enjoyed the patronage of the King.

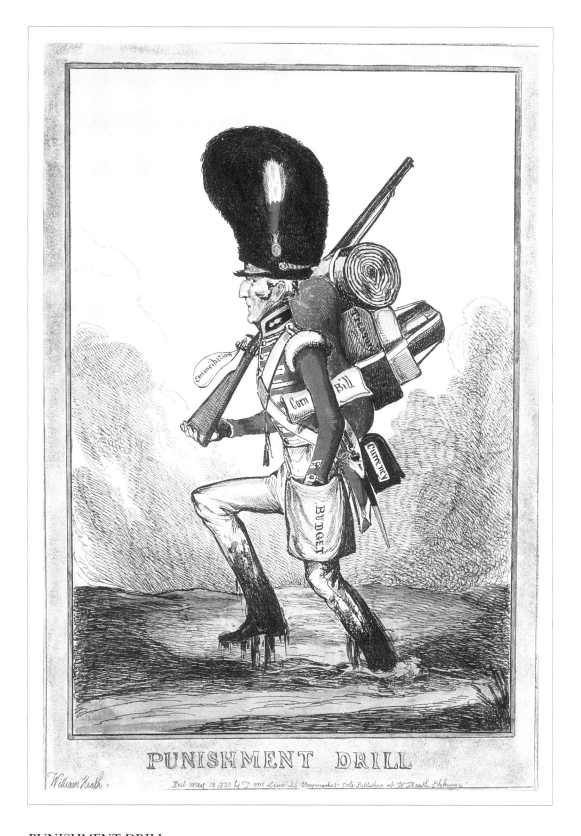

PUNISHMENT DRILL

PUNISHMENT DRILL
William Heath. Published Thos. McLean 1830. BM 16117.

Wellington in May 1830, burdened by his precarious political position, endeavours to soldier on through the heavy going. His substantial kit includes the budget, the currency, Catholic emancipation, the Treasury and the Corn Bill – all of which were increasingly weighing him down. Any subsequent Prime Minister could be portrayed in a precisely similar position – with his kit including many of the same problems.

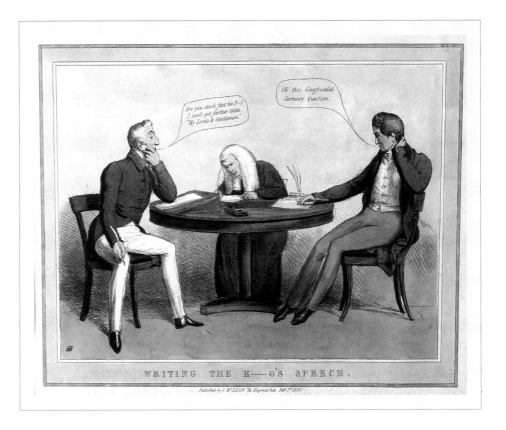

WRITING THE K — G'S SPEECH.

WRITING THE K — G's SPEECH
HB (John Doyle). Published Thos. McLean 1830. BM 16013.

The Sovereign's speech, drafted by Ministers, is the annual announcement of the Government's legislative intentions for the forthcoming session of Parliament read by the Soverign to members of both Houses assembled together. Here, Wellington, Lyndhurst and Peel are shown as having considerable difficulty thinking of something positive to say – hardly surprising considering the fearful economic situation, widespread distress, and accusations that the Government was indifferent to the poor.

Opposite above: **A VISION**
William Heath. Published Thos. McLean 1830. BM 16030.

This caricature contrasts the Duke's past (military) glories with his present (political) tribulations. On the left, in the prime of life and success, he stands over Napoleon's tomb. On the right, in contrast, he balances precariously on a globe covered with political problems, the weight of which is crushing a group of artisans and farmers. Between the past and present is King Charles X of France, partly obscured by a fleur-de-lis.

The implication is that the Duke's defeat of Napoleon had only served to restore the corrupt Bourbons, whose throne was tottering.

Opposite below: **THE DUMPS!!!**
William Heath. Published Thos. McLean 1830. BM 16077.

A scene which all Parliamentarians have observed at different times; the leaders of a Party, in this case Wellington and Peel, gloomily contemplate a defeat. In the House in March 1830 the Ministry lost a division by eighteen votes on a pensions issue.

Wellington's Ministry was unquestionably weak at this time. It was under fire from both radicals and ultra-Tories over the economic situation and the Duke had to endure personal criticism also. He contemplated resignation in favour of Peel, reasoning that Peel would be likely to be better supported.

Managing the Government Party in either House was difficult in those days when Party disciplines as we now know them hardly existed. (Observers of contemporary events may reflect that it still is difficult.)

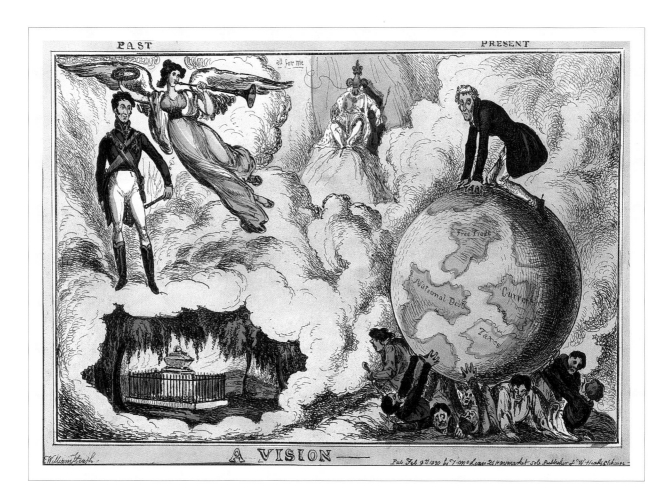

STATE WATCHMEN of 1829

Sharpshooter (?) J. Phillips. Published Field 1829. BM 15768.

In this example, Peel had just carried through the Metropolitan Police Act which set up the first police force in greater London. The sign on the left refers to AW (Wellington) as the cabinet maker – a reference to his ruthlessness in making Cabinet changes. RP the orange peel merchant refers to the unfounded hopes of the Protestant Orange Lodges that Peel would support their cause against Catholic emancipation.

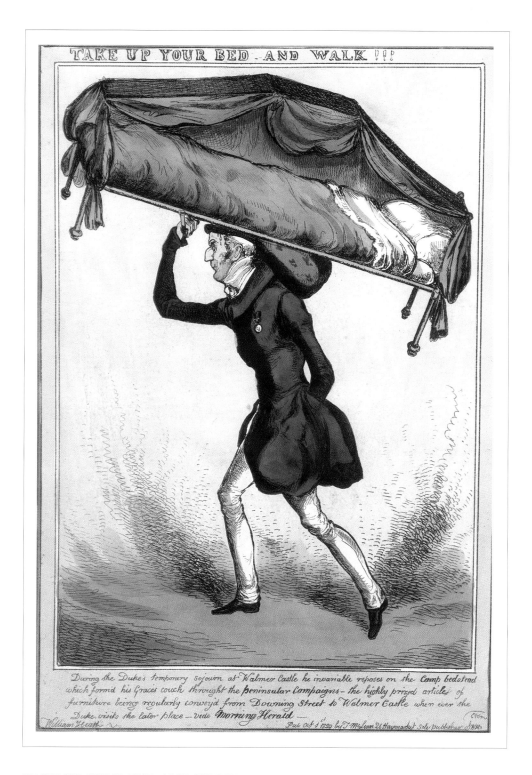

TAKE UP YOUR BED AND WALK!!!

William Heath. Published Thos. McLean 1829. BM 15867.

This caricature confirms the press campaign in the summer and autumn of that year to oust the Duke. He wears a knot on his head with a double shoulder pad of the sort used by London porters of the day. In his left hand he seems to hold a large purse. He carries his camp bed from the Peninsular Wars. It had been reported that this bed was regularly transported between London and Walmer Castle where he much enjoyed staying.

In January 1829 Wellington was appointed Lord Warden of the Cinque Ports with Walmer Castle as his official residence. In London he lived at Apsley House and not in Downing Street which, while he was Prime Minister, was occupied by his servants. The present Lord Warden of the Cinque Ports (2000) is HM the Queen Mother.

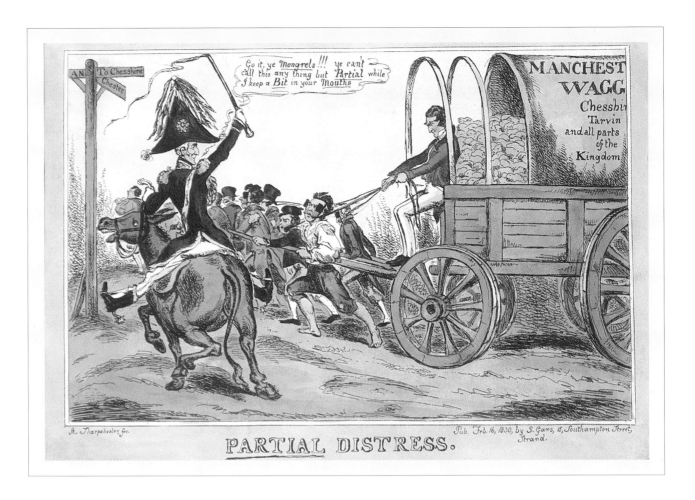

PARTIAL DISTRESS.

PARTIAL DISTRESS

Sharpshooter (?) J. Phillips. Published S. Gans 1830. BM 16039.

Home Secretary Peel drives the wagon pulled by the impoverished who are lashed by Prime Minister Wellington riding a donkey.

Though there had been great hope that the end of the Napoleonic Wars would bring prosperity as well as peace, it was not to be. The winter of 1829/30 was particularly harsh for the British people, bringing widespread poverty and hunger. It was hardly surprising that many people clamoured for major constitutional reform. The caricaturists were quick in their attack on Wellington, alleging indifference in the face of public suffering. The term 'partial distress' refers to a section of the King's speech in January 1830 which maintained that the nation's distress was partial and 'qualified by expanding industry'. (As is the case today, the Sovereign's speech in Parliament was not the Head of State's own opinion: it was a statement of the view of the Government of the day).

The criticism of Wellington was unfair. In his memoirs Greville wrote, 'I firmly believe his mind is incessantly occupied with projects for its relief', i.e. the relief of public distress. There was considerable contemporary evidence of his understanding of the difficulties of others. But this fact did not suit the caricaturists. (Greville was a well-known political diarist and Clerk to the Privy Council for 39 years, an intimate of the Duke.)

— Four —

Economic Distress

Social conditions in Britain at the beginning of the nineteenth century and throughout Wellington's time were better than in many other European countries. One instance will suffice: the British death rate was a fifth below that of France. Also, conditions in Britain were improving. Infant mortality was falling, scourges such as the plague and smallpox were being controlled and the standard of living generally was rising.

Even so, the family circumstances of many were often appalling. For example, 12% of the population of Somerset were paupers, people utterly without means. In neighbouring Wiltshire, paupers constituted a quarter of the population. Less than 15% of British families had an income of more than £50 per annum and of those only one quarter earned more than £200 per annum. It is recorded that in 1841 a poor rural family of seven were living on a weekly allowance of thirteen shillings and nine pence (sixty-nine new pence) of which a large proportion, nine shillings (forty-five new pence), went on bread and one shilling and two pence (seven new pence) was paid in rent. Bread, the staple diet, was expensive because home production of corn was protected. There were heavy duties on imports.

It was fortunate that our Parliamentary system was effective and perhaps the most sensitive of any in Europe to popular opinion; according, that is, to the standards of the day. Even so, the mass of the population was wholly unrepresented in Parliament. There were many political organisations but little means for people to state their case other than by petitions to Parliament, demonstrations at mass public meetings – or by rioting in the streets.

Wellington's lifetime spanned an era of immense social and economic change. In the reign of George III the population of Great Britain doubled. Westminster Bridge was first lit by gas at the time of Waterloo. (In my boyhood omnibus conductors would call out the addresses of their stops – Parliament Square was often called the Westminster Gasworks). The development of mechanical power introduced large scale production and facilitated travel for many where previously only tens, perhaps hundreds, had travelled on foot or by horse. The effect of such developments on the lives of our fellow citizens, on their employment and living standards was to be profound and the adjustments were often painful.

There was neither an adequate diagnosis of the widespread social deprivation which existed in Britain nor any agreement about remedies. To the modern observer such social improvements as were attempted appear minor. It is difficult to avoid the feeling that our country's rulers were largely indifferent to the

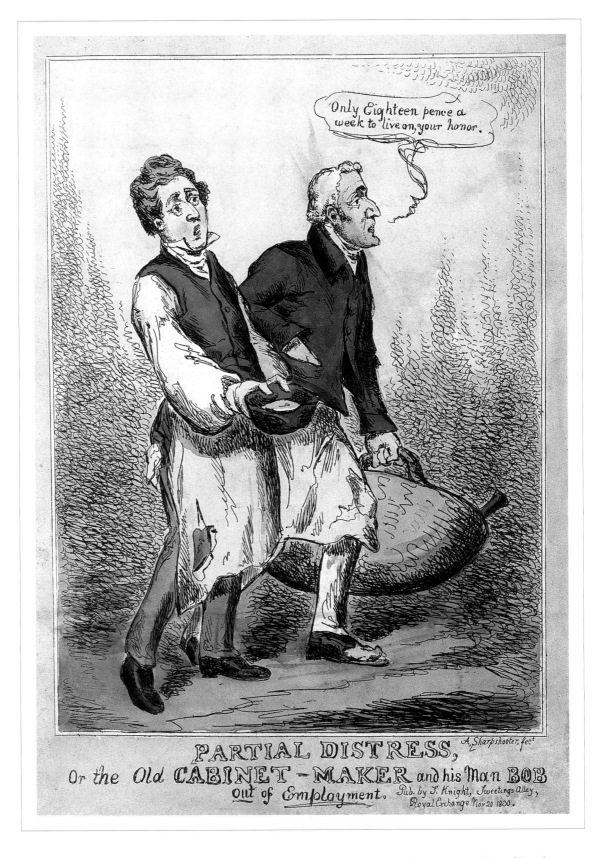

PARTIAL DISTRESS Or the Old CABINET-MAKER and his Man BOB <u>Out</u> of <u>Employment</u>
Sharpshooter (? J. Phillips). Published S. Knight 1830. BM 16336.

Again, the theme of partial distress is taken up by the caricaturist. This time it is the distress that might be inflicted on Wellington and Peel – the old cabinet maker and his mate – out of employment and begging, wishful thinking perhaps.

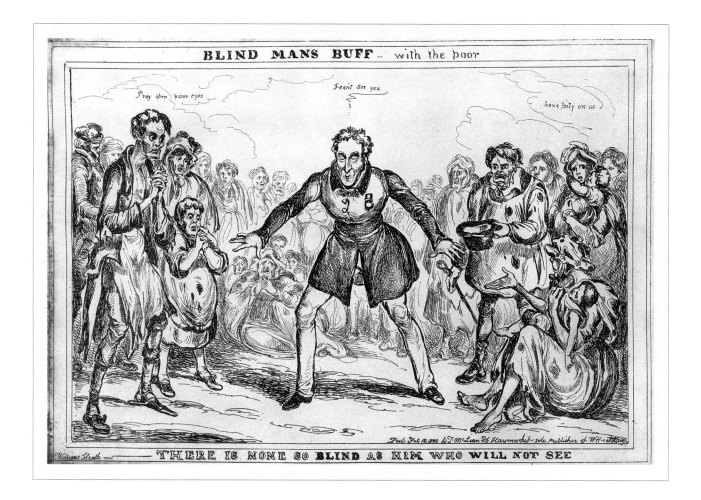

BLIND MAN'S BUFF – with the poor
William Heath. Published T. McLean 1830. BM 16032.

Wellington, wearing his Waterloo medal, is graphically shown ignoring the poor and starving. 'There is none so blind as him who will not see.' The unwillingness of the Ministry to act to relieve suffering was heavily criticised by the opposition, which included ultra-Tories.

sufferings and disappointments of the common people. For the most part these discomforts were accepted as inevitable, even when they were at their most severe. Yet there was no lack of discussion, inside Parliament and outside it, and it would be quite wrong to suggest a complete lack of humanity. Public debate was continuous and the pamphleteers and orators flourished. Among the best known were Hone, one of whose pamphlets (a satirical parody called 'The Political House that Jack Built' and illustrated by George Cruikshank in 1819) sold nearly 100,000 copies in fifty-four editions; Henry Hunt, the radical orator who addressed the disastrous meeting at Peterloo attended by some 60,000 people, of whom eleven died and 400 were injured following a military charge ordered by the Magistrates; William Cobbett, the politician and journalist who published a weekly 'Political Register' and Thomas Paine one of the English leaders of the American revolution. (Many today would agree with the quotation from Paine's pamphlet entitled 'Common Sense', published in 1776:

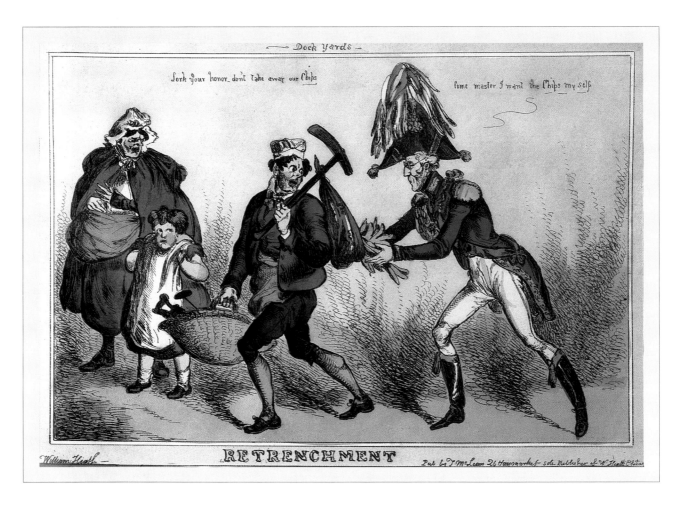

Dock Yards

Fork your honor_dont take away our Chips

fome master I want the Chips my felf

RETRENCHMENT

William Heath

Pub by J McLean 26 Haymarket sole Publisher of Wm Heath Prints

RETRENCHMENT
William Heath. Published Thos. McLean 1830. BM 16066.

In the hard times of 1830, retrenchment (economy) was called for. This satirical caricature shows a desperate Wellington chasing a shipwright to commandeer his perquisite ('perk', most would call it) of firewood, watched by the man's dismayed wife and daughter. It has to be admitted that sharp practice occurred with regularity, as in the cutting of useful timber deliberately so as to make waste. The final hour of work was devoted to the collection of waste by the workman.

This caricature refers to The Naval Estimates debate in early 1830, which proposed economies in the dockyards including the abolition of modest allowances made in 1801 in consideration of waste timber for firewood. (6d a day for a shipwright, 4d or 3d for other workmen). Times were desperate indeed. (Shades of the 'Geddes axe' a century later in the 1930s during Lloyd George's coalition Government when a businessman was appointed as head of a committee to recommend economies in Government spending, or the cuts in unprofitable railway lines initiated by the late Lord Beeching after World War II.)

Prime Ministers earn opprobrium not only for what they do, but sometimes for what they have no intention of doing. Wellington was also assailed in a series of caricatures for his supposed intention to reform the Church of England by appropriating its tithes. This he vehemently denied.

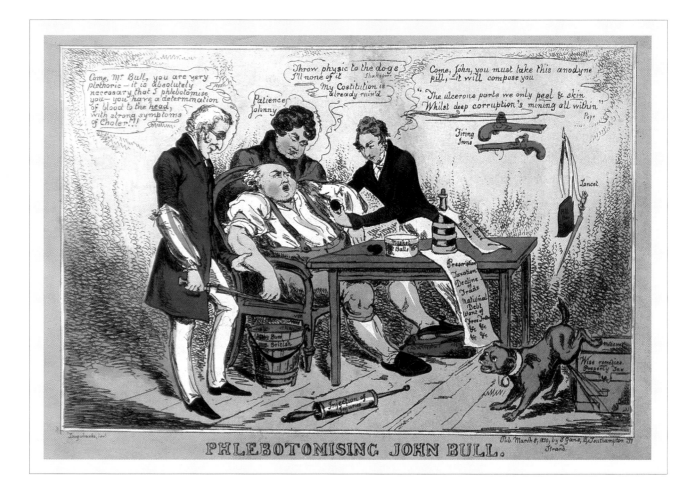

PHLEBOTOMISING JOHN BULL

Sharpshooter (? J. Phillips). Published S. Gans 1830. BM 16069.

Taxation was the subject of this caricature published in anticipation of the budget in March 1830 amid talk of national bankruptcy. Wellington, supported by the King and Peel, prepares to bleed John Bull. One of the 'wise remedies' proposed by Peel was a Property Tax. A dog clearly shows his opinion of this proposal by urinating on it. When I became a Minister at the Treasury in 1962 I am glad to say we abolished an annual tax on property owners known as Schedule A. Alas, I do not recall any contemporary caricatures showing tail-wagging dogs. Good news sells few newspapers.

'Government, even in its best state is but a necessary evil: in its worst state an intolerable one.')

Among the middle ranks of society the horrors of the French Revolution of 1789 were fresh in the mind. Disorder continued in France and other countries. (In the summer of 1830 Charles X of France fled to England). Although there was concern to maintain order in England, the forces of law and order hardly existed in any modern sense. It was not until 1829 that Peel created the Metropolitan police as part of his programme of reform. Until then there was in practical terms no organised constabulary in the metropolis, there being only local watchmen and constables, many of whom were corrupt. Furthermore, the loyalty of the army, the last resort for peacekeeping, could not always be counted on.

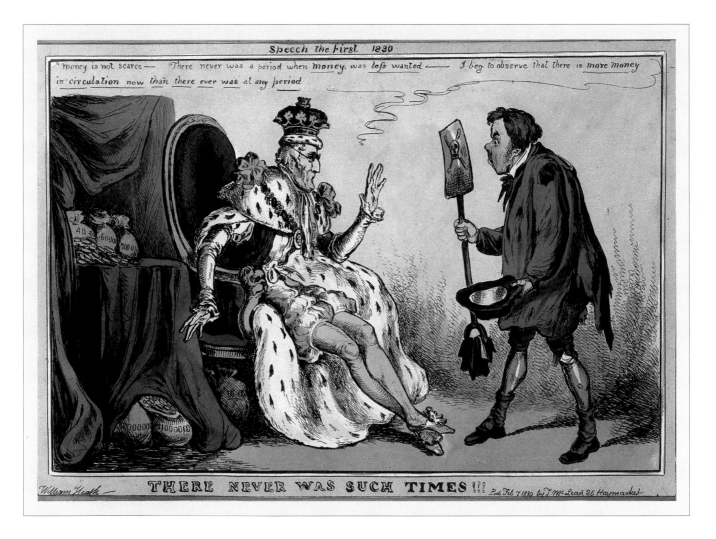

THERE NEVER WAS SUCH TIMES!!!
William Heath. Published Thos. McLean 1830. BM 16028.

Among rumours of currency shortages, depreciation of the pound was urged by some as a solution to poverty. Wellington replied that there was more money in circulation than ever before – a statement which must have been wholly incomprehensible to the hard-pressed working man.

William Heath rubs this point home. The contrast between 'King' Wellington surrounded by bags of gold, and the poor threadbare labourer, could hardly be starker.

Mobs were often in the streets; Wellington's house was twice stoned. Rioting sometimes resulted in deaths and injuries among the rioters, the Gordon riots and Peterloo being notorious examples. Following Peterloo and the 'seditious practises', which the Government alleged their Six Acts of Parliament were promptly passed, gagging the press, banning drilling and the possession of arms in disturbed areas, speeding up the judicial process in appropriate cases and restricting public meetings. Such was the real concern in responsible quarters at the prospect of public disaffection and its consequences.

There was a plot to assassinate the entire Cabinet (the 'Cato Street

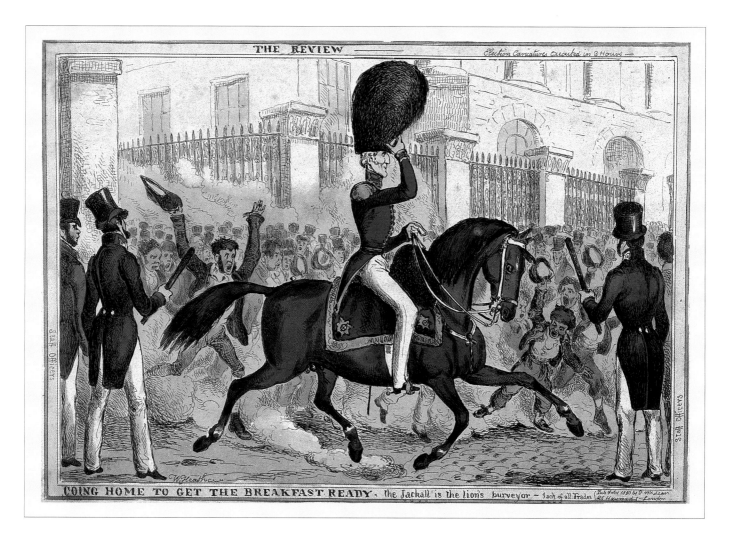

GOING HOME TO GET THE BREAKFAST READY – The Jackall is the lion's purveyor
William Heath. Published Thos. McLean 1830. BM 16188.

King George IV died on 26 June 1830 and was succeeded by King William IV (King Billy, the Sailor King). On 26 July 1830 there was a grand review in Hyde Park, followed by a breakfast for the Royal Family at Apsley House (Wellington's home, shown here in the background). This event is portrayed here. Contrasting the mob's unhappy condition with such ostentatious shows of wealth, it illustrates the public's growing disaffection with the *status quo*. Wellington needed to be protected by Light Dragoons in addition to the six hundred 'new' policemen on duty.

Conspiracy', a plot by a few desperadoes); and before the passage of the Reform Bill in 1832, revolution was time and time again considered to be a possibility. Even after that there was much public disaffection: Wellington's last military campaign was to be in his own country when aged almost eighty he masterfully contained the Chartist riots. Fortunately, revolution was never to take place in our country.

Against this background the caricaturists referred in sharp tones to the prevailing economic situation. It was always the bad news they emphasised, rarely the good. (They were the forebears of our contemporary media).

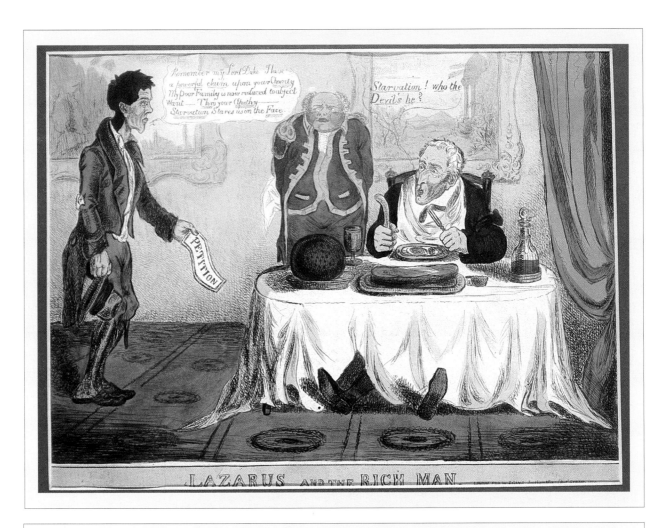

LAZARUS AND THE RICH MAN

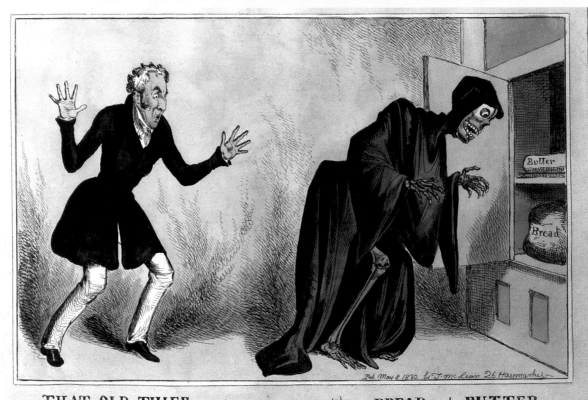

THAT OLD THIEF - wants to run away with my BREAD and BUTTER

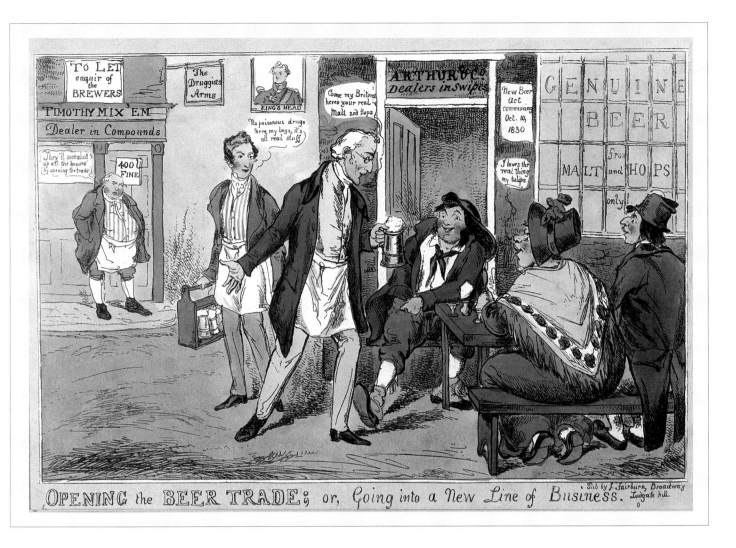

OPENING the BEER TRADE; or Going into a New Line of Business
Sharpshooter (perhaps). Published J. Fairburn 1830. BM 16100.

Wellington and Peel are shown in charge of the 'Kings Head' public house.

In the Budget of 15 March 1830, the Chancellor of the Exchequer announced the repeal of the Beer Tax, amounting to three farthings in the quart. This was designed to bring relief to the working class and to check the increased practice of watering down or adulterating beer. In addition, publicans lost their monopoly. This meant that beer could henceforward be sold by anyone with a licence. This is one of the few times Wellington is shown in a happy caricature.

Opposite above: **LAZURUS AND THE RICH MAN**
Artist unknown. Published S. Gans 1830. BM 16047.

According to St John's Gospel, Christ raised the dead man Lazarus. So, the caricature argues, the English poor looked to Wellington to perform a similar miracle for them. Alas, they hoped in vain. The contrast between Wellington, shown as eating heartily, and the starving wretch who respectfully addresses him, could not be more stark.

Opposite below: **THAT OLD THIEF – wants to run away with my BREAD and BUTTER**
William Heath. Published Thos. McLean 1830. BM 16115.

The Prime Minister expresses alarm at the skeleton's intention to steal bread and butter from his cupboard – yet another example of the bitter attacks on Wellington throughout this period.

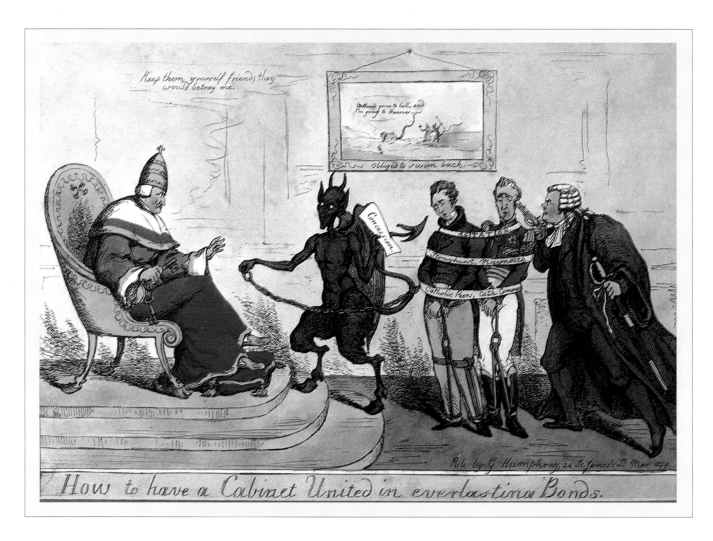

How to have a Cabinet United in everlasting Bonds
(?) J. Phillips. Published G. Humphrey 1829. BM 15704.

Wellington is accused of yielding to pressure from the Catholic Association whose objective was Catholic emancipation by constitutional means.
The devil, concession in hand, and O'Connell, the Association's leader, present Wellington and Peel in chains to the Pope but he distrusts the gift.

'Keep them yourself friend,' says his holiness, 'they would betray me…'

The painting on the wall shows the King leaving England, swimming. 'Arthur's gone to hell and I'm going to Hanover,' he says.
The title of the painting is 'Obliged to swim back'. The King had made a threat to abdicate and go to Hanover, but he never carried it out.

Opposite above: **A LONG PULL, A STRONG PULL and a Pull Altogether!!!**
H. Heath. Published Tregear 1829. BM 15719.

The King believed that emancipation would mean the ruin of the Church of England. In the Coronation Oath he had sworn to uphold Protestant ascendancy. Moreover, he was under substantial pressure – from both leading religious and political figures and the public – to resist any change to the *status quo*. As a result, he even went as far as saying he would abdicate rather than support emancipation. The fight for Royal Assent to the Bill was therefore fierce and is represented here by ultra-Tories Lord Chancellor Eldon and Cumberland (the King's brother) bullying the King one way, Wellington, Peel and Sir James Mackintosh the other. The King's mistress, Lady Conyngham, peeps from behind the curtain.

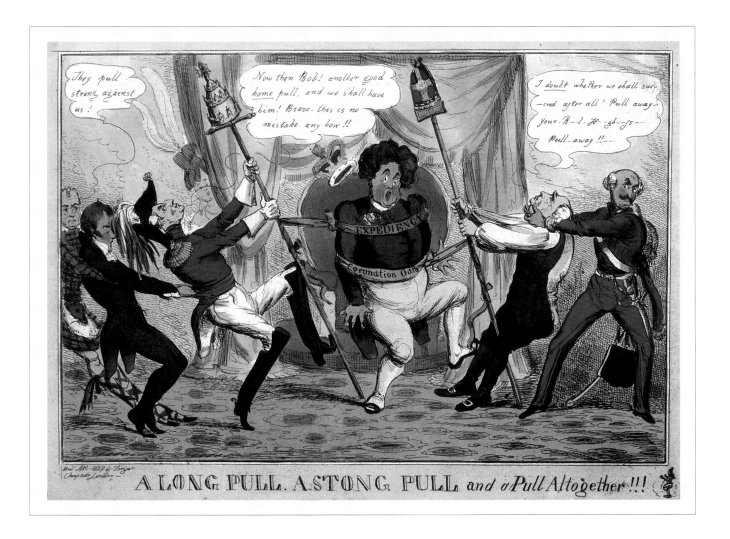

— FIVE —

CATHOLIC EMANCIPATION

It could be argued that Wellington's background fitted him better than most Englishmen to comprehend the Irish situation. His family had lived in Ireland for perhaps 600 years. He was born in Ireland and had been Chief Secretary for Ireland between 1807 and 1809. And yet there was a wide emotional and social divide between the Anglo-Irish Protestants and the Catholic Irish – as there still is today.

The story may or may not be true, but it is said that a lady once remarked to him, ' …being born in Ireland makes you an Irishman.' 'Madam,' replied the Duke, 'because a man is born in a stable that does not make him a horse.'

Wellington was in India in 1798 when a rebellion led by the Society of United Irishmen was put down at terrible cost – it is estimated that there were 150,000 Irish and 2,000 English dead.

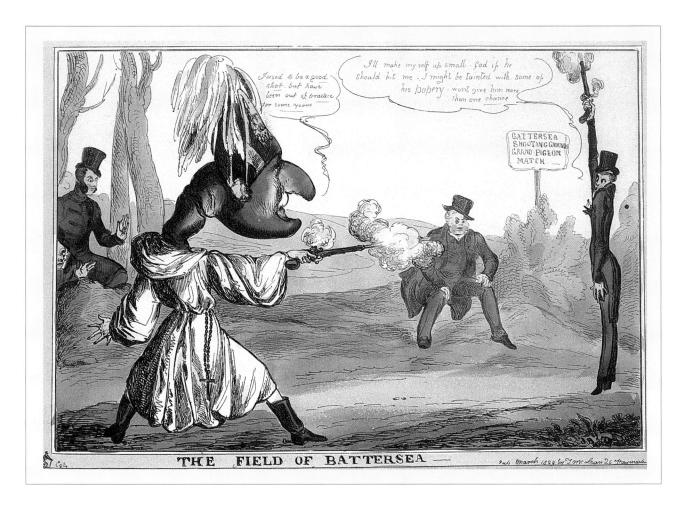

THE FIELD OF BATTERSEA
Paul Pry (William Heath). Published Thos. McLean 1829. BM 15697.

The strength of feeling over Catholic emancipation is illustrated by a bizarre duel which took place between Wellington and the ninth Earl of Winchilsea, an anti-Catholic. In a published letter to a newspaper, Winchilsea had accused the Duke 'under the cloak of some outward zeal for the Protestant religion' of carrying on 'insidious designs for the infringement of our liberties.' The Duke demanded an apology. Winchilsea refused. The challenge followed. This unprecedented event aroused huge public interest. The duel nearly did not take place. Winchilsea arrived late at Battersea, his driver having mistakenly taken him to Putney. The Duke is shown firing at an artificially thin Winchilsea. Wellington is portrayed as a lobster, a vulgar and derisive term for a soldier. Winchilsea held his fire until the Duke (a notorious bad shot) fired to miss, whereupon Winchilsea replied in kind, firing into the air. Honour satisfied – Winchilsea apologised.

In 1801 (Wellington was now just over thirty years of age) the Union of Great Britain and Ireland came into being. Strong senses of grievance, some real, some exaggerated, some imaginary, the unhappy legacies of some sad histories, remained among the Irish and were fostered by patriots and agitators alike (as they still are today).

In English history anti-Catholicism was long identified with patriotism – encouraged by events such as the Spanish Amada's attempted invasion of England and Guy Fawkes' plot to blow up Parliament. So the law disadvantaged Catholics. Nonetheless, there was also a liberal view and a succession of Catholic

TREASURE SEEKERS

R.S. (Seymour). Published anon. – 1829. BM 15838.

In the company of the King, Lyndhurst and Peel, Wellington – disguised as a wizard and armed with a magic divining rod – is shown looking for buried treasure on church lands, a clear indication of him profiting from the Catholic Emancipation Bill. There was much speculation that his Government was keen to appropriate church treasure and income, as in the days of the Tudors.

Wellington emphatically denied this. He wrote to a colleague in November in clear terms:

> 'I am aware that it has been said by some, believed by others and asserted positively by a third set of people, that Government had a plan in contemplation for a reform of the tithe system in England and Wales. I assure you that this is not the case.'

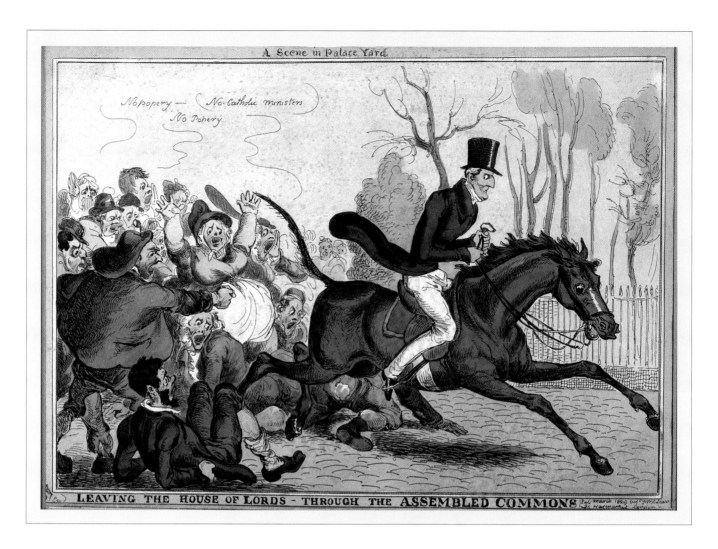

LEAVING THE HOUSE OF LORDS - THROUGH THE ASSEMBLED COMMONS

LEAVING THE HOUSE OF LORDS THROUGH THE ASSEMBLED COMMONS
Paul Pry (William Heath). Published Thos. McLean 1829. BM 15694.

Wellington was prominent in the Parliamentary debates. It was his habit to lead from the front. This caricature shows him going about the business in the teeth of violent popular opposition.

Opposite above: **DOING HOMAGE**
Paul Pry (William Heath). Published Thos. McLean 1829. BM 15660.

Following O'Connell's election to the Imperial Parliament at Westminster, Wellington accepted that Catholic emancipation was inevitable and began what was to be a bitter and protracted battle on its behalf. Owing to high respect for the established church, there was strong religious prejudice in England, and especially against papal influence. These public emotions and convictions combined to bring fierce criticism onto Wellington. Here he is portrayed as a papal lackey, kissing the Pope's foot. Peel awaits his turn to do homage.

Opposite below: **The Faithful Shepherd; or, the Sheep and the Wolves**
Anon. (?) Sharpshooter. Published G. Humphrey 1829. BM 15660.

The battle lines are drawn. The public's opposition to Catholic emancipation is clearly highlighted here. Lord Eldon, a staunch anti-Catholic, and an ultra-Tory, is portrayed as a shepherd, ready to protect the flock against the wolves – Wellington and Peel among them. The devil is shown enjoying the mayhem.

 Sharpshooter also represented Eldon in a coachman's clothes, horsewhip in hand as 'the man wot drives the Opposition', copying William Heath.

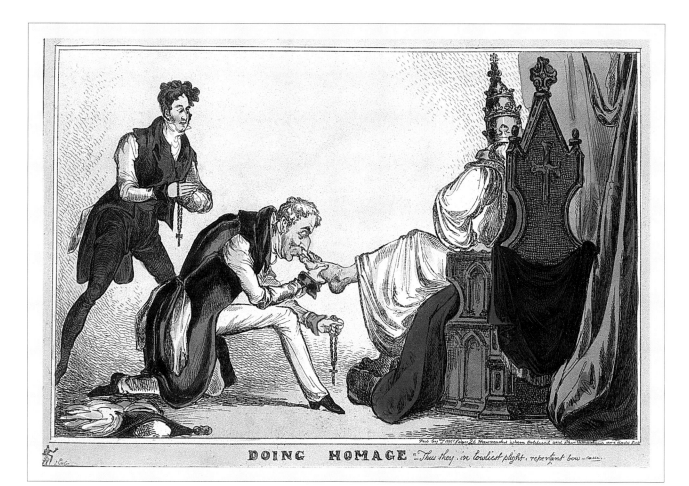

DOING HOMAGE "Thus they, in lowliest plight, repentant bow" _____

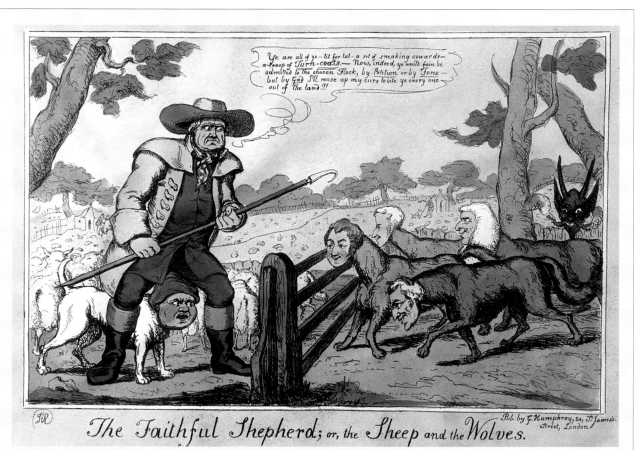

Ye are all of ye—tit for tat—a set of sneaking cowards—
a troop of Turn-coats.— Now, indeed, ye would fain be
admitted to the chosen Flock, by Petition or by Force—
but by Gad I'll rouse up my curs to bite ye every one
out of the land !!!

The Faithful Shepherd; or, the Sheep and the Wolves.

Pub. by G. Humphrey, 24, St. James's
Street, London.

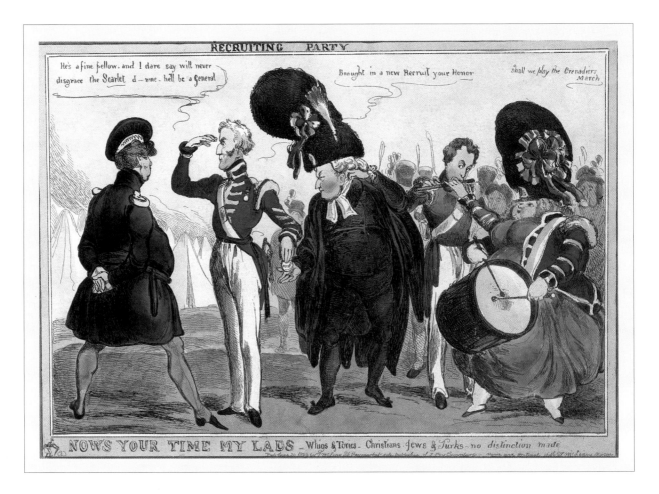

RECRUITING PARTY
NOW'S YOUR TIME MY LADS
Paul Pry (William Heath). Published Thos. McLean 1829. BM 15812.

The Attorney General, Sir Charles Wetherall, was sacked by Wellington after making a violent speech against Catholic emancipation. Wellington and Peel were forced to 'drum up' additional Ministers, including the Whiggish Scarlett.

The Duke is shown as a recruiting sergeant dropping a coin marked 'Attorn' into the hand of James Scarlett 'a new recruit' and saluting George IV. Says the King, 'He's a fine fellow and I daresay will never disgrace the scarlet' (i.e. the army uniform). The King was known to hold strong views about political appointments and to express them with vigour. Lady Conyngham, the King's mistress, dressed in scarlet, energetically bangs the drum. She was reported to have a considerable influence over the King.

Scarlett, born in Jamaica, was a Whig and had been Home Secretary in Canning's Ministry. The legend reads – 'Whigs & Tories, Christians, Jews & Turks. No distinction made'.

Relief Acts were passed by Parliament at the turn of the eighteenth century. In 1778 came the first Catholic Relief Act, easing the restrictions on Catholic priests and education, allowing Catholics to join the army (but not as commissioned officers) and the removal of a disability affecting the purchase of property by Catholics. In 1791 came a second Catholic Relief Act by which all religious disabilities (but not civil disabilities) were removed, Catholic churches could be built and the saying of Mass in Britain was no longer illegal. In 1793 Irish Catholics were enfranchised, though the Irish domestic Parliament, one year earlier, had voted against it. (To an English eye paradoxes are seldom far

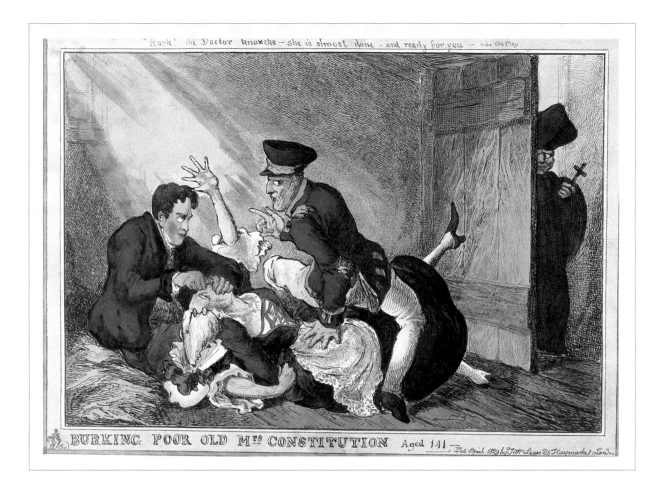

'Hark! the Doctor knoocks — she is almost done — and ready for you — vide Old Play

BURKING POOR OLD Mrs CONSTITUTION Aged 141 — Pub April 1829 by Thos McLean 26 Haymarket London

BURKING POOR OLD Mrs CONSTITUTION Aged 141

Paul Pry (William Heath). Published Thos. McLean 1829. BM 15707.

The furore over the Catholic Relief Bill led to many attacks on the Duke as a potential destroyer of the Constitution. During this period a new word entered the English vocabulary – the verb to 'burke', meaning to strangle or secretly suppress, taken from the favoured methods of notorious 'body-snatchers' Burke and Hare. (Burke and Hare lured travellers to Hare's lodging house, made them drunk, murdered them and sold the bodies of their victims for medical experiments. They killed sixteen before they were arrested). In this example, Wellington and Peel are shown burking poor old Mrs Constitution, aged 141 years (born in the Glorious Revolution of 1688).

from the surface in political Ireland).

Earlier, in 1780, the Gordon riots in England, demonstrating the strength of popular anti-Catholicism, had impressed King George III as to the dangers of legislating further to remove the remaining disabilities. Some 450 people were killed in the riots, a huge number. So Catholics were still barred by law, the so-called Test Act, from sitting in the Imperial Parliament at Westminster.

The prejudice against Catholic emancipation cannot be underestimated. The King's position was particularly difficult. The oath taken by the Sovereign at the solemn ceremony of the Coronation in Westminister Abbey is wholly specific.

During it the Archbishop of Canterbury demands of the Sovereign:

> 'Will you to the utmost of your power maintain in the United Kingdom the Protestant Reformed Religion established by law? Will you maintain and preserve inviolably the settlement of the Church of England, and the doctrine, worship, discipline and government thereof, as by law established in England? And will you preserve unto the Bishops and Clergy of England, and to the Churches there committed to their charge, all such rights and privileges as by law do or shall appertain to them or any of them?'

That is still the position. Hence the title of *Fidei Defensor* – defender of the faith – which at the beginning of the new millennium is still printed on our coins. King George IV, like his father before him, was racked by conscience about the possibility of breaking this solemn undertaking. He was by no means alone in fearing that Catholic emancipation would be the thin end of the wedge hammered home by those who would overturn the historic position of the Church of England in the constitution. The idea of Catholic rule, of subservience to Rome, was greeted with genuine fear throughout the Union. (Similar feelings are no less strong in some parts of the United Kingdom today, notably in Ulster.)

What, one wonders, will the nation require of its Sovereign in a future Coronation ceremony? Will the Coronation oath, in a Britain of many cultures and different religions, remain unaltered?

Relations between the King and his Ministers were often strained over questions of Catholic emancipation. William Pitt the younger had left office in 1801 because King George III would not agree to his proposal to remove the disability which prevented Catholics becoming MPs at Westminster. In 1807 the Grenville Ministry ('the Ministry of All the Talents', or 'the Broad-Bottomed Ministry', a name which was a cartoonist's gift) was expelled from office by the King after Grenville had proposed to open all naval and military ranks to Catholics.

The Irish were never quiet for long. In 1823 Daniel O'Connell formed the Catholic Association in Ireland. It was an irresistible force, with a mass membership. Its object was Catholic emancipation by legal and constitutional means. 'Pro deo, pro rege, pro Hibernium Unanimus' was the slogan of the Gaelic Irish whose aim was to achieve their due rights, but under the Imperial Government.

After immense and protracted thought, Wellington had produced his own emancipation plan in 1825. He had thus been seeking a solution to the problem at the same time that Sir Francis Burdett first introduced a Catholic emancipation

Opposite: **THE MAN WOT'S APPOINTED RAT-CATCHER TO THE KING !**
H. Heath. Published Tregear, 1829. BM 15806.

Even leading Protestant clergy did not escape attack from the caricaturists. Here Wellington, with Peel's support, is shown gathering a 'few fat church leaders', in other words, lobbying Anglican Bishops. The 'rat-catcher' was the equivalent of today's Parliamentary Whip – the man who encourages the back bench MP to vote in support of the Ministry, to toe the party line (as one would now say).

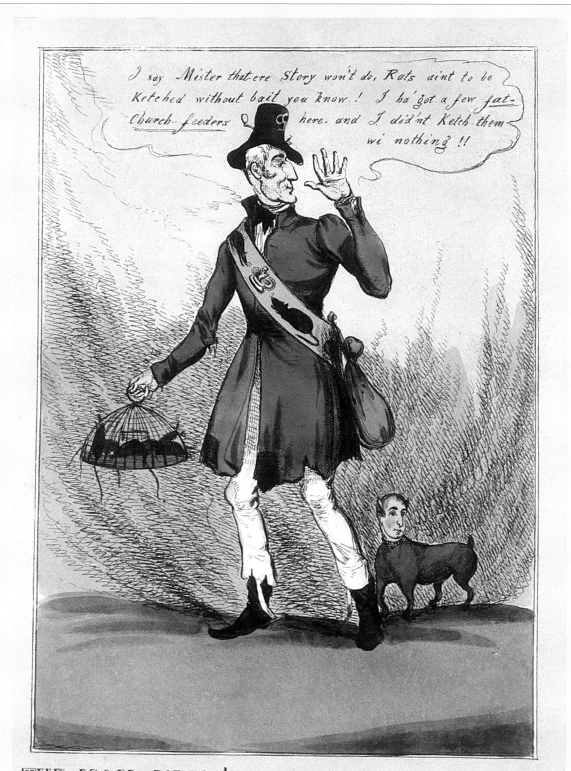

THE MAN WOT's APPOINTED RAT-CATCHER
TO THE KING !

Publd June 16 1829 by T Trigear Cheapside.

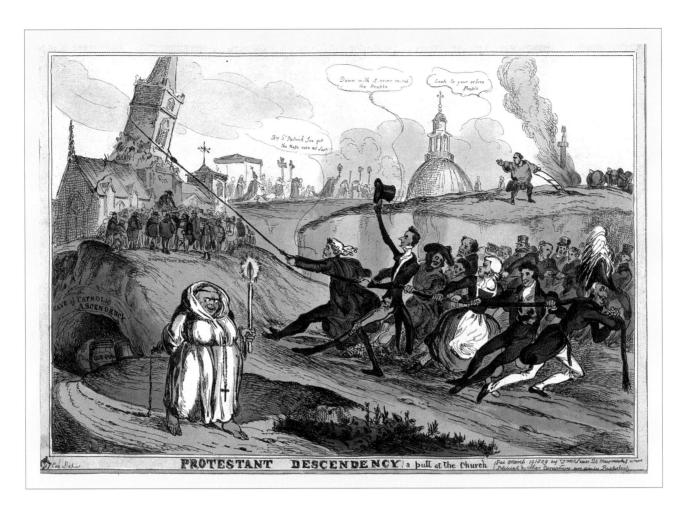

PROTESTANT DESCENDENCY: a pull at the Church
Paul Pry (William Heath). Published Thos. McLean 1829. BM 15701.

The Church in danger was a less usual theme of caricatures than the constitution in danger, though the point is the same. Here Wellington, Peel (with a stained orange waistcoat) Burdett, O'Connell and others are shown pulling down the church. The old church is on a hill labelled 'Protestant Ascendency'. The hill is mined with gunpowder stored in a 'Cave of Catholic Ascendency'. A gloating monk lays a trail of explosive preparatory to detonating it.

Opposite: **THE NURSE, CHILD, AND PLAYTHING**
Sharpshooter. (? J. Phillips) Published Field 1829. BM 15772.

The battle for reform hinged largely on Royal support. Without Royal assent the Bill could not pass. Wellington was believed to have the King in his power, and concern in this regard is made visible here. The Duke is depicted as an old nurse, with King George in one hand and Lady Conyngham (the King's mistress) on the other. The implication is that Wellington, in league with Lady Conyngham, is forcing Catholic emancipation on the King at the expense of the country.

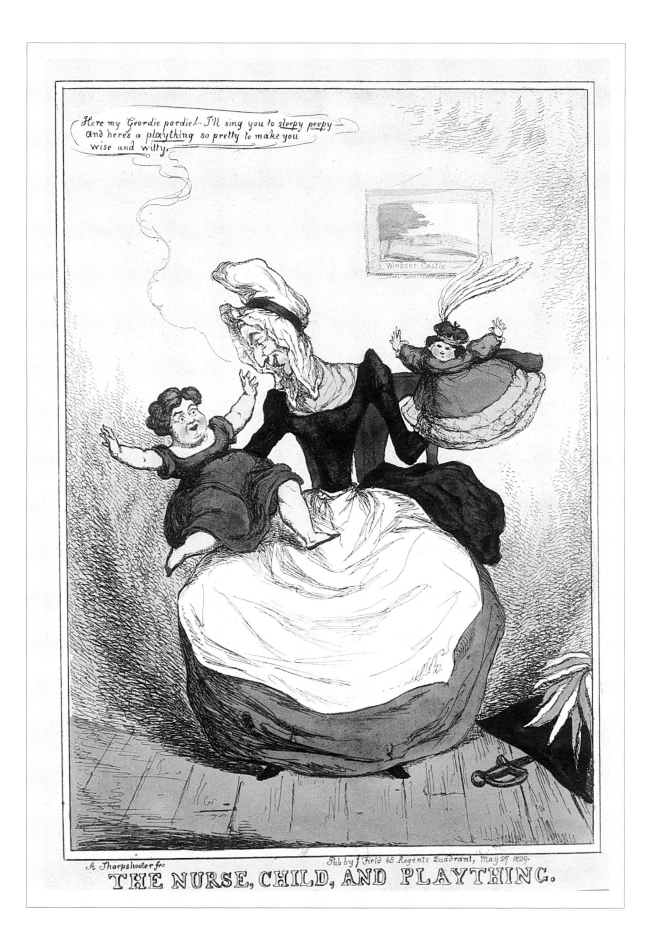

THE NURSE, CHILD, AND PLAYTHING.

Bill into the House of Commons to remove the ban on Catholics sitting as MPs. Though Burdett's Bill passed its third reading (its final stage of debate) by a small majority of twenty-one votes in the Commons, the Lords rejected it resoundingly on a second reading (when the principle of the Bill was debated) by forty-eight votes, so it failed to become an Act.

The strength of feeling against Catholic emancipation among members of the all powerful British establishment was strong, and it was sincere. The Duke of York, then the heir to the throne, had made a fierce speech in the Lords stoutly maintaining support for the Coronation Oath, that is to say the supremacy of the established Protestant church. (Within two years York was to die and thus it was that the Duke of Clarence would become King William IV in due course).

It was a subject which would not disappear and it remained high on the nation's political agenda. In May 1828 Burdett's Bill was again debated in the Commons. It passed again but this time by a narrower majority of six votes.

Both Wellington and Peel believed that change was inevitable but neither would admit it publicly. Peel, who had also been Chief Secretary for Ireland for six years, was fearful that emancipation would in the end mean the separation of Ireland from the Union and he had threatened Wellington with his resignation. However, he gave the Prime Minister excellent advice – to leave the door open to progress. So Wellington had opposed Burdett's second Bill in the Lords but his speech was moderate. He was not antagonistic towards Catholics; he stressed the constitutional problems; he pleaded for patience and in effect suggested that with goodwill 'something' might be done. The Lords followed Wellington's lead and Burdett's Bill failed a second reading in that House. So the cause was lost a second time – but the door was ajar.

Perhaps both Wellington and Peel hoped that the Irish volcano would remain dormant. The hope was sanguine. As the caricatures show, Irish electors expressed their uncompromising view clearly at the polls. There was a vast popular support in Ireland for the Catholic Association led by Daniel O'Connell.

Matters came to a head in an unexpected way. Four members of Wellington's Cabinet had resigned over a minor matter involving some (comparatively small) electoral reform promoted by the Ministry. One of those resigning was the President of the Board of Trade. Wellington appointed Vesey Fitzgerald, the MP for Clare, in his stead. In those days a new ministerial appointment involved a by-election. On paper Fitzgerald was a strong candidate for election, a Protestant but also a supporter of Catholic emancipation. Daniel O'Connell was his opponent. The law forbade a Catholic to sit in Parliament but not to stand as a candidate. On

THE MAN WOT CAN CHANGE THE SOVEREIGN
Sharpshooter. (? J. Phillips) Published G. Humphrey 1829. BM 15758.

Wellington's achievement is sarcastically represented here, where he is seen giving the Pope a sovereign, i.e., a gold coin of the time, carrying King George IV's head. In other words the suggestion was that the Prime Minster had delivered the King into the Pope's hands – similar to the many public complaints at the end of the twentieth century following the subordination of the authority of the British Parliament to the European union.

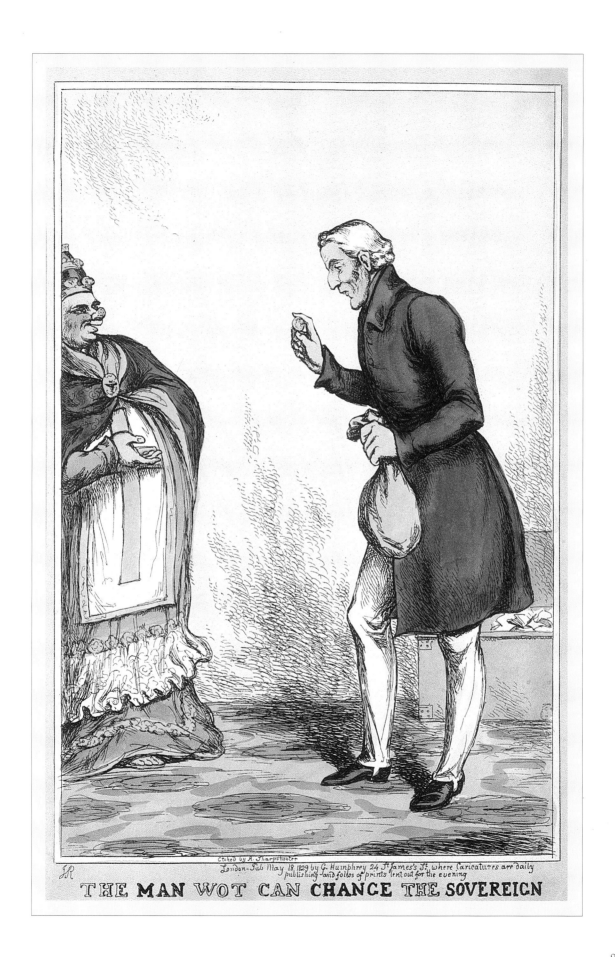

Etched by A. Sharpshooter
London-Pub May 18, 1829 by G. Humphrey 24 St James's St where Caricatures are daily
publishing and folios of prints lent out for the evening

THE MAN WOT CAN CHANGE THE SOVEREIGN

5 July, 1828 O'Connell triumphed at the polls and Fitzgerald was heavily defeated.

So O'Connell was elected, but he could not take his seat. Now the prospect, at best, was for the election to the Westminster Parliament by the Irish electorate of a majority of Irish Catholic MPs who would also, under existing law, not be able to take their seats. Thus the Irish electorate would be largely disenfranchised. Serious popular unrest was bound to follow. At worst, open rebellion and civil war in Ireland was the possibility.

It was this event above all that convinced the Duke, and also Peel, that the nettle must be grasped. There must be legislation to remove the disability.

Negotiations with the King were difficult and apparently interminable. The King was under great pressure from many influential figures to maintain the *status quo*.

Problems abounded.

Peel had been elected MP for Oxford on an anti-emancipation ticket. (The caricaturists often showed him covered in 'orange peel'.) Having changed his opinion he thought it right to seek re-election at a by-election. That was an honourable move but a catastrophic one. He was heavily defeated and much abused. Happily, he immediately found another seat, the pocket borough of Westbury, having obtained the resignation of Sir Manasseh Lopez, the previous incumbent, for an undisclosed sum. When the Ministry eventually decided to support Catholic emancipation it was Peel who introduced the Catholic Emancipation Bill in the House of Commons.

In March 1829 King George IV asked the ultra-Tory Lord Eldon to form a Government to prevent the passage of a Catholic Emancipation Bill. Eldon (Old

Opposite above: **A SLAP UP TURN OUT!!!**
H.Heath. Published Tregear 1829. BM 15764.

George IV drives his cab, drawn by a horse with the head of Lady Conyngham, the King's mistress. Wellington sits beside him with Peel as groom behind. Again, it looks as if Lady Conyngham is in league with the Duke and Peel. The print appears to signify the King's wish to be independent of the Duke.

An additional insinuation relates to the King's relationship with Lady Conyngham as 'cab', also slang for brothel.

Opposite below: **FINIS**
Paul Pry (William Heath). Published Thos. McLean 1829. BM 15730.

Wellington's persistence – coupled with a powerful speech in the Lords, in which he raised the spectre of civil war in Ireland if the Bill did not pass – carried the day and the Act was finally passed in April 1829. The Duke of Sussex – the sixth son of King George III – paid him a remarkable compliment by claiming that Wellington's achievement in passing the Bill was greater than any of his military victories.

This caricature represents the moment of victory. The King (partially concealed) is shown giving Royal Assent to the Bill, while the fireplace is filled with petitions against emancipation. Robert Peel is kneeling and the Duke is seen blocking out the portrait head of King George III, who had believed that Catholic emancipation would mean the ruin of the Church of England. Lord Lyndhurst, the Lord Chancellor, obscures the Coronation Oath with his mace.

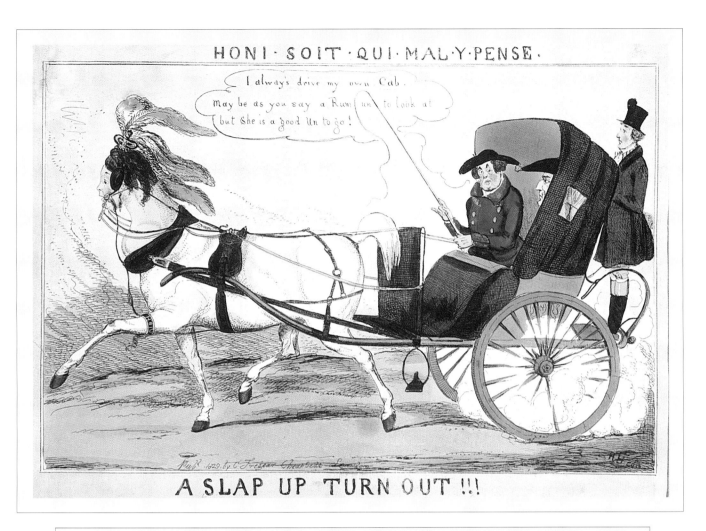

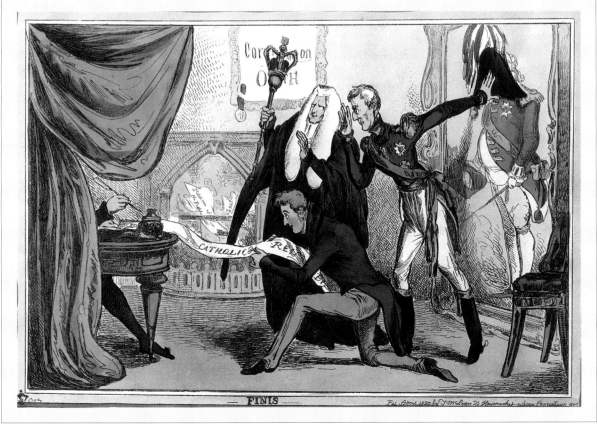

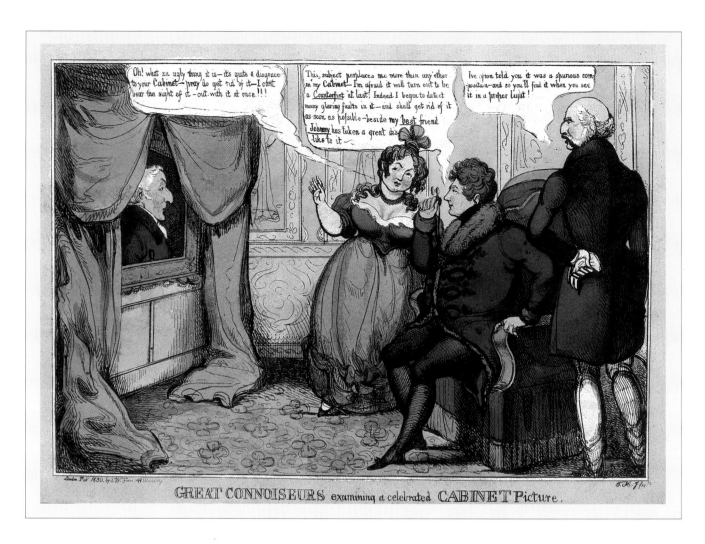

GREAT CONNOISEURS examining a celebrated CABINET Picture
T.H. (Jones). Published S.W. Fores 1830. BM 16048.

Following the Royal assent and the passing of the Catholic Emancipation Bill into law, Wellington's unpopularity grew. This caricature shows the King, Lady Conyngham and Wellington's arch-enemy, the King's brother, the Duke of Cumberland, clearly expressing their desire to get rid of him. Cumberland was set on driving Wellington from office by bringing his influence to bear on his brother, the King. Johnny is John Bull, the King's best friend, representing the opinion of the British public.

Bags, as the King called him) deliberated for some time before refusing the invitation.

It was at this time that Wellington fought a duel with pistols against an ultra-Tory, the Ninth Earl of Winchilsea. Winchilsea had publicly attacked the Duke in ferocious terms. Charles Greville wrote in his memoirs, 'Lord W. is such a maniac, and has so lost his head… that everybody imagined the Duke would treat what he said in silent contempt'. The Duke demanded an apology. It was an extraordinary action for a Prime Minister, but it had the effect of rallying moderate opinion in his favour.

Wellington and Peel succeeded in spite of everything: legislation was eventually passed and the disabilities removed. In the debates Wellington led from the front.

His recorded words in the second reading debate in the Lords were memorable:

> 'I… have passed a longer period of my life engaged in war than most men and… if I could avoid, by any sacrifice whatever even one month of civil war in the country to which I am attached, I would sacrifice my life in order to do it.'

The caricatures of the day show clearly the strong public feeling in England against emancipation. The Duke is caricatured more often on this subject than on any other. They thus underline the magnitude of Wellington's achievement in securing the passage of the Bill. The attacks on him were vitriolic: he was accused of being a papal lackey, of dismantling the constitution, of having the King in his pocket and even of being in league with the devil. Resentment lingered. In the end, the statesman-like action of Wellington and Peel would lead to the destruction of their Ministry as they lost the support of too many Tories.

There is a postscript, not without contemporary relevance. The Act of Settlement of 1701 is still in force and under it the Monarch must not be a Roman Catholic or marry one.

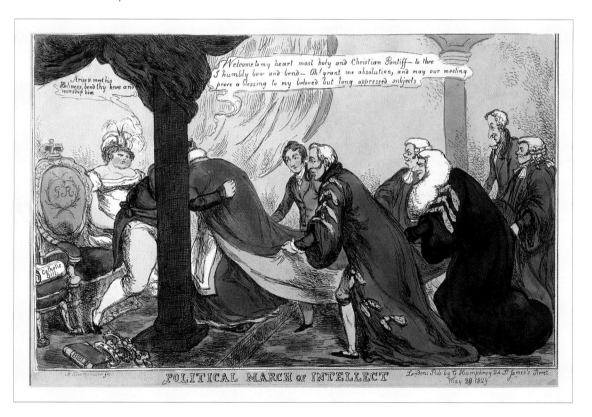

POLITICAL MARCH OF INTELLECT
Sharpshooter. (? J. Phillips) Published G. Humphrey 1829. BM 15775.

A twist to the story. The King rises from his chair to embrace the Pope, Lady Conyngham behind. The Protestant constitution is abandoned. The papal robes are held among others by Peel, the Duke, O'Connell and a Jew.

The passage of the Catholic Relief Bill raised high hopes of emancipation for the Jews. A Bill on their behalf was presented in April 1829 but it did not pass until thirty years later.

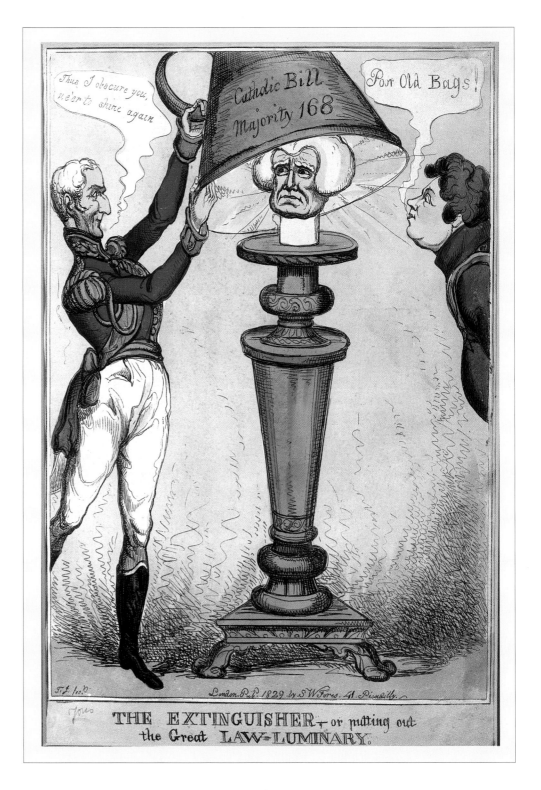

THE EXTINGUISHER – or putting out the Great LAW-LUMINARY
T.J(ones). Published S.W. Fores 1829. BM 15718.

The Duke in the role of a candle extinguisher is 'putting out the Great LAW-LUMINARY' Lord Eldon, the ultra-Tory and arch opponent of the Emancipation Bill.

'Poor old Bags' says George IV ('Bags' was the King's name for Eldon, his father having been a coal merchant).

The caricature shows the majority for the Bill as 168. To be precise, the majority for its first reading in the Commons was 188. It gained its second reading with a majority of 180 and its third reading by 178. In the Lords, majorities of 105 and 104 were also substantial margins. For all the scorn and fury of the caricaturists, Wellington and Peel had their way.

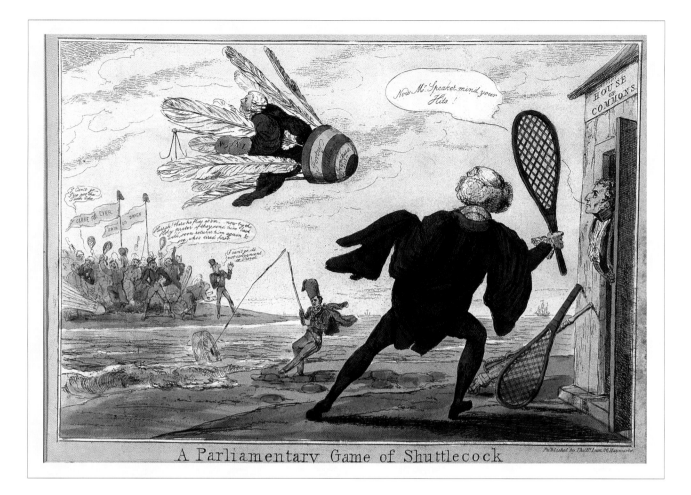

A Parliamentary Game of Shuttlecock
(?) Seymour. Published Thos. McLean 1829. BM 15761.

The Speaker of the House of Commons is shown getting ready to bat Daniel O'Connell back across the Irish sea, watched by Wellington. Lord Anglesey (Lord Lieutenant of Ireland, recently reinstated after a disagreement with the Duke) is shown hooking a large 'conciliation millstone'.

The legislation to remove the disability, when it was passed, was not retrospective. Therefore, even after its passage, O'Connell was still barred from taking his seat as MP for Clare in the Westminster Parliament. When O'Connell arrived at Westminster in May 1829, Mr Speaker Sutton ordered him to withdraw, refusing to hear him. For political ends O'Connell made the most of his apparent discomfiture, returned to Clare and resubmitted himself for election. Needless to say, he was triumphantly received by the electors and re-elected unopposed in August 1829, eligible now to take his seat in the Westminster Parliament. Seemingly, he was in no hurry to make his mark. He waited until February 1830 to make his maiden speech.

On 12th February 1829 the Catholic Association had voted for its own dissolution – twelve days before a Bill to suppress it passed both Houses of Parliament, unopposed and without a vote.

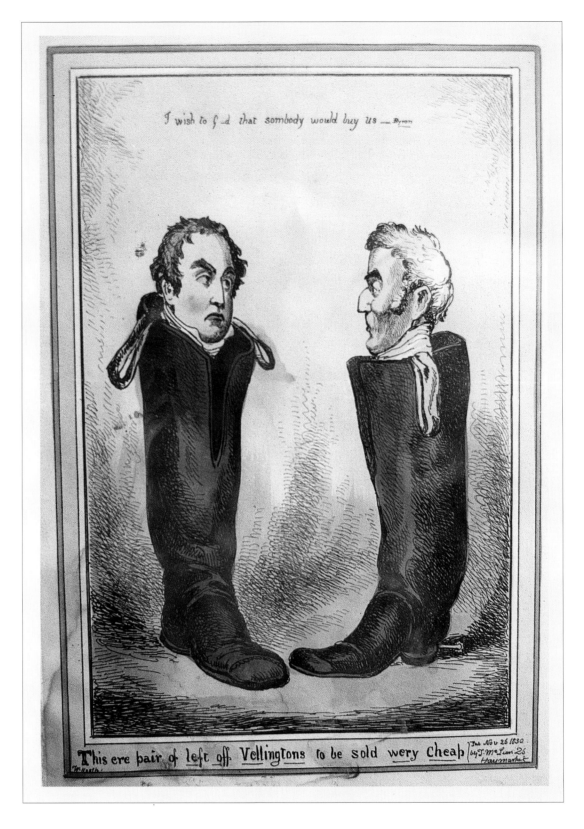

This ere pair of <u>left off Vellingtons</u> to be sold <u>wery Cheap</u>
William Heath. Published Thos. McLean 1830. BM 16345.

When they lost office, Wellington and Peel were yesterday's goods, 'I wish to G-d that somebody would buy us'. In office and out of it they are depicted together.

William Heath borrowed this idea from Gillray's earlier caricature of 'a Pair of Polished Gentlemen' – a rare example of Heath, a much copied caricaturist, plagiarising the work of another artist.

— SIX —

REFORM, RESISTANCE
AND RESIGNATION

The emotion-charged matter of Catholic emancipation having been settled, the need for electoral reform (by which was meant the broadening of the electoral base, thus making the membership of the House of Commons more representative of the population) was the issue that now dominated domestic politics.

The House of Commons was patently unrepresentative of a rapidly changing demographic scene. There were 658 MPs – almost exactly the same number as make up today's House. There the coincidence ends. Unlike today, most adult people in Britain then had no vote. Of the 202 English boroughs returning 403 MPs in 1830, fifty-six had an electorate of 50 or fewer, twenty-one had an electorate of between 51 and 100, thirty-six had an electorate of between 101 and 300 and only seven had an electorate of over 5,000. (In 1999 most Parliamentary constituencies in Britain have between 60,000 and 70,000 electors). Great towns, with their burgeoning power as manufacturing centres, were either not represented by even a single MP or were under-represented; for example, a mere thirty-three voters elected one Member of Parliament for the great city of Edinburgh. Small electorates enabled patrons to use influence or money in securing the election of a Member – and this they did. It was estimated that almost half the seats in Parliament in 1830 were in the hands of landed patrons, some 200 controlled by the Tory aristocracy and over 70 by the Whig equivalent.

With every year that passed the British electoral system became more obviously absurd. Paradoxes abounded in parliamentary representation. Cornwall, a comparatively small rural county, elected over forty MPs (today, with a vastly larger population, it has five) while populous industrial Lancashire had only a dozen. Manchester was unrepresented. So was Birmingham. So was Leeds. These three cities had a combined population of almost half a million and not an MP between them.

The history of Parliamentary reform in the long years before Wellington became Prime Minister is a story of inaction by the majority of Parliamentarians in the face of an obvious need which had long been recognised.

As long ago as 1647 the Levellers, a radical faction of artisans and apprentices in Cromwell's new Model Army, had sought universal suffrage for 'free born Englishmen' (the Levellers were so radical a group that they even mutinied on one occasion). After John Wilkes was expelled from Parliament in 1769, the

Society for the Defence of the Bill of Rights aimed not only to raise sufficient finance to pay off his debts and seek his re-election, but to work for shorter Parliaments, a wider franchise and the abolition of aristocratic 'pocket' boroughs. In the 1780s, William Pitt the younger attempted to extend the franchise. In 1797, Grey, whose Reform Bill was eventually passed in 1832, lost his proposal for triennial Parliaments, a uniform household franchise for boroughs and the substitution of more county members for corrupt borough nominees by the huge margin of 256 to ninety-one. He had other defeats, in 1793 and 1800. Various other potential reformers made their attempts: Curwen in 1809 and Brand in 1810. The most colourful of them was perhaps Sir Francis Burdett, who was jailed several times for his radical views. He defeated his Whig and Tory opponents and was elected the Independent MP for Westminster in 1807. His attempts at electoral reform failed in 1809, and again in 1817, 1818 and 1819.

So, the dozen or more serious attempts that were made in the first quarter of the nineteenth century to achieve some substantial degree of electoral reform had all failed ingloriously. Yet, paradoxically, the century had begun with the British Parliament in the van of some other important aspects of social reform. For example, Britain abolished slavery in 1807, half a century before the United States – and that country had first to endure a bloody civil war.

Some minor electoral reforms had been introduced over the years. The practice whereby revenue offices controlled the voting in some boroughs had been ended. Government contractors had been disqualified from membership of the House of Commons, thus ending the practice of votes in Parliament being traded for contracts.

The further efforts at major reform in the early 1800s failed not only because of vested interests, but also because of the genuine distrust of many who felt that reform was the equivalent of revolution and violence. The fearful excesses of the French Revolution caused widespread and understandable alarm among propertied people in Britain and a shock wave among men and women of all classes. There were also serious disturbances in England at Peterloo in Manchester, and some that were not so serious, at Stockport and Macclesfield, for example, but which nonetheless provoked anxiety. In consequence, progress with electoral reform was only hesitant. On the other hand it was widely and sincerely believed among the poorer sections of society that Parliamentary reform would be a certain remedy for the widespread economic and social distress that existed in Britain at that time. Inevitably, the mass of the population grew increasingly impatient at Parliamentary inaction.

Outside Parliament the cause of electoral reform in Britain had powerful and persistent advocates: Tom Paine, William Cobbett, Henry 'Orator' Hunt, Horne Tooke and William Hone, among others.

Events abroad helped also to create a climate of opinion that change was inevitable. The New World countries, Chile, Peru, Mexico, Uruguay and Brazil, were declaring their independence from Spain and Portugal, their colonial masters. The poet Byron was a passionate supporter of Greece's struggle to shake off the Turkish rule of almost four centuries. Catholic Belgium was seceding from the thrall of Protestant Holland.

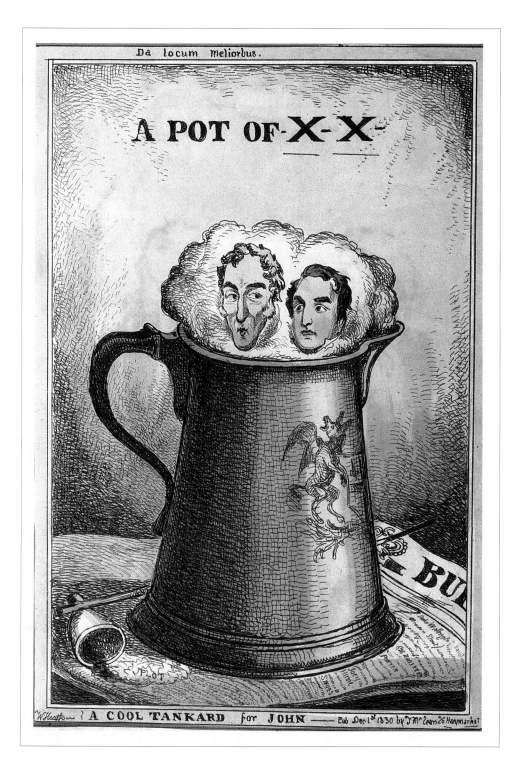

A POT OF X-X-

W. Heath. Thos. McLean Published 1830. BM 16383.

X is the sign of the cheat; the double X the double-cross. Wellington and Peel are shown as in it up to their necks.

Wellington's assassination and rebellion were threatened in the City of London on Lord Mayor's day. The visit by the King and his Ministers was therefore cancelled on the Duke's advice. This led to a rash of caricatures, some accusing him of cowardice.

As ever, Government had a hard road to hoe. Had the threatened rioting and murders of Ministers taken place, the Ministry would have received much blame and probably that would have been deserved for they had been clearly warned of the very real danger they faced. The peace having been kept, and desperate trouble avoided, the Ministry is criticised for its temerity.

Educated opinion in Britain was well informed about developments in continental Europe. Sundry caricatures were published in London in this period which related to various events abroad, including the persecution of the Spanish people by the authorities under Ferdinand VII after the Peninsular War, and the (still) unsettled political situation in France. Had there been no popular interest, the caricatures would not have found purchasers. These disturbances in Europe also added to the general nervousness felt by responsible people in Britain. Understandably, they feared to see the turmoil that was reported to occur in so many countries in the continent of Europe recurring in their own country.

In a contemporary speech in the House of Lords, the Duke said:

> ' …the state of the public feeling and opinion in London as well as in the north of England and elsewhere in the country have been influenced by the state of affairs in France, in Belgium and in other parts of Europe.'

One example will suffice to make the point how aware British people were of events in Europe. Athens had been under the suzerainty of Turkey since the middle of the fifteenth century. In October 1827, Admiral Codrington and the allies sank more than fifty Turkish and Egyptian warships in Navarino Bay thereby saving the Greeks from further attack (Greece was already being attacked on land by Egypt). It was a tremendous victory. Unlike Nelson at Trafalgar, Codrington survived this crucial battle, though he had 'four bullets in his hat and clothing and a fifth in his watch'. If that was so, he was indeed lucky to live through such a day. Parliament voted its thanks to Codrington. Even so the news of his brilliant victory was received with mixed feelings in England: there was sympathy with Greece, and impatience with Turkish domination, but fear that the Turkish defeat might encourage Russian ambitions. The King's speech in January of 1828 described the battle as an 'untoward event'. It also deeply lamented the 'conflict… with the naval force of an ancient ally'. He had given Codrington the Order of the Bath but he thought better of it later when he said that the Admiral better deserved the rope than the ribbon.

In Britain, criticism could justifiably be made of the unrepresentative nature of the Commons or of the Lords, and it was. Some critics went on to argue that so long as Parliament was unreformed then other necessary improvements – such as reform of the municipal corporations – or any other of the great domestic institutions such as the Church, the Universities or the Courts – would be delayed in turn: it followed that this made the need for electoral reform all the more urgent. Then it was argued that the system of widespread jobbery or patronage (on which politics in the United States and some other countries still depends and of which there are continuing examples in the United Kingdom) was discreditable. All these views were incontrovertible. And yet – Wellington and many others could reasonably defend the system of control that Britain's unwritten constitution guaranteed, for in spite of its manifest defects and imperfections, remarkably, the Parliamentary system in Britain was universally

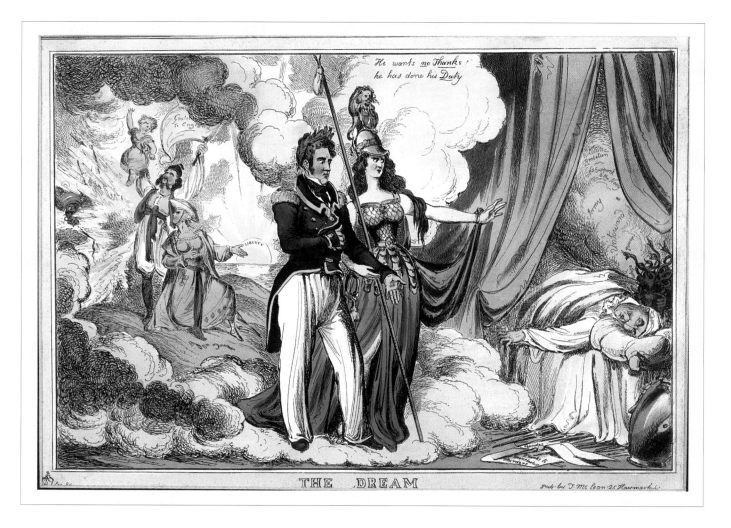

THE DREAM
Paul Pry (W. Heath). Published T. McLean 1828. BM 15514.

Admiral Codrington and Britannia stare at the sleeping Duke whose ambitious dreams are influenced by his demoniac *alter ego*. A Greek family in the background give heartfelt thanks to England, as well they might. Greece (which had yet to exist in its modern form) would be free again after almost 400 years.

A confusing print: on the one hand it celebrates the imminent liberation of Greece from Turkish rule; on the other hand it criticises the Duke unfairly for his supposed militarism.

Truth to tell, Wellington was horrified at the potential repercussions of the crushing naval victory at Navarino. Turkey was weakened by the sinking of her fleet. That opened up the possibility of further intervention by Russia. His fears were justified as within six months Russia and Turkey were at war.

regarded as providing the most stable Government in the world, and with reason. In a sentence – the Parliamentary system might have had its defects, but it worked (exactly the same argument that the opponents of the reform of the House of Lords advanced in 1999 – but as in the 1830s it did not carry the day).

Public opinion was for change, and it grew increasingly restive.

Certainly Parliament could hardly be unaware of the public mood at any time, or on any subject. Post Waterloo there were more than 250 newspapers in Britain. In 1830 the press was well informed and able to be independent of Government subsidy. *The Times* newspaper sold around 11,000 copies daily.

Moreover, there were in addition those other opinion formers, the pamphleteers. One of Hone's pamphlets sold the huge number of 100,000 copies. Cobbett brought out a cheap edition of his *Weekly Political Register* – more a newspaper, perhaps, than a pamphlet – in 1816 at two (old) pence a copy. Of course, it was vulgarly known as the 'Tuppenny Trash', but it was read by thousands. The most influential pamphleteers were unanimous for electoral reform.

All shades of political opinion, too, found expression. *The Edinburgh Review and Critical Journal*, which published articles by Sidney Smith and Brougham, among others, in 1815 had a circulation of 15,000 in the Whig interest. The Tories published the *Quarterly Review*. The radicals published the *Westminster Review*, whose happy theme was a plague on the houses of both their political opponents (the traditional third Party stance). There was thus a huge variety of published political, economic, social and constitutional comment.

And this was a golden age of caricatures. Our nation was rich in the talent which accomplished their production, and the popular interest in politics was intense and almost universal. Had it not been so, the caricaturists would never have sold their production. The caricaturists caught the popular mood and they too argued for reform.

So – the cause of reform became unstoppable. The developing industrial revolution lent a strong impetus to a belief in the minds of thinking people and masses alike that it was an era of change. Huge public meetings were held in favour of electoral reform. Sometimes, agitation took an ugly turn. Wellington was threatened with violence and his house was twice stoned. It was even forecast that he would be assassinated on Lord Mayor's Day in 1830. In consequence, the traditional ceremonies, including a state visit of the King and Queen to the City of London, were cancelled. The threat was a credible one. The previous evening a radical meeting at Blackfriars had been attended by 2,000 people with an overflow of 34,000. Six hundred rioters rode to Downing Street. Happily, the excesses of Peterloo in Manchester were not repeated in London. The caricaturists accused the Duke of cowardice. Lord Wellesley, Wellington's brother, speaking about the letter sent to the Lord Mayor putting off the banquet, said it was 'the boldest act of cowardice he had ever heard of' to deprive the King's subjects of the opportunity to see their 'Sovereign'. That seemed to be something of a backhanded compliment.

A decision by Parliament in favour of major electoral reform had been long denied. A crisis point was bound to come and it did; but in an unexpected way.

Although Wellington had a Parliamentary majority after the General Election of July/August 1830, his position was less strong than it appeared on paper. Party disciplines as we know them today hardly existed. Wise heads realised he could not invariably count on the support of all the county MPs. A number of deals had been suggested – the inclusion of some Whigs in the Ministry, perhaps the adoption by the Duke of a minor measure of reform. None was proceeded with – Wellington was not, by nature, a man for compromise.

His speech, winding up for the Government in the debate on the address in the House of Lords on 2 November, 1830, was an unquestioned political disaster.

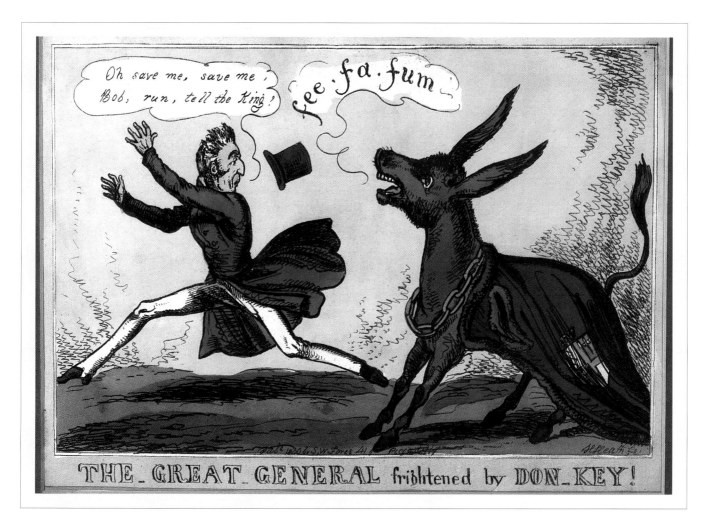

THE – GREAT – GENERAL, frightened by DON – KEY!
H. Heath. Published S.W.Fores 1830. BM 16305.

John Key was the Lord Mayor elect. 'Call the King!' says the Duke, as he runs away.

Wellington and Peel were also represented as 'Terror-Stricken, Horror-Smitten Ministers'. In fact, the King had recommended that the visit to the City be cancelled before he received the Duke's advice. The criticism was cruel: whatever Wellington's other qualities, he was no coward.

In that speech the Duke set out his uncompromising attitude to electoral reform. He was, he said, wholly opposed to constitutional change. It was the speech of an honest man expressing an honest opinion, honourably held, deriving from reasons which he believed to be valid and incontrovertible. He and his supporters believed that the broadening of the franchise would put MPs in thrall to the electorate and their independence would be lost. (Who, as politics have developed, can honestly say he did not have a point?)

The Duke's view was sincere. He believed, too, that electoral reform would inevitably result in the destruction of our country's institutions: it would be only one of a series of constitutional changes affecting the Monarchy, the Church, the House of Lords, the union of Ireland and the Empire, 'a bloodless revolution'. (Now, at the end of this millennium, the Empire and Irish union have gone while

The MINISTRY FLOOR'D; or, Majority 29!!!
Sharpshooter. (? J. Phillips) Published J. Fairburn 1830. BM 16333.

Britannia, with her Medusa shield, advances menacingly towards the defeated Tories, Lyndhurst, Wellington, Peel, Scarlett and five others.

the Church, Monarchy and the House of Lords are seemingly powerless. The reasons for these happenings are more complex and many are different from those the Duke could have imagined in 1830. Nonetheless his prophesy was accurate and the process of change, sometimes for the better and sometimes not, remains unfinished, a century and three quarters later).

His speech was a speech that a politician with a different background would never have made. In the circumstances of the moment Wellington had no need to make it. Remarkably, it was delivered, apparently, without any previous reference to his colleagues.

The Duke's forthright and uncompromising statement about electoral reform caused head shaking even among his friends and supporters – though that was only one of the subjects he had covered. Almost seven-eighths of his speech had related to Irish and foreign affairs. Only then did he turn to the subject or reform. Various other speakers had already referred to the economic distress under which people were suffering. The Duke castigated those who were involved in rioting or disorderly conduct at home, but as far as the constitution was concerned, his

THE NEW STATE LIGHT
Artist unknown. Published Hodgson (undated, c.1830). BM unlisted.

Grey, having founded his Government with a programme of peace, retrenchment and reform, is shown as a brilliant light, apparently blinding the Duke who attempts to blow out the flame. Policeman Peel misdirects his puff, whilst fanning the flame with his bellows. 'Church' and 'State' on the right are shown to be equally ineffective. Criticism of Grey's nepotism would soon surface: in politics popularity is usually transitory.

attitude was wholly compatible with that of Voltaire's philosopher Dr Pangloss, Candide's adviser. He spoke of the perfections of the present electoral system, not of its imperfections. Everything was for the best, he argued. 'I am not… prepared to bring forward any measure of reform', he added. Furthermore, as if that were not enough, he declared that it would always be his duty to resist any such measures if they were brought forward by others.

The debate in which Wellington had declared his unequivocal opposition to major electoral reform had been wound up for the Opposition by Earl Grey (who spoke before the Duke). In his speech Grey was complimentary about the Duke. Grey spoke of reform as a remedy for distress, but only at the end of his speech. His moderation was in contrast to that of other speakers in the country and the House of Commons, who were calling repeatedly and loudly for specific and

A REGULAR TURN OUT: or, Cleansing the Augean Stable.
Sharpshooter (?J. Phillips). Published Fairburn 1830. BM 16340.

'I'm determined to have a clean house…', says John Bull. The caricature's message is plain.

substantial constitutional changes such as universal suffrage, regular ballots and the like. To be fair to him, at heart Grey was strong for reform. He had held a consistent view and been active in seeking reform, but his speech was anodyne. If he believed that the abolition of a large number of the rotten boroughs and a redistribution of Parliamentary seats was essential to protect Parliamentary Government in Britain, if not to save it, he did not say so in those terms. If these were his fine ideals it seemed that he also believed that the time was not yet ripe for them to be translated into immediate action. Yes, but not yet, appeared to be his opinion – a precedent being followed by today's British politicians when addressing the question whether Britain should join the single European currency.

The Duke's inflexible opposition to reform was such a provocation that those in favour of electoral change redoubled their efforts. Yet, it now seems surprising that his critics then were surprised at what he said. It was not as if the Duke had changed his attitude or his opinions. He had been constant in his view, in Parliament and outside it.

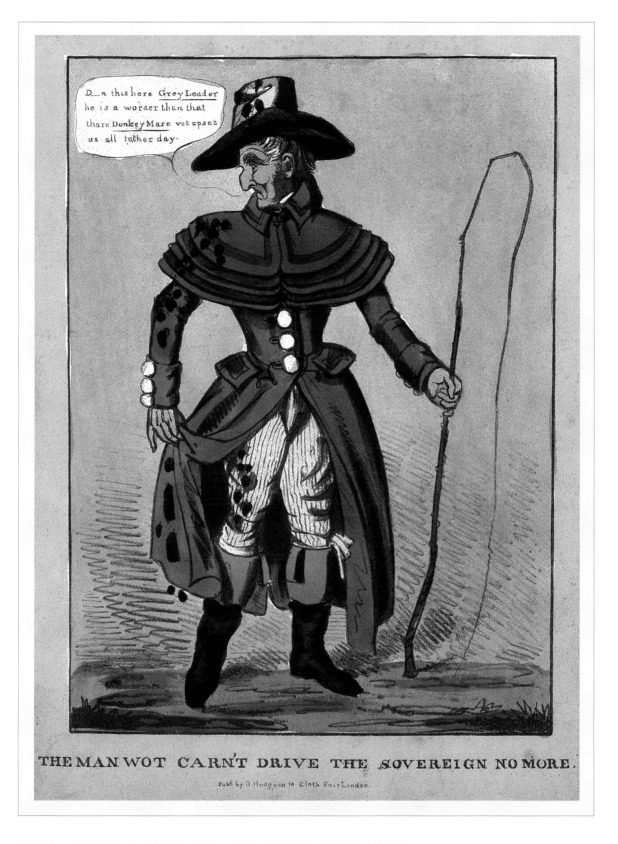

THE MAN WOT CARN'T DRIVE THE SOVEREIGN NO MORE
Anon. Published Hodgson (undated). BM unlisted.

The Duke, represented again as a coachman, with soiled clothes and crooked whip, is drawn
by an anonymous plagiarist. The caricature makes the simple point – the Duke is out of office
and he will not be driving the King anymore.

 That Grey Leader, he says, is 'worser than that there Donkey-Mare vot upset us all tother day.'

Thus Wellington sowed the seeds of his downfall. Already there were many among his conservative friends, his natural supporters, who sought revenge for his espousal of the process of Catholic emancipation. The Duke now had additional enemies, the advocates of electoral reform who would not forgive him his outright opposition to their cause. Ironically, it is possible that one of the effects of his speech was to accelerate the progress of the march towards reform. Attitudes crystallised.

Nemesis was not long in arriving, one day less than two weeks.

On 15 November, 1830 the Ministry (i.e., the Government) was defeated in the Commons by 233 votes to 204 on an unimportant motion for submitting the Civil List accounts to a Committee of the House. The motion was moved by Parnell (an Irish MP – there is little gratitude in politics) and seconded by Knatchbull, an ultra-Tory (and you cannot always count on those who are supposed to be your friends – ask any of the ten Prime Ministers I have known in my own political experience – from Churchill to Major!). Then it was backed by other ultra-Tories who must have been fully aware of the likely damaging consequences of their actions (politicians, like elephants, never forget a grievance).

The Government's defeat on this minor matter, by twenty-nine votes, was a watershed.

Brougham's Reform Bill was scheduled for debate in Parliament the next day. Brougham was certain not to withdraw. A vote was sure to follow. The confident prediction was that the Government would not get its majority and the advocates of reform would win the vote.

After the Commons defeat on this minor matter, Peel, Goulburn and Arbuthnot went to meet the Duke of Wellington that night at Apsley House. The Duke had excused himself from a dinner he was hosting, attended by the Prince of Orange, to join his colleagues. They decided upon a tactical withdrawal, conceding that it was better to resign over the Civil List defeat than to be beaten and then forced to resign over the emotive issue of Reform when that was debated on the morrow. (It has to be said that the Cabinet by this time was hardly a happy group: to some of its members it was a relief to give up office – it was ever thus).

So, Wellington's Ministry ended: not with a bang but quietly. Grey, the Whig, succeeded Wellington, the Tory, at the end of 1830.

The prospect of defeat was to be denied by the Duke in a subsequent account of events given by him in a speech in the Lords; one may perhaps be allowed some scepticism. The fall of his Ministry was remarked in a great number of caricatures.

Opposite: **RUBBISH may be Shot here**
Artist unknown. Published Hodgson 1830. BM unlisted.

Following Wellington's resignation as Premier, the King and Grey (the new PM) observe Wellington with the rubbish, the caption linking him with Humpty Dumpty.

> 'Arthur Dukey sat on a wall
> Arthur Dukey had a great fall
> All his fine cunning and all his friends power
> Could not keep Arthur Dukey in place for an Hour'

RUBBISH may be Shot here

PLACE W R

PLACE W R

PLACE W R

London Pub.d by O Hodgson 10 Cloth Fair

Arthur Dukey sat on a wall
Arthur Dukey had a great fall
All his fine cunning and all his friends power
Could not keep Arthur Dukey in place for an Hour.

— SEVEN —

ELECTORAL REFORM AT LAST

Grey, the new Prime Minister, Wellington's successor, was committed to a measure of electoral reform – though paradoxically his first Cabinet was the most aristocratic of the century – and Grey had earlier been apparently lukewarm in favour of it. Most of the caricaturists showed him in a favourable light – but not all. There were accusations of nepotism with £18,000 of public money bestowed annually on family members (although it could be argued that Wellington's family and connections cost the State more).

After the fall of Wellington's Ministry, the first attempt to introduce into Parliament a Reform Bill designed to broaden the franchise was made by Lord John Russell in March 1831. His proposals caused a sensation. The Bill listed sixty boroughs to be disenfranchised, 168 Parliamentary seats to be abolished and 106 new ones to be created. Not every MP could be happy to see his seat disappear. (I remember the agonies that the comparatively minor recommendations of the Boundary Commission would cause in some individual cases in my time in Parliament). The Bill passed with a majority of one vote, but then a wrecking amendment was narrowly carried.

So Russell's Bill failed – failure number one.

At Grey's request, King William IV, the new King, dissolved Parliament at the end of April in order to give the Whigs a working majority in a new Commons. The King had been reluctant to agree, regarding dissolution as 'Tantamount to Revolution', but the Cabinet had advised it to be essential. Parliament broke up in disorder. Two days later Wellington's wife died. While she still lay in their London home at Apsley House the building was stoned by the mob, angered by Wellington's opposition to reform. Such was his unpopularity at this time. His windows were now to be shuttered by metal protection – hence the term the 'Iron Duke'.

At the General Election that followed the Tories were routed. In June, a new House of Commons passed a second Reform Bill, drafted in much the same terms as Russell's first Bill. On its second reading (second reading debates are debates

Opposite: **The School of REFORM**
C.J. Grant. Published S. Gans 1831. BM 16586.

Wellington's opposition to electoral reform is clearly illustrated – the dunce in the class is unable to obey the instructions of Lord Grey (the Prime Minister following the fall of Wellington's Ministry). Grey is lecturing a class of recalcitrant Tories.

Grey was frustrated in his drive for reform, and requested that Parliament be dissolved shortly after his appointment. It was done 22 April – two days before the death of Wellington's wife Kitty. This sad occasion did not stop Wellington's house being stoned by a rioting mob, much upset by his continued resistance to reform.

about the general principles of a Bill) the Reform Bill had a majority of 136. Serious attempts were then made to obstruct the Bill's passage but it passed its third reading in the Commons (its final stage) by 109 votes; another sizeable majority. Now it required the approval of the House of Lords, a harder test by far.

In October of the same year this second Bill was debated for five days on second reading in the House of Lords. The Tories had decided on opposition at a meeting at Apsley House. In his speech, the Duke expressed his reasons for opposing the Bill. The franchise, he said, implied responsibility; given a property qualification it would be exercised responsibly; let it become universal and irresponsibility would be the norm; elected MPs would become mere delegates. He quoted Grey's

THOSE FELLOWS ARE A GREAT NUISANCE
William Heath. Published Thos. McLean 1831. BM 16614.

Public sentiment – and the caricaturists – were patently in favour of reform and antagonistic to those who opposed it, Wellington in particular. The 'blindness' of Wellington and Peel and their inability to see the obvious are featured here.

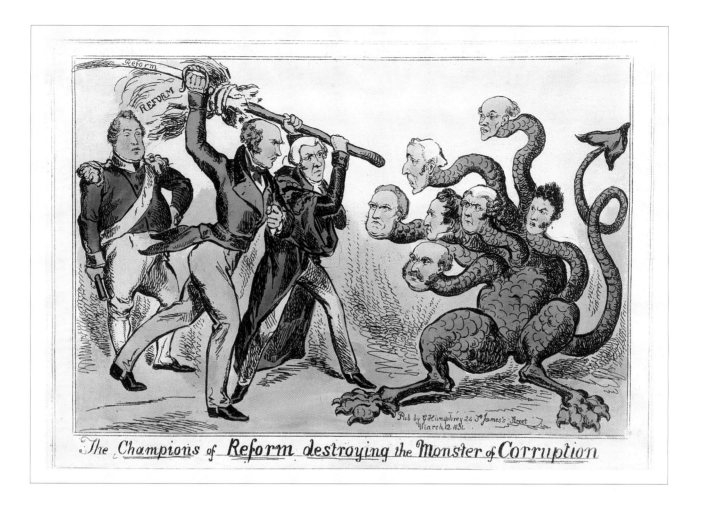

The Champions of Reform destroying the Monster of Corruption
(?) Sharpshooter. Published G. Humphrey 1831. BM 16606.

It is clear on which side the public sympathy lies. Here Prime Minister Grey and Brougham (with King William IV looking on) attack the seven-headed monster of corruption. Among the seven heads, Wellington and Peel are, of course, prominent.

words of fourteen years earlier, when Grey had spoken with warm approval of the constitution of the House of Commons in its existing form – what he asked, had Parliament done in the meantime to earn Grey's disapprobation? It was a telling point. Their Lordships took the Duke's advice. The Lords defeated this second Reform Bill by a majority of 41. (Out of twenty-three Bishops in the Lords, twenty-one voted against the Bill: they made an unholy alliance with the Tories).

That made failure number two.

Rioting and huge public meetings of protest followed. Apsley House was stoned again. In Bristol there were riots for three days; the Mansion House was sacked and the Bishop's Palace burned. There were serious riots, too, in Derby and in Nottingham, where the castle was fired. In Birmingham the bells tolled as for a funeral. In London two newspapers were printed as if in mourning, their pages edged in black. The Duke's pew in the Church at Stratfield Saye was fired.

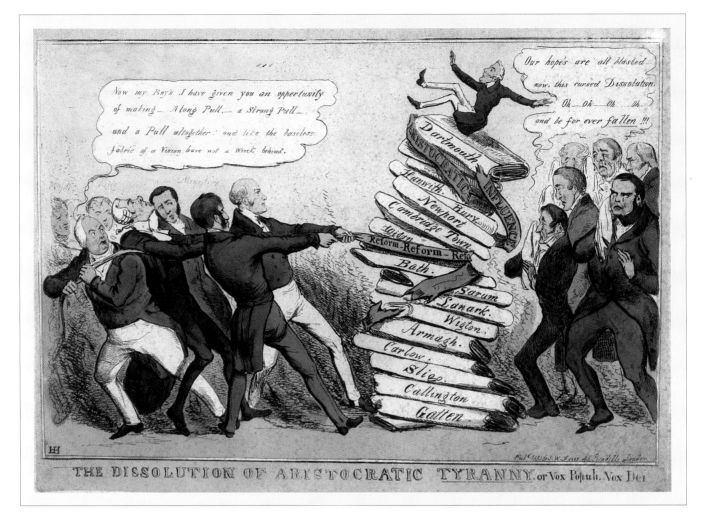

THE DISSOLUTION OF ARISTOCRATIC <u>TYRANNY</u>
H. Heath. Published Fores 1831. BM 16673.

This shows the King helping the reformers (Brougham, Lord John Russell, Althorp and Grey) to pull down the Duke from his high perch on a pile of named boroughs – the ones the anti-reformers had to win in order to obtain a majority in the Commons. The Tories were routed in the General Election for denying the reformers. A Bill was passed in the Commons but rejected by the Lords. (In those days the Lords had an absolute power of veto.) This led to serious rioting in Bristol and Birmingham, while in London two newspapers were printed with black borders – as if in mourning. Three bills in all were introduced to Parliament: two were to fail, the third passing into law in 1832.

In December 1831 a third Reform Bill passed its second reading in the Commons by 324 votes to 162, a huge majority in favour, greater than for the second Bill. The final stage in the Commons, the third reading, (that is, a debate confined to the contents of a Bill) had a smaller majority of 86; smaller but still impressively large. Grey then moved the Bill's second reading in the Lords and the Bill achieved approval in principle in April 1832 by the narrow majority of 9. (This time there were twelve Bishops for the Bill and fifteen against). So far so good. However, Lord Lyndhurst – the Lord Chancellor in Wellington's Ministry – moved and got carried a wrecking amendment. So the Bill appeared

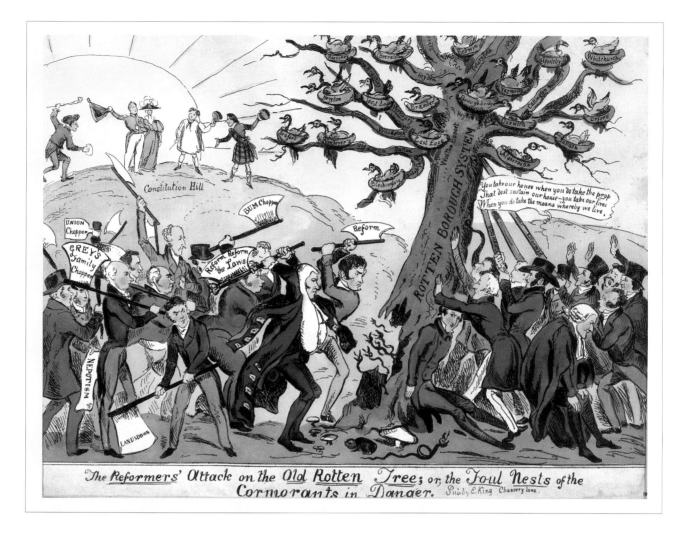

The Reformers' Attack on the Old Rotten Tree; or, the Foul Nests of the Cormorants in Danger. Shibly E. King Chancery lane.

The Reformers' Attack on the Old Rotten Tree

? Sharpshooter. Published E. King 1831. BM16650.

The tree of corruption shelters the cormorants' nests labelled as the Rotten Boroughs – Saltash, Petersfield, Blechingley, Woodstock and Old Sarum among them. The reformers – Grey amongst them supported by Wellington – prepare to demolish the tree while the anti-reformers attempt to shore it up. The Rotten Boroughs were so called because they were those depopulated constituencies that retained their original representation in spite of the fact that there was hardly anyone left to vote. The worst case was Old Sarum with an electorate of two voters: it returned two Members.

to be lost. It seemed that the third attempt to get reforming legislation would become the third failure in just over two years.

Popular opinion was outraged. Now began the so called 'May Days' or days of near revolution in Britain.

Much political manoeuvring then took place. Prime Minister Grey resigned on the 9 May facing the King with an ultimatum – a demand that at least fifty new Peers be created, a number adequate to force the reform measure through the Lords. For this there was a precedent: only the creation of additional Peers had assured the acceptance of the Treaty of Utrecht in 1713. (Before World War II a

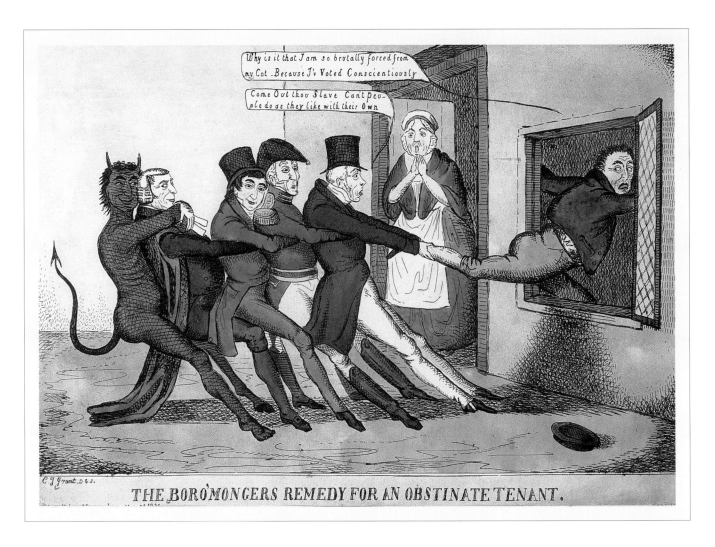

THE BORO'MONGERS REMEDY FOR AN OBSTINATE TENANT

C.J. Grant. Published King 1831. BM unlisted.

Inevitably, the elections were being held on the issue of reform. This print suggests the end of the era when members of the electorate voted as they were instructed. Aided by the devil, Wellington, Peel, Wetherall and Newcastle – strong anti-reformists all – are shown putting pressure on an individual voter.

similar threat would again be made.) Now, in the last years of the twentieth century the composition of the House of Lords has been radically altered. 170 new life Peers were appointed by a new Labour Government: almost all the hereditary Peers were excluded from membership of the Lords. Before this, Prime Minister Thatcher had been almost as radical: in the eleven and a half years of her Ministry 204 new life Peers were created – plus four new hereditaries.

The King refused to agree to Grey's proposal and invited first Lyndhurst and then Wellington to form a Government: the reasoning was that if a Reform Bill was passed by a Tory-dominated House, the necessity to create additional Whig Peers would be avoided. So, again, the Duke had his chance to be Prime Minister. The Whigs proposed to support him until reform was achieved and then to withdraw – a shady but understandable tactic. Again, he was unable to attract adequate support from among

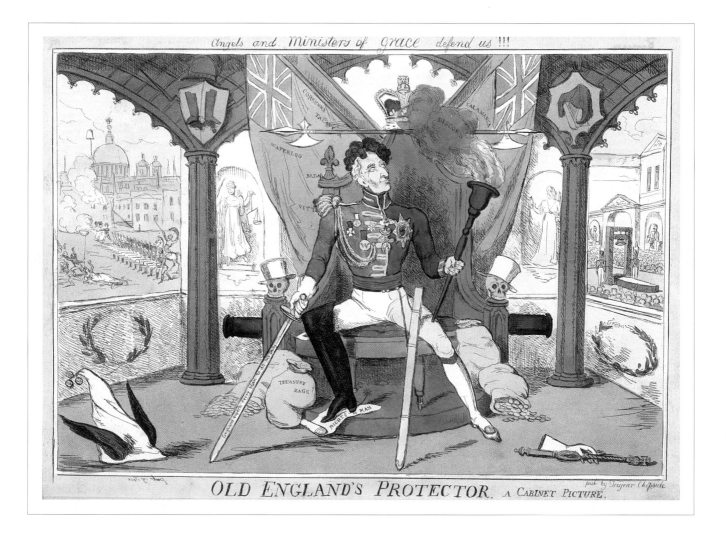

OLD ENGLAND'S PROTECTOR. A CABINET PICTURE.

OLD ENGLAND'S PROTECTOR

Author unknown. Published by Tregear (undated) c.1832. BM 17059.

The Duke is virulently attacked. Houses in front of St Paul's Cathedral in the City of London are shown as on fire: soldiers are about to bayonet the fleeing men, women and children. On the Duke's other side is a guillotine, flanked by more soldiers.

his friends. Peel refused to join him and without Peel's support in the House of Commons his Ministry could not function. Meantime, Government was in abeyance.

There were some who genuinely believed that Wellington intended dictatorship. Resistance to military rule was prepared in some towns in England. Barricades were set up and reform meetings were held everywhere. Rumours of Wellington's imminent assassination abounded. Placards appeared in London and the provinces:

> To Stop the Duke
> Go for Gold

with the successful result (for the reformers) of causing a short-term run on the Bank of England. (Many locally established Banks went out of business in these

years when holders of the banknotes which the individual Banks had issued suddenly demanded gold coin instead of their paper).

On the 15th May the King summoned Grey to Windsor. During the audience he did not ask him to sit down. Grey resumed office, his hand strengthened by the King's unconditional consent to allow the creation of sufficient Peers to make a majority for the Bill in the House of Lords and by the inability of his political opponents to form a Ministry.

In 1831 and 1832 the unelected Lords had resisted the proposals of the Government of the day, even though they were supported by the elected Commons and, to a substantial extent, the proposals safeguarded the position of the landed classes. Now, one side or the other (those in favour of Reform or those against it), had to give way. When the trial of strength came it was the anti-Reformers who yielded.

Grey himself moved the third reading of the Reform Bill in the Lords. It passed on 4 June, 1832 by 106 votes to 22 but many Peers abstained from voting, including the Duke. 'Are we to be ruled by numbers?' one Peer asked. The Bill received royal assent by Commission (the King refusing to give it in person) on 7 June, 1832. Henceforth, numbers would assuredly rule the nation.

The battle was over. The Lords (and the Duke) had fought hard and bitterly and had lost. The popular will had prevailed and Grey had followed it. Within two years Grey retired from politics.

There was a substantial redistribution of Parliamentary seats and an extension of the franchise in England and Wales by almost a half from 435,000 to some 650,000 voters (out of a total population in the UK of well over twenty million). Fifty-six rotten boroughs were abolished and thirty small boroughs had their representation reduced with seats newly allocated to the cities and the counties. In effect the Bill remedied middle- class grievances by acknowledging a property qualification, but it still left the working classes disenfranchised. Reform Bills for Scotland and Ireland followed, similar in effect to the measure already passed by Parliament for England, without fuss.

Thus our country proceeded (unlike France, comparatively bloodlessly, and unlike most other European countries, without serious turmoil) albeit slowly towards the evolution of the democracy that we currently enjoy and practise in our own particular, eccentric way. We are fortunate indeed to have escaped the horrid experiences of other European nations in their violent journeys to the same end.

The Act of 1832, radical as it was in the circumstances of the time, was only a half-measure. It certainly was no panacea for Britain's economic ills as so many of the under-privileged had confidently hoped. It was inevitable that there would be pressure for further reform. 1838 saw the birth of the Chartist Movement whose aim was a further broadening of the franchise. Rioting still occurred. Four more Acts of Parliament were needed to complete the progress of reform, in 1867, 1884, 1885 and 1918: until the 1918 Act some 40% of adult males in the UK were not registered to vote and women were entirely excluded from the vote. Although we now have universal adult suffrage in Britain and in spite of all the

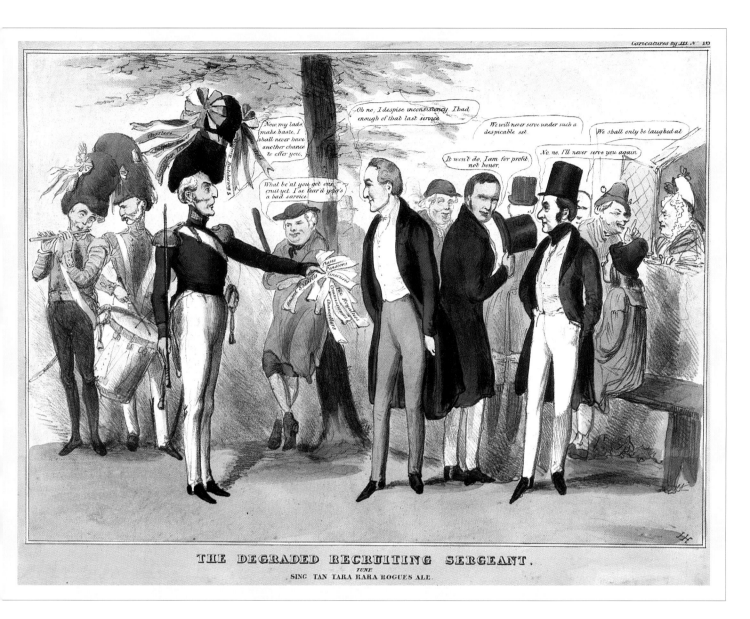

THE DEGRADED RECRUITING SERGEANT

H(enry) H(eath). Published Fores 1832. BM unlisted.

After yet another defeat of the Reform Bill in the House of Lords on 7 May 1832, revolution was in the air. These were the so called 'May Days'.

Grey resigned as Prime Minister because the King had refused to create sufficient Peers to give him the majority he needed to get a Reform Bill passed by the Lords. Wellington was then invited to form a ministry. Peel would not join in – and here Wellington is shown trying to entice him with a fistful of offers. All other Tories turn their back on Wellington or watch gleefully at his discomfiture. Wellington was unable to find support and admitted defeat. Grey was reinstated, and Wellington now reluctantly accepted that electoral reform was inevitable.

SCHOOL FOR BORO'MONGERS

C.J. Grant. Published Tregear/Drake 1832. BM 17086.

The Duke, in his new capacity as reformer, is shown as a devil teaching the anti-reformers to conjugate the verb 'I shall go to hell…' The third Reform of Parliament (England) Bill was given Royal Assent on 7 June 1832. The battle was over.

sacrifices of the past, the proportion of the electorate which troubles to vote is often disappointingly low.

The Reform Act of 1832 destroyed the elaborate system of patronage and nomination which enabled the King to choose his Ministers and thereafter to ensure Parliamentary support for them. Power had shifted. It was the end of an era.

A test of the new reality of political power was not long in coming. In 1834, King William IV dismissed Melbourne's Ministry and he sent for Wellington with a view that he should succeed as Prime Minister. However the Duke, now aged sixty-five, insisted that Peel should become Prime Minister instead. It was the

The REFORMERS VICTORIOUS!!! or the Tory Gang Upset!!!

The REFORMERS VICTORIOUS!!!
Artist unknown. Published Fairburn 1832. BM unlisted.

With the passing of reform, the 'Tory Gang' is clearly upset. John Bull, ridden by the King with the Bill and the Union Flag in his hands, tosses Wellington. Other anti-reformers are shown in disarray. Wellington's about-turn, that is to say the sacrifice of his anti-reform beliefs in favour of his duty to his King and country, has apparently been overlooked.

last time a Sovereign was able to dismiss a Ministry which commanded a majority in the Commons. The situation was complex but the reality was that the House of Commons was unwilling any longer to tolerate the arbitrary use of Royal authority. The 'King's Party' no longer dominated. The Sovereign's powers were curtailed and the power of the elected chamber enhanced. Henceforth party politics, in the sense that we understand that term today, were to grow in significance.

In our own age, new constitutional changes are happening – but that is another story – to be commented upon by another generation of caricaturists.

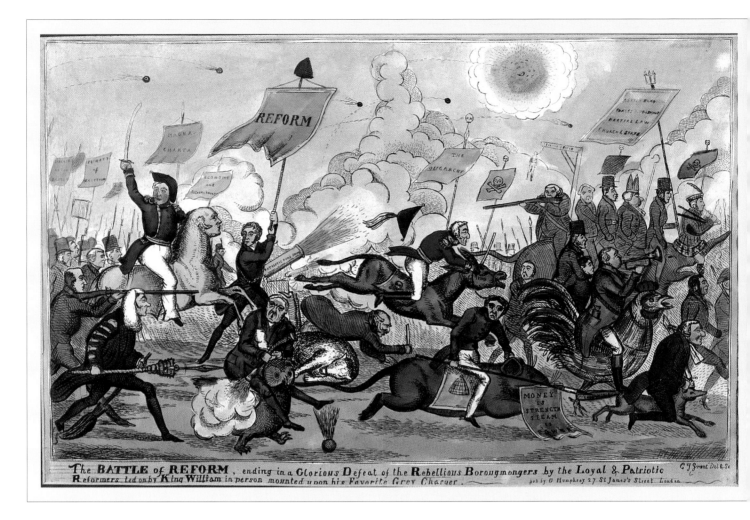

The BATTLE of REFORM, ending in a Glorious Defeat of the Rebellious Boroughmongers by the Loyal & Patriotic Reformers led on by King William in person mounted upon his Favourite Grey Charger.

pub by G. Humphrey 27 St James's Street London

The BATTLE of REFORM

C.J. Grant. Published G. Humphrey 1832. BM unlisted.

Wellington is shown being routed in his favourite milieu – battle. The King is mounted on 'his favourite' grey charger (a pun on the name of the Prime Minister). Wellington is mounted on a donkey.

As a result of the passage of the Reform Bill, now an Act of Parliament, the King's power grew more limited, while that of Parliament increased. Henceforth, party politics was to grow in significance.

Thus Wellington's prediction that electoral reform would inevitably result in far-reaching constitutional changes was soon proved correct. We have not seen the end of them even now, 170 years later.

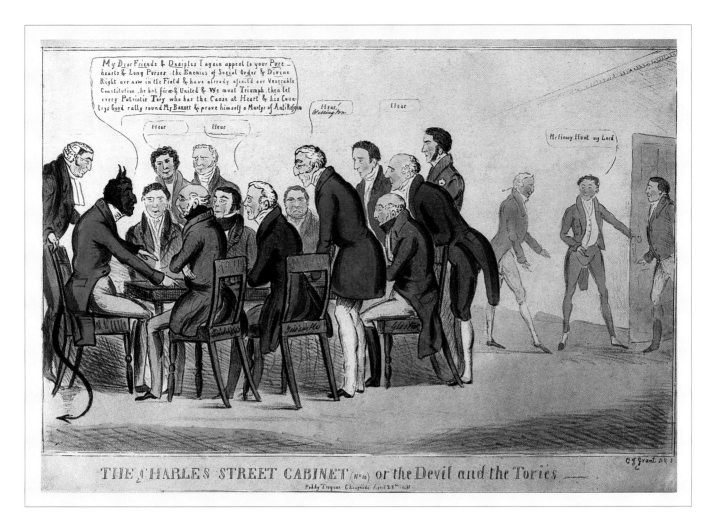

THE CHARLES STREET CABINET

C.J. Grant. Published Tregear 1831. BM unlisted.

This caricature depicts the devil at a meeting of prominent Tories at their headquarters in Charles Street (superseded in 1832 by the Carlton Club). The Club occupied magnificent premises in Pall Mall but these were bombed during World War II and rebuilt as a Bank. The Carlton Club is now on the site of what was known as 'Arthur's' (in St James's Street).

The devilish Wellington appeals for the support of the anti-reformers.

'Orator' Hunt, the radical agitator, who addressed the tragic public meeting at Peterloo in Manchester in 1819, is at the door.

The broadening of the franchise in 1832 inevitably led to more formal political organisations. The birth of modern party politics in Britain dates from this time.

The Duke, on seeing the membership of the first reformed Parliament, said (according to one writer, writing some sixty years later), 'I never saw so many shocking bad hats in my life.'

(If that was his opinion in the first third of the nineteenth century, what would his opinion be now, in the first third of the twenty-first century?)

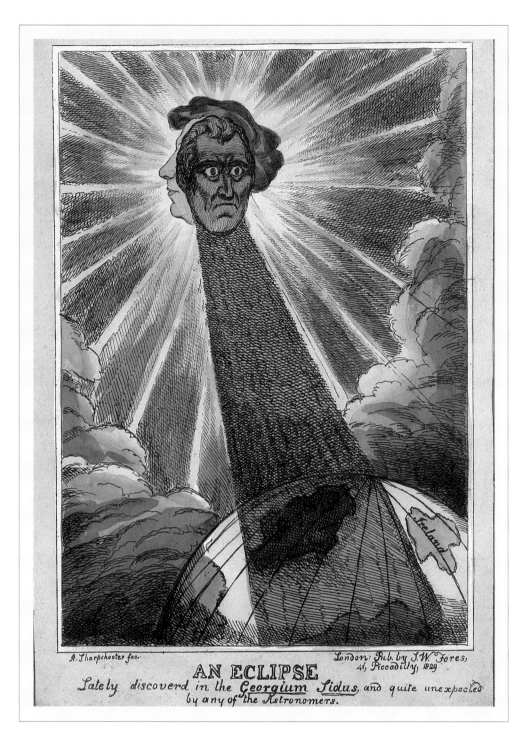

AN ECLIPSE
Sharpshooter (?J.Phillips). Published Fores 1829. BM 15810.

Wellington's commanding manner inevitably provoked an assumption of overwhelming ambition. Several caricatures show the Duke as ambitious to assume supreme power – as a dictator if not as King. In this caricature he is shown apparently trying to eclipse the King and failing to do so.

Opposite: **A POLITICAL REFLECTION**
Paul Pry (William Heath). Published 1828. BM 15521.

King George IV – depicted as a baby – is asleep, rocked by Lady Conyngham (the King's mistress) while Wellington is accused of assuming both the civil and the military power and trying on the crown for size.

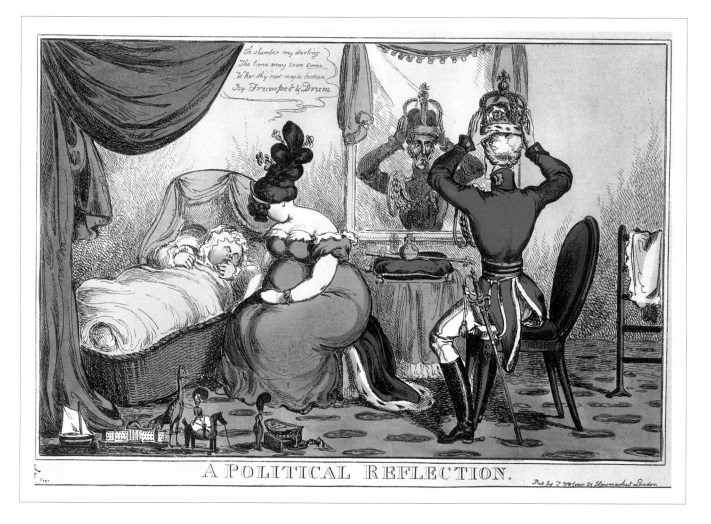

Oh slumber my darling
The time may soon come
When thy rest may be broken
By Trumpet & Drum

A POLITICAL REFLECTION.

Pub by I M°Lean 26 Haymarket London

— Eight —

Relations with his Sovereign

As a matter of historical fact, Wellington lived more years during the reign of King George III than under any other sovereign, but his relationship with this sovereign was comparatively distant, inevitably so as after the King's repeated attacks of alleged madness his son became Prince Regent (after bitter debates in both Houses of Parliament at the end of 1810 and early in 1811). George III died in 1820 and the Prince Regent now became King George IV.

Caricaturists frequently portrayed Wellington as exercising a dominant influence over the new King George IV – especially at the time of the furious debates over Catholic emancipation. The Duke is usually represented (accurately) as leading a reluctant monarch to its acceptance, aided by the King's mistress, Lady Conyngham, who was known to be sympathetic to the Catholic point of view (even though she alleged that she never sought to influence the King). Caricatures were published implying that Wellington's personal ambitions were unlimited – including, perhaps, an intention to replace the Sovereign as the nation's Head of State.

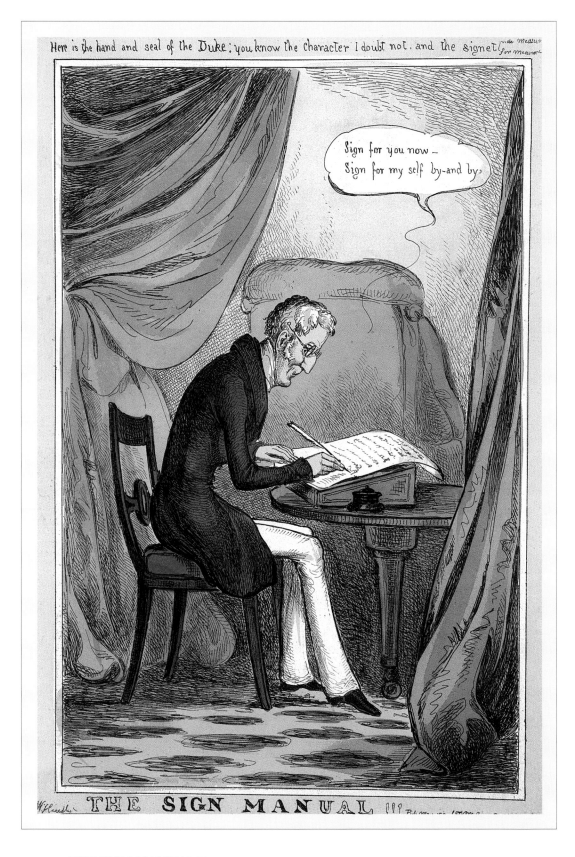

THE **SIGN MAN**UAL!!!
William Heath. Published Thos. McLean 1830. BM 16122.

When King George IV, at the end of his days, became too ill to sign State papers, the Sign Manual Bill provided for the royal signature to be affixed to documents by means of a stamp – naturally with rigid safeguards. Here Heath suggests that Wellington had ideas above his station.

THE JOLLY WATERMAN and his FAIR!!!
William Heath. Published Thos. McLean 1830. BM 16137.

Note the play on words. While Wellington was invariably depicted as having substantial influence over King George IV, the opposite was supposedly true with his successor, King William IV (the popular 'King Billy'). Here Wellington is depicted as warding off the Duke of Clarence during King George's terminal illness, suggesting difficulties to come. Clarence rows his Duchess in a Thames wherry towards Wellington standing on the Crown stairs, dressed (apart from his hat and boots) as if in the uniform of the royal barge.

The idea that the Duke aimed at sovereign power was the absurd contention of a letter in the *Morning Journal* on 30 July, 1829, part of a press campaign against Wellington at this time. The writer alleged that the Duke was ' …aiming at the Crown, but we shall take care that he does not succeed in this'. The author, who was sued for libel by the Duke, proved to be the chaplain of the Duke of Cumberland, the King's brother, a major opponent of Wellington during the passage of the Catholic Emancipation Bill. However, the legal action by Wellington was generally disapproved of. Greville, writing in his memoirs, said:

> 'The whole press has risen up in arms against the Duke's prosecution of the
> *Morning Journal* which appears to me (though many people think he is
> right) a great act of weakness and passion. How can such a man suffer by the
> attacks of such a paper and, by such attacks, the sublime of the ridiculous?'

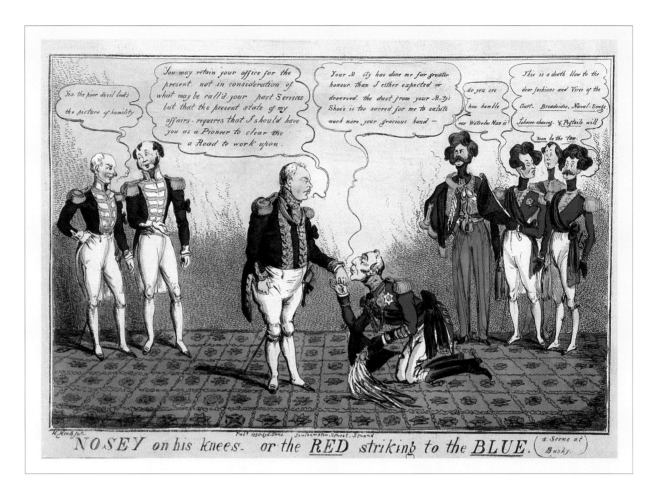

NOSEY on his knees or the <u>RED</u> striking to the <u>BLUE</u>
H. Heath. Published S. Gans 1830. BM 16183.

'Nosey' was the street name for Wellington – no doubt after his distinctive profile. Under King William IV (King Billy), the new Royal Court was navy-based and spartan in comparison with the luxurious and military life-style of the previous Sovereign, who had surrounded himself with officers of the top regiments. Thus the red (soldiery) is shown striking (i.e. surrendering) to the blue of the Navy.

Valuable advice to today's politicians, one may reflect. And yet – there is always a dilemma. One can ignore a calumny as being unworthy of serious notice or the trouble and expense of contradiction: but the misleading press cutting goes in the file to be picked up by other journalists, the libel will be repeated and, because it has not been denied, it becomes the damaging fact.

The Duke regarded loyalty to the Sovereign as his paramount duty. He had spent his life in the service of the Crown and to the Crown he owed all his honours. 'I have eaten the King's salt,' he would say.

Peel was frequently displayed as a rat-catcher, i.e., the equivalent of today's Parliamentary Chief Whip, the Member of Parliament appointed by his Party's leader to discipline Members and to ensure their support for the Government's policies and individual legislative measures. As Home Secretary and Leader of the House of Commons, he was in effect Wellington's deputy during the Duke's time as Prime Minister.

I turns my hand to any thing now;
I ketches Rats like winking.

THE CAD TO THE MAN WOT DRIVES THE SOVEREIGN
Paul Pry (William Heath). Published Thos. McLean 1829. BM 15734.

The cad was the coach ticket tout and handyman – conductor. Here Peel is shown not only as the coachman's factotum but also as the rat-catcher, that is to say, the chief whipper-in of his Party's MPs in Parliament.

King George IV died in June 1830 after a period of illness, the power of the Crown having much reduced during his reign. Authority was passing to the Prime Minister and the Cabinet, a constitutional development of immense significance. Wellington paid him a handsome tribute in the House of Lords: ' …he was admitted by all,' said the Duke, 'to be the most accomplished man of his age.'

Wellington was not given to extravagance of language – the compliment was sincere. They had had many difficult meetings, notably over the vexed subject of Catholic emancipation. The King had a reputation as a spendthrift, a libertine and profligate (damningly pictured by Gillray, among others) but he had taste; he could be a generous private benefactor; as a collector, he had discretion; he was a patron of the arts and he was knowledgeable. We owe him the Pavilion at Brighton and also Regent's Park; we owe him besides the modern aspects of Buckingham Palace and Windsor Castle – a fine legacy. In politics his attitude was realistic and pragmatic: there was in him, said the Duke, ' …a great preponderance of good'. In the eyes of most historians, however, his personal misconduct, his profligacy and his raffish behaviour, made a weightier entry in his lifetime's account.

King George IV had no living issue, so he was succeeded by his brother the Duke of Clarence who became King William IV.

Wellington's Ministry ended in November 1830, only five months after the death of George IV. King William received his departing Ministers 'with the greatest kindness, shed tears, but accepted their resignation without remonstrance' (wrote Greville).

Wellington's time as Prime Minister was comparatively short. The Duke's Ministry had been defeated in the House of Commons in November 1830 on a comparatively minor matter by 233 votes to 204, a majority against the Government of 29 votes. The issue under debate was whether the Civil List accounts should be referred to a Committee, not by any means a matter of significance in its own right. Whigs, Canningites and thirty ultra-Tories combined to beat the Government in the division lobbies. In ordinary circumstances that defeat would not have been fatal. However, electoral reform was to be debated on the following day. Defeat for Wellington's Ministry on that issue (a strong probability) would have been a disaster. The Duke at once resigned as Prime Minister, glad it was not on account of reform. He promptly became 'the man wot used to drive the Sovereign'.

Opposite: THE MAN WOT WILL STEER HIS OWN VESSEL
Asmodeus (probably Seymour). Published Thos. McLean 1830. BM 16164.

Nautical references are rife. In a variation of the 'coachman wot drives the King', King Billy (the sailor King) implies that Wellington, a mere soldier, is unfit to steer the country. The King calls Wellington a 'Horse marine' i.e. a landlubber, ignorant about a sailor's work. Wellington, on a lower level, touches his hat respectfully.

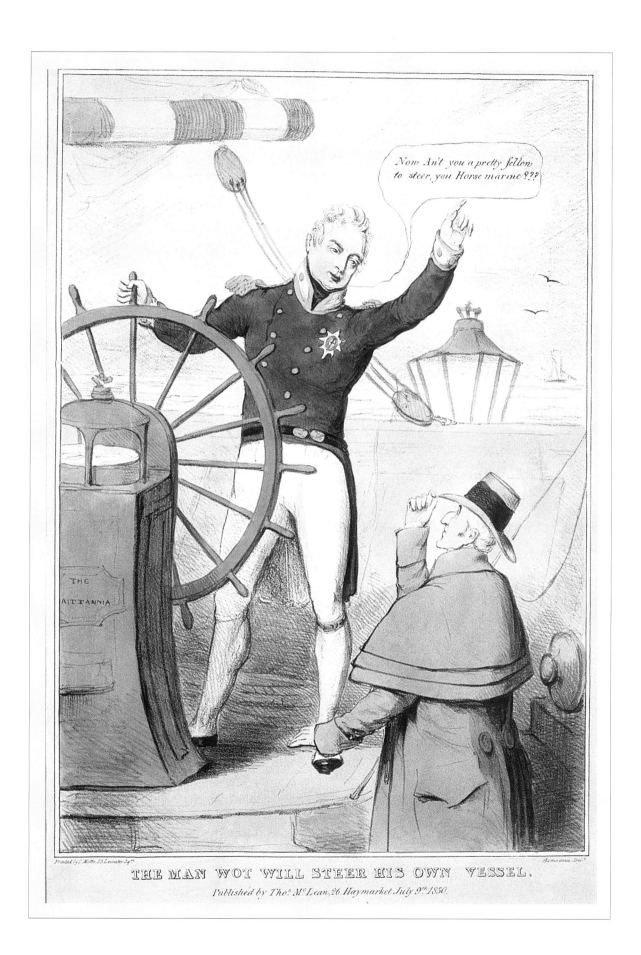

PITY OUR FALL, GOOD SEAMEN ALL!!!

Sharpshooter (?J.Phillips). Published King 1830. BM 16334.

Sharpshooter shows King William IV, the 'Sailor King' kicking Wellington and Peel off the deck of the good ship *Britannia*. He was no longer the King's First Minister, but Wellington would outlive his new Sovereign in the service of the State.

William Heath's original portrayal of Wellington as a coachman ('The man wot drives the Sovereign') was often copied. On the death of King George IV in June 1830, caricaturists were quick to assume that the soldier Duke would not exercise a similar dominant influence over the new 'sailor' King William IV – Sailor Billy. King William's youth had been spent as a career naval officer after which he had lived quietly in the country with his mistress, the actress, Mrs Jordan. She bore him ten children (George, Sophia, Henry, Mary, Frederick, Elizabeth, Adolphus, Augusta, Augustus and Amelia).

King William IV succeeded his brother King George IV because of the death of the heir-presumptive Princess Charlotte, daughter of the ill-fated Queen Caroline, in 1817. The Prince Regent (as he then was) having no other legitimate children the race was on for one of his brothers to produce an heir.

CAPTAIN CL—ANCE taking Command of the Ship British Constitution
H. Heath. Published S.W. Fores 1830. BM 16182.

The public's great expectations of the new King are shown here: King William is being relied upon to take command of the ship *British Constitution*. The papers on the deck list some of the issues of the day – including reform, free trade and rotten boroughs. The King promises the maintenance of the Navy and reform of the Church and Army, while Queen Adelaide pledges her support to virtue and morality – doubtless a relief to the public after the escapades of King George IV. Wellington (with Peel to his left) hopes that his power will continue under the new regime.

William, Duke of Clarence, married Princess Adelaide of Saxe Meiningen in 1818, but sadly both their daughters died in infancy, leaving the line of succession open to Princess Victoria, born in 1819, the only daughter of the Duke of Kent. Victoria become Queen when King William IV died in 1837. The Duke was gregarious, enjoyed company and informed conversation and entertained generously and often at Walmer Castle in his later years. Queen Victoria and Prince Albert took over the castle for a month at the end of 1842. Wellington thus lived during the reigns of four British sovereigns.

Over the years to come the Duke's role would increasingly be that of the elder statesman, of declining interest to the caricaturist: but meantime, as pressure built up in favour of electoral reform, to which he was strongly opposed, he continued to feature prominently (and invariably unfavourably) in their works.

AND IF I HAVE GOT A PENSION HAVE I NOT A RIGHT TO IT?
William Heath. Published Thos. McLean 1829. BM 15912.

Wellington in the dress of a Chelsea Pensioner (Chelsea Pensioners lived in the Hospital for old soldiers whose foundation stone was laid by King Charles II in 1682. It still happily serves its same purpose over 300 years later). After his death in 1852 his body was brought from Walmer Castle to lie in state at the hospital before the funeral.

— EPILOGUE —

The passage of the Reform Bill, now the Reform Act 1832, was widely celebrated. Wellington having finally acquiesced in its passage, the caricaturists were now deprived of an obvious and attractive target to attack. All the same, they did their best. It is impossible not to sympathise with the title of this caricature.

Not that the Duke was inactive in public life, far from it. He held many distinguished public offices outside politics. In 1826 he had become Constable of the Tower of London; in 1829 Lord Warden of the Cinque Ports and an Elder Brother of Trinity House. In 1834 he became Chancellor of Oxford University and, in 1850, Ranger of the Parks – St James's Park and Hyde Park in London. He was Lord High Constable for the Coronations of King George IV in 1821, King William IV in 1831 and Queen Victoria in 1838. There was little in those public offices for the caricaturists to lampoon – though they did their best.

But politics did not easily let him out of its thrall. When Prime Minister Grey resigned in 1834 and was succeeded by Melbourne, the latter's Ministry lasted only four months. On Melbourne's resignation, King William IV invited Wellington to become Prime Minister again. He did not accept. Instead he acted as caretaker for Peel for a frenetic twenty-four days during which he held the following offices: Prime Minister and First Lord of the Treasury, Home Secretary, Foreign Secretary and Secretary for War and Colonies. The wags asserted that at last the Government was of one mind. (Cartoons, during her term of office as Prime Minister, have shown Margaret Thatcher occupying every seat at the Cabinet table.) Then Wellington became Foreign Secretary under Peel's premiership (as Alec Douglas Home loyally served Prime Minister Heath a century and a half later and Heath failed to serve Thatcher similarly). When the Tories fell in 1835, for some six years the Duke was Leader of the Opposition in the Lords.

King William died in 1837, to be succeeded by the young Victoria. In 1841, after the General Election, Wellington entered the Cabinet without office (Minister without portfolio in today's parlance). In 1842 he again became Commander-in-Chief of the Army, a post he held for the rest of his life. In 1846 he was prominent in supporting Peel's Ministry during the repeal of the controversial Corn Laws.

There was much political unrest throughout these years, not least in Ireland where a devastating potato famine occurred in 1845.

The high duties on cereal imports had already been mitigated in 1842 but Peel proposed the repeal of the Corn Laws three years later. Peel understood that popular clamour for cheaper food could not be denied, in spite of the need to protect home agricultural production. There was substantial support for the Anti-Corn Law League, led by Richard Cobden and John Bright, which argued for the repeal of the duties on imported grain which were considered to raise the

price of food for the working man and to benefit only the landowning classes. Though he had misgivings about the wisdom of the policy, in 1846 Wellington urged the Lords to allow the passage of the Corn Bill and thereby ensure the unity of the Ministry. Parker's biography of Peel quotes the Duke as saying: 'a good Government, is more important than Corn Laws...' This great event, again showing Wellington's commonsense in his willingness to adapt or change his views in the light of events and experience, in effect marked his retirement from party politics.

Not that his public service was by any means over. In the late 1840s agitation and revolution were the norm; revolutions abroad, and Chartist activities at home. The Reform Act of 1832 was hardly the panacea for economic distress that some of its proponents had so devoutly believed it would be. It was only a minor broadening of the franchise. Now the 'People's Charter' of 1838 sought annual Parliaments, secret ballots, payment of Members, equal electoral constituencies, no property qualifications for Members and universal male suffrage.

National petitions were raised, but the post-1832 'reformed' Parliament was unsympathetic. By 235 votes to 46 the House of Commons refused to consider the petition of 1839 even though it was signed (it was said) by one million two hundred thousand signatories. The petition of 1842 was signed by more than three and a quarter million names. These were high numbers. Even so, a proposal that this petition be heard was rejected by the Commons by an even larger majority, 287 votes to 49. The petitioners were wretched, uneducated, half-starved and poor: their chief demand was for their voice to be heard through universal suffrage. Their audience was unsympathetic: even Macaulay believed that universal education must precede a widening of the electoral base.

The petitioners were not always wisely led and the strikes and riots that occurred alienated much responsible opinion. In the end Parliament would

Opposite: **NIL FUIT UNQUAM TAM DISPAR SIBI!!!**
(*Nothing was ever so unlike himself*)
William Heath. Published Tregear 1834. BM unlisted.

As he told Mr Arbuthnot, Wellington had studied Latin for 'a few days' and professed to understand the language well. Even so, he made two errors in his oration. (No doubt this was what led him to recommend that Latin should not be used in public speaking). Nonetheless, his installation as Chancellor of Oxford University was a personal triumph: the young applauded him warmly. Following his unpopularity over his resistance to Parliamentary reform before the passage into law of the Reform Bill of 1832, that, on the surface, was remarkable. However, Greville, the aristocratic and cynical Clerk to the Privy Council, commented waspishly in his well-informed memoirs: 'Many people kept away at Oxford, which seems to have been a complete Tory affair, and on the whole a very disgraceful exhibition of bigotry and party spirit; plenty of shouting and that sort of enthusiasm... The Duke made rather indifferent work of Latin speeches. As usual he seemed quite unconcerned at the applause with which he was greeted: no man ever courted that sort of distinction less.' That last observation was certainly true.

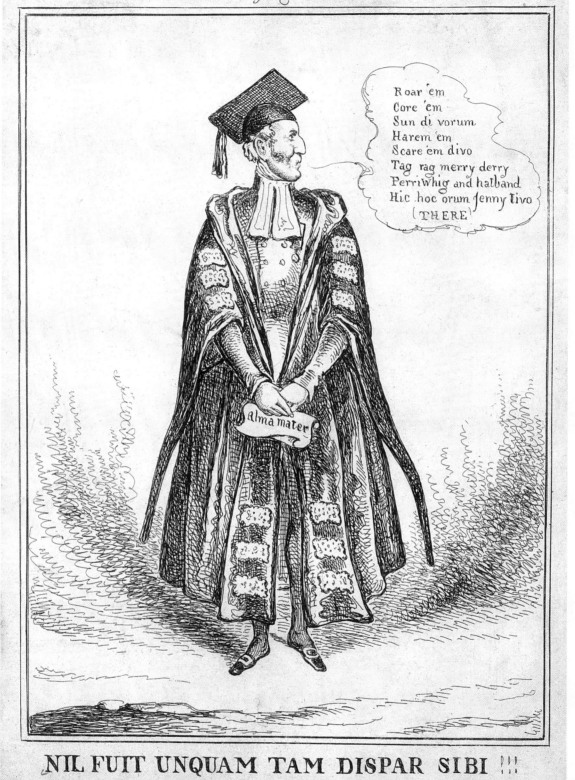

accept the logic of the demands of working people, which to present-day eyes seems reasonable enough. It says much for the innate good sense of the British people that those days passed without revolution in spite of much suffering.

As Commander of the Army, Wellington successfully defused a potentially riotous situation in London in 1848. The Chartists planned to march from Kennington to Westminster to present their five million signature petition and replace Parliament with a 'French-style National Assembly'. They were persuaded instead to transport the petition by cab. Petitions are not always what they seem to be. On examination, this one was found to contain the signatures, among others, of Mr Punch, the Queen, Sir Robert Peel and the Duke.

Now his lifetime of public service was almost ended.

'Think of me at my best,' said Steerforth to David Copperfield, as he moved off life's stage. This is how we should remember Wellington. His best was excellent and he habitually gave nothing less, as a military man, as a statesman, as a politician.

Napoleon and his Marshals were supposedly invincible. Wellington defeated the man who was ruler of Europe and had wider ambitions still, Britain's enemy who had brought economic isolation to Britain with its attendant damage – the equivalent in the nineteenth century of Germany's ferocious submarine policy which brought Britain almost to its knees in both World Wars in the twentieth century. Wellington repeatedly conquered Napoleon's formidable armies: not only in that final victory at Waterloo but earlier in Portugal, in Spain and in France itself.

We have too many heroes in our islands' long history to assert that he alone was England's greatest son but the man whom his proud soldiers called the 'long nosed b..... who defeated the French' or 'Old Nosey' was an incomparable general. That is undoubted. We owe to him and those who served with him the maintenance of our country's freedom and that of the many nations of Europe in his time and later.

When his soldier's service was over, so commanding a personality could not have long avoided prominence in political affairs. First, he proved himself a wise and generous administrator of defeated France and he was honoured for that, not least by that old enemy. Successful in war, he then brought a long period of peace to Europe. That too was a formidable achievement.

His temperament, proud and strong, was less suited to domestic politics. Ever a patriot, he was driven by a stern and uncompromising sense of duty. Discipline was his habit and his strength. He drove himself hard. He rode a horse as strongly at seventy as he ever had as a young man. His energy was great and he worked long hours.

'My business was always to do the business of the day in the day,' he remarked.

He was not always fit. He became deaf in one ear through the incompetence of a doctor. He had suffered from cholera. Sometimes there were heavy colds and, later in life, seizure attacks. In 1828, after a bout of sleepless nights, he took the waters at Cheltenham. That too caught the eye of the caricaturists.

There will always be doubts as to his statesmanship in home affairs. Obdurate he could be. On one occasion he said, ' ...there is no mistake; there has been no mistake and there shall be no mistake.' Yet he had the wisdom to change his mind if he believed the general interest required it.

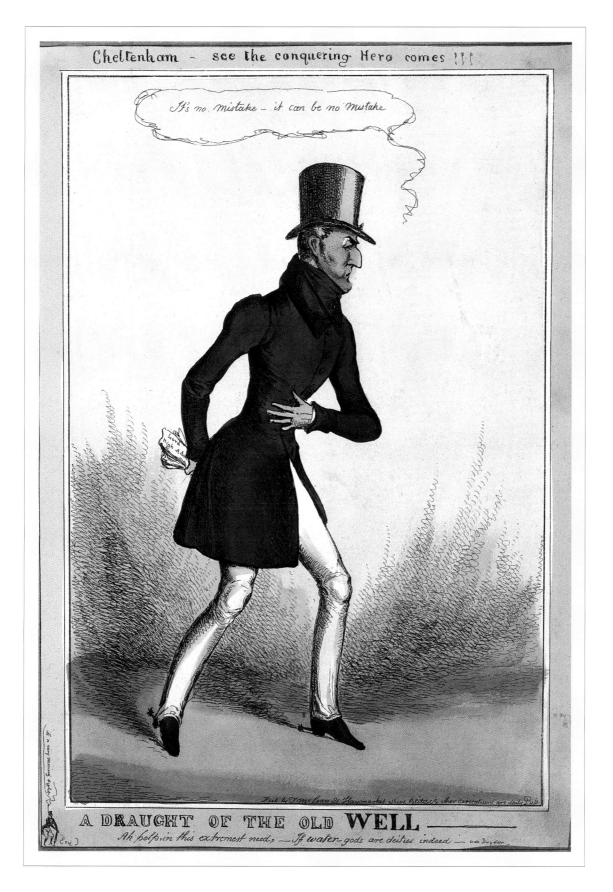

A DRAUGHT OF THE OLD WELL

Paul Pry (William Heath). Published Thos. McLean 1828. BM 15548.

Overwork and illness took the Duke to Cheltenham in August 1828 for the waters.

May we ne-er want a <u>FRIEND</u> or a Bottle to give him!!
Unknown. Published c.1832. BM 17103.

Here the Duke is portrayed being in league with the devil, as he often was in the earlier days of the Catholic Emancipation Bill. The calumny was repeated in the notorious 'May Days', when electoral reform was so great a matter of popular concern.

ALAS! POOR JOHNNY!

Paul Pry (William Heath). Published Thos. McLean 1828. BM 15510.

Here he is depicted as riding John Bull in to the pit of hell. The ultra-Tories (who opposed Catholic emancipation) ride away while on the hill stands a temple to Canning and 'Civil and Religious Liberty'.

Not for him the inflexibility of those who were careless of the need to avoid civil war in Ireland. So he successfully secured Catholic emancipation during his time as Prime Minister. For this he was virulently attacked by the caricaturists (the paparazzi and the tabloids of the day).

Good sense was his strength: it led him in the end to acquiesce in a substantial broadening of the electoral franchise in Britain – against which he had formerly argued out of his conviction that this must lead inevitably to less independence on the part of Parliamentarians from the demands of a more numerous electorate. (Who is to say that he was wrong about that? – even if today's proper conviction is that democracy demands universal suffrage). For this view, too, he was pilloried.

It is debateable whether, had he introduced some minor measure of electoral reforms in 1830 his Government might have survived. As with Catholic emancipation, such was his authority and standing that he could have probably

carried his party and friends in his support. His reputation as a reforming Prime Minister would have then been unassailable. As it was, his apparently inflexible stance was to cost him dear in terms of personal popularity at the time – and history too must judge him unfavourably in this context.

By the time he died of a stroke in September 1852 at Walmer Castle, the traditional home of the Warden of the Cinque Ports (in 1829 called the 'most charming massive chateau' by Harriet Arbuthnot, his confidante, in her Journal) he had recaptured all his lost popularity – as his euphoric reception by the students at Oxford University presaged. He was buried as a national hero in St Paul's Cathedral in the City of London, his funeral being the best attended since that of Nelson, England's other great Captain. Extraordinarily, it seems that they never knew each other, having met only once and then by chance at the Colonial Office in Whitehall.

Palmerston said that no man lived or died in the possession of '…more unanimous love, respect and esteem from his countrymen.' In his funeral ode, Tennyson called Wellington 'England's greatest son'. For certainly, regardless of the passing political controversies in which he was involved, he served our country all his life with courage and conviction.

As he once said, '…there is nothing like a clear definition.' How well did the caricaturists define the man?

While he was prominent in public life the caricaturists had much pleasure at his expense. They could paint him in stark colours – as a would-be dictator or as a man in league with Satan. And they did and were merciless about it. These contemporary drawings add little to our understanding of the man, but then it was not their purpose to present a rounded picture of him. They set out to amuse or to make a political point or to ridicule, and in this respect they were brilliantly successful. Nor does it seem that they exercised much influence either on the political scene or on Wellington himself. Where the caricaturists have done us a particular service is in drawing attention to subjects that were of greatest popular interest at the time they made their engravings.

The Iron Duke could afford to laugh at their works (and with them). And this he did.

His sterling character was always clearly defined in the contemporary public's mind, whether they agreed with him or not.

His life as a civilian mirrored his experiences as a soldier. In battle he risked his life and when he triumphed he was fêted. After his military service, his life was again often threatened by the mob or by madmen, but he was more frequently applauded in the streets. At the very end more than a million turned out to honour him as his funeral cortège passed through the centre of London. There are 'ups and downs,' he said, 'the only way is never to care about them.'

His integrity, his greatness, his diligence and his sense of duty were unaffected by his critics while he lived. 'I am but a man,' he said ('his refrain', wrote Elizabeth Longford). What a man! we may comment.

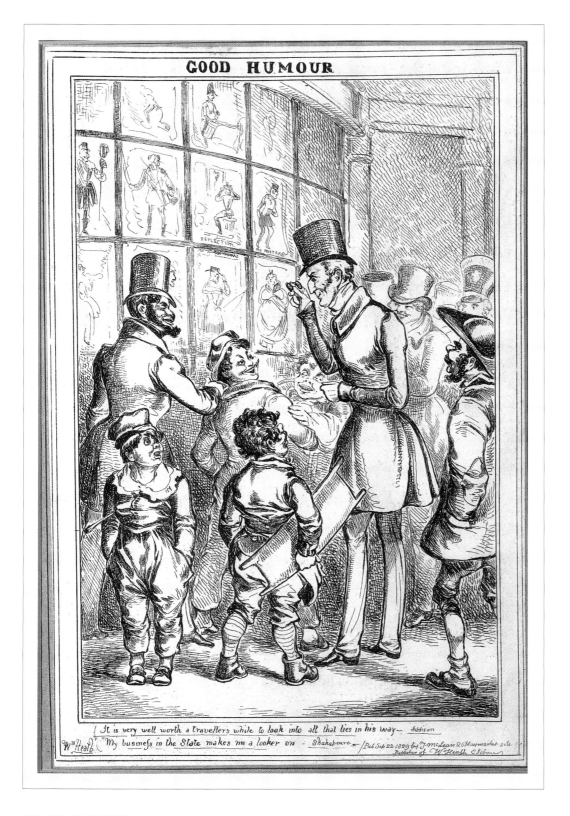

GOOD HUMOUR
William Heath. Published Thos. McLean 1829. BM 15859.

Though there is little evidence that Wellington took any serious notice of caricatures, he is shown here admiring a display outside McLean's print shop in the Haymarket. Representations of him as a coachman or a mute trying on the crown for size (an inference that he was personally over-ambitious) are clearly visible. The crowd, a mixture of all classes, a Jew, a dustman, a butcher's boy and a gentleman, is laughing. The Duke, too, is evidently amused. All contemporary accounts of him confirm that he had a keen sense of humour.

— BIBLIOGRAPHY —

Many excellent books have been written about Wellington and on the subject of caricature and the caricaturists of the period. Some of these titles are of greater interest to the serious historian while others will appeal to the general reader. The selection which follows is by no means exhaustive but may be useful as a guide to what is available.

Important documents and contemporary evidences of Wellington's life and times, such as diaries, letters, speeches and biographies, are also available. A selection may be found in the appendices of some of the books listed below. There is no shortage of printed material about the Duke.

The British Museum possesses a substantial collection of prints of the Duke of Wellington and the excellent Wellington Museum at Apsley House has a smaller collection of sixteen prints on display.

Bryant, Sir Arthur, *The Great Duke*, (Collins) 1971.

Campbell, Cynthia, *The Most Polished Gentleman, George IV & The Women in His Life*, (Kudos Books Ltd) 1995.

Donald, Diana, *The Age of Caricature – Satirical Prints in the Reign of George III*, (Yale University Press for the Paul Mellon Centre) 1996.

Fraser, Flora, *The Unruly Queen*, (Macmillan) 1996.

George, M.D., *Catalogue of Political and Personal Satires*, (British Museum Publications) 1938-1978.

Guedalla, Phillip, *The Duke*, (Hodder & Stoughton) 1946.

Heneage, Simon and Bryant, Mark, *Directory of British Cartoonists & Caricaturists 1730-1980*, (Scholar Press) 1994.

Hinde, Wendy, *George Canning*, (Purnell Book Services) 1973.

Holyoake, Gregory, *Wellington at Walmer*, (Buckland Publications) 1996.

Houfe, Simon, *The Directory of British Book Illustrators and Caricaturists 1800-1914*, (Antique Collectors' Club) 1978.

Leslie, Shane, *Curiosities of Politics: George the Fourth*, (Ernest Benn Ltd.) 1926.

Longford, Elizabeth, *Wellington: The Years of the Sword*, (Weidenfeld & Nicholson) 1969.

Longford, Elizabeth, *Wellington: Pillar of State*, (Weidenfeld & Nicholson) 1972.

Longford, Elizabeth, *Victoria RI*, (World Books) 1969.

Mackenzie, Ian, *British Prints – Dictionary & Price Guide*, (Antique Collectors' Club) 1987.

Physick, John, *The Duke of Wellington in Caricature*, (HMSO for the Victoria & Albert Museum) 1965.

Smith, E.A., *George IV*, (Yale) 1999.

Smith, E.A., *A Queen on Trial*, (Alan Sutton) 1993.

Strachey, Lytton and Fulford, Roger (Ed.), *The Greville Memoirs 1814-1860*, (Macmillan & Co.) 1938.

Wardroper, John, *The Caricatures of George Cruickshank*, (Gordon Fraser) 1977.

Wilson, Joan, *A Soldier's Life: Wellington's Marriage*, (Weidenfeld & Nicholson) 1987.

INDEX

Entries and page numbers in **bold** refer to caricatures and their captions.
Entries with an asterisk * denote caricaturists.